Praise for Charles Kelly's
The Great Limbaugh Con

"If there were a way to force people to read this book, I would. Instead, I'll have to content myself with a heartfelt recommendation for all libraries and people who care (and even, or especially, those who don't) about our jobs, our future, and the planet.

—*Counterpoise* Vol. 1, #3
a publication of the American Library Association

"This book dissolves the daily Limbaugh gasbag with the hard facts about the corporate powerbrokers he is fronting for and the future directions that a progressive America can take. *The Great Limbaugh Con* is for people who want to think for themselves."

—Ralph Nader

" 'Just listen for two weeks,' Limbaugh routinely asks his audience. It's a reasonable proposition, so here's one in exchange: Just read two chapters. It'll only take a few minutes, and Kelly has written a challenging take on the World According to Rush."

—*Fort Worth Star-Telegram*

"A smart, rational book."

—*Mother Jones*

Class War
in
America

*How Economic and Political
Conservatives Are Exploiting
Low- and Middle-Income
Americans*

Charles M. Kelly

2000 · FITHIAN PRESS, SANTA BARBARA, CALIFORNIA

Published by Fithian Press
A division of Daniel and Daniel, Publishers, Inc.
Post Office Box 1525
Santa Barbara, CA 93102
www.danielpublishing.com

LIBRARY OF CONGRESS CATALOGING-IN-PUBLICATION DATA
Kelly, Charles M.
 Class war in America : how economic and political conservatives are exploiting
low- and middle-income Americans / by Charles M. Kelly
 p. cm.
 ISBN 1-56474-348-9 (pbk.: alk. paper)
 1. United States—Economic policy—1981–1993. 2. United States—Economic
policy—1993– 3. Conservatism—United States. 4. Working class—United States—
Economic conditions. 5. Capitalism—United States. I. Title.
 HC106.8.K44 2000
 305.5'62'0973—dc21 00-009090

*To those who created, developed, and produced
the true wealth of this country:*

America's workers

Contents

Part Two:
The Conning of America

Part Three:
The War Against Traditional Values

PREFACE

American capitalism was on a roll in 1962 when I started my management-consulting career. Our country had overcome a major depression, won and paid for a world war, created outstanding colleges and universities across the nation, financed an advanced education for millions of GIs, and built a huge number of effective corporations.

People remembered the wretched excesses of the wealthy and powerful of earlier times and, through enlightened politicians and legislation, created an economic system that was fundamentally fair to both investors and workers. Not only did investors become wealthier and more numerous, but a typical working-class American—working only 40 hours a week—could support a family of four.

The income and wealth disparities that existed in the 1920s had been slightly reversed in the '40s and '50s, and were largely stagnant in the '60s and '70s. Except for minorities, this was probably the best of times ever for working-class citizens in a large country.

But that's not all. American capitalism was beginning to have a sense of moral responsibility. Progressive managers believed that loyalty meant something, and that it was earned and owed, by both employee and owner. Large companies all across the country shifted their management strategy away from brute force, threats and intimidation, toward improving the "quality of work life."

By building a climate of fairness and openness, they tried to create a sense of community. People could identify with, and take pride in, their organizations. They saw a close relationship between their own interests and the interests of their companies.

Many smaller companies succeeded and prospered because workers started with the business and accepted low wages and hard working conditions. The implied promise from the corporate executive or business owner was: "Work hard with me, grow with me, and you will share in my prosperity."

Since they felt they had a stake in the business, millions of workers put their best efforts into "quality circles," productivity improvement teams and special task forces to help their organizations become more efficient and profitable. When they expressed concern that their greater efficiency might lead to headcount reduction, they were promised that, no, that wouldn't happen.

Management consultants like me, business owners, and high-level executives explained that as productivity and profits went up, as technology improved and as the economy grew, everyone would benefit. Work would become less stressful. People would have a better quality life at home with their families. Eventually, they would get more vacation time, better medical care and possibly a 35-hour workweek.

At the time, I did not believe that I was lying. After all, that had been the trend during the '40s, '50s, and into the '60s. We had become a modern, enlightened country. We believed that honest work deserved to be fairly compensated—according to *this* country's improving standard of living, and *this* country's cost of living.

Then the 1980s arrived with a vengeance. Apologists for the wealthy and powerful sold a new set of values to the voting public that allowed pro-business, anti-worker politicians to get elected. They, in turn, changed our economy from one that benefited both investors and workers, to one that now benefits investors at the expense of workers.

Once the balance of power shifted totally in their own direction, the philosophy of conservative politicians, business owners, investors and high level executives mysteriously changed—back to the way it was pre-1930, when fairness and justice had no place in business decisions.

With their newly acquired set of old robber-baron values, investors can now confiscate the wealth that workers, professionals and low-level managers have produced over the decades and invest it outside our country—purely to benefit themselves, and with no regard for those who originally produced the wealth.

Today, the chief executive officer's only responsibility is to himself and his stockholders. Workers have the same status as machinery and are steadily losing whatever human rights they once had. It's a ruthlessly one-sided arrangement. No matter how much time and effort workers spend in improving equipment or work procedures, they don't share in the benefits. They not only have no vested interest in the organization, their work doesn't become any easier or less stressful.

It gets worse. As a work group becomes more effective, it increases the likelihood that some of their members will be fired, and those who remain will have to work harder than they did before, with incomes that don't keep pace with inflation. Workers are told that "competition demands it"—despite record corporate profits and skyrocketing incomes for executives and investors. Of course, executives and stockholders exempt themselves from participating in the cost-cutting competition and get fabulously rich in the process.

Although we can't legislate morality, we can legally require behaviors that voters consider moral. We also can destroy the legislation that protects those moral values, and that is exactly what pro-business politicians, both Republicans and conservative Democrats, have done.

As a result, between 1979 and 2000, the stock market rose over 1100%, but real wages for the bottom half of America didn't keep up with inflation. As *Business Week* put it,

> What's happening is that a new class of left-behind workers is being created, encompassing a large portion of the workforce. They have jobs, sometimes with high salaries, but while their New Economy counterparts' earnings soar, the left-behinds are struggling to post small real gains in income. That's why, despite the overall prosperity, many households keep taking on more debt....
>
> But for the foreseeable future, most Americans will be locked into Old Economy jobs without much hope of big income gains.[1]

Unfortunately, only about 20% of working Americans are employed in the "New Economy," and, as will be pointed out later, their high incomes are coming at the expense of the 80% employed

in the "Old Economy." Of course, the investors and high-level corporate executives in the old economy make sure that they are largely immune to the sacrifices forced onto the low-level old economy workers who are stuck in this country's labor market. By manipulating that market—as well as the technology, world trade and international investment markets—investors and executives actually benefit handsomely from their own industry's decline in this country.

Despite all this, in 1999 wages for many workers started to rise faster than inflation—by about 3-miserly-percent. Better late than never, but that pitifully small increase is probably an indicator that our country's one-sided economic boom is near its end.

The recent two-decade increase in the disparity in wealth and income between the ultra rich and the poor-and-middle-class is not, as the apologists claim, because the wealthy work harder or are more successful on a level playing field. It's because corporations now have all the power, and they have conveniently shifted their values from fairness and reciprocal loyalty to survival of the fittest.

Right now, investors and business owners are the fittest, and fairly-paid workers are on the verge of extinction. Admittedly, there is a benefit to investors for their new found values: their high-level executives don't have to be hypocrites any more by promising that they will be fair in their future dealings with workers. When employees are powerless, threat and intimidation are quite effective, and artful deception is not required.

So don't buy the popular delusion that today's income disparity is the result of natural economic forces that should not be controlled. This delusion leads to a sense of futility and the search for scapegoats, and makes it impossible to attack the origins of the problem. Too many people blame

- The Internal Revenue Service (instead of the Congress that shifted tax burdens from the rich to the middle class),
- "Big Government" (instead of the Congress that passed the free-world-trade and anti-labor laws that sold out working-class Americans), and
- Liberals (who, admittedly, fought for the rights of minorities to compete with white males for jobs—but they are the same people who have always fought for *anyone* unfairly treated, including workers of all categories).

12

All that count in today's economy are power and the laws that control incomes. As we enter the new millennium, voters had better figure out which politicians have the interests of our total society at heart, rather than just the interests of the "educated," the established and emerging rich, and the powerful.

Charles M. Kelly
Tega Cay, South Carolina
April, 2000

INTRODUCTION:

Conservative America's Economic Bible and New Morality

Although the dictionary definitions of both "liberal" and "conservative" are positive and complimentary, they tend to take on new, derogatory meanings when applied to contemporary political parties or ideologies. That's unfortunate, because it encourages an ideological absolutism that closes itself off from valid opposing viewpoints.

Liberals, for example, often address significant social problems by spending government funds to benefit the poor and disadvantaged. Damn liberals, on the other hand, create a dependent class of hopeless people by wastefully spending tax dollars.

Conservatives create jobs and a growing economy by cutting taxes on the rich who will invest their money. Damn conservatives unfairly sacrifice the interests of workers in order to maximize corporate profits.

Problem is, all of the above statements are to some extent true, as are similar statements that could be made about most of our country's problems. The direction our country should take with regard to any specific problem depends upon what's actually happening now. Usually, that's somewhere between the extremes, and if the politicians in power choose to close their eyes to any evidence that denies their view of reality, there is no way their solutions to problems can be effective.

The Drift to the Economic Right

Our country has drifted much too far toward what is commonly thought to be the economic strategies of America's financial conser-

15

vatives. To be sure, their traditional fundamental financial principles are sound. However, in implementing them, there are valid qualifications that always should be recognized and addressed. For example, consider the following principles that relate specifically to the issues raised later in this book:

- Government policies should discourage inflation. True, but who is causing the inflation, *how* should it be discouraged, and how *much* should it be discouraged?
- Taxes should be both minimal and fairly assessed. Yes, but how much is minimal and what constitutes fairness?
- Individuals should have the right and the opportunity to achieve gainful employment. Sure, but what's the realistic definition of "gainful" in today's economy, especially for the bottom 40% of Americans?
- Corporations should be free to pursue their goals and to compete in the world markets. Right, but, considering basic human rights and minimum environmental requirements, what is the proper definition of "free"?
- Economic growth is beneficial and should be encouraged. Agreed, but how *much* should it be encouraged, and how can the downsides of excessive growth be avoided?
- Everyone should be free to achieve a higher standard of living by working harder or more intelligently. Of course, but how far does the definition of "free" extend in terms of the individual's infringement on the rights of others?

Although these are listed as conservative principles, they actually are liberal principles as well. After all, each one relates to a desirable outcome. The difference is in strategy: How should they be interpreted and applied—given the reality of the environment (social and economic, as well as physical)? In an ideal world of objective observers, conservatives would see what is happening in America exactly the same way as liberals do.

However, judging from their actions—as evidenced by Congressional legislation, executive proclamations, and judicial decisions—they interpret reality quite differently. But, then again, as the following chapters will demonstrate, maybe they do see reality the same

way as liberals do. Maybe conservatives just pretend they see it differently.

The Liberal View

In his books, *Politics of Rich and Poor* and *Boiling Point*, Kevin Phillips, a former conservative Republican, documented the growing wealth and income disparity between the rich and the middle class, and clearly explained the political causes of the disparity.

Edward Wolff proved the same case beyond any reasonable doubt, and offered suggestions as to how to help solve the problem in *Top Heavy: The Increasing Inequality of Wealth in America and What Can Be Done About It.*

In *There's Nothing in the Middle of the Road but Yellow Stripes and Dead Armadillos,* Jim Hightower demonstrated how corporate America has gained control of our political system, and to the detriment of the average citizen. Barlett & Steele, *America: Who Really Pays the Taxes,* explained how our elected officials have shifted major tax burdens from the wealthy to the middle class. William Grier, *One World, Like It or Not,* warned of the growing problems that unmanaged world trade is creating for our future, especially for working-class Americans.

These and a host of other writers have clearly demonstrated that most of the benefits of free trade, technological development, income tax cuts, deregulation, and so on—go to the top 20% of Americans, and almost all of the sacrifices that accompany these benefits are forced onto everyone else, especially the bottom 40%. Unfortunately, the American public has yet to catch on to these patently obvious realities, and for good reason.

To their shameful credit, conservative America's financial community has done a fantastic job of conning the American public, and even themselves, into thinking that writers like these cannot be trusted. They accuse them of being socialists, possibly communists, or at the very least, liberals.

The Conservative View: A Classic Case of Denial

Naturally, conservative economists and politicians deny that they are conducting class warfare against working Americans. To defend themselves against this charge, they even profess ignorance about the obvious causes and effects of their class war. Take, for example, a

May, 1998 article in *The Wall Street Journal* that proclaimed in a headline that the "U.S. Jobless Rate Drops to 28-Year Low."

Then, it presented a mystery: The historic low in the unemployment rate had not caused wages for working-class Americans to accelerate, as traditional economic theory said they should. In fact, as everyone knows, wages in the United States hadn't kept up with inflation, or with economic growth, or with the rise in corporate profits, or the rise in the stock market—for over 20 years.

This is in stark contradiction to traditional economic theory. Low unemployment was supposed to cause higher wages, rising prices and inflation. In the words of the *Journal,*

> The fact that none of those dire consequences has come to pass even as the unemployment rate slipped under 4.5% has left economists befuddled about the very nature of the economy.[1]

(Note that the *Journal* considers higher wages for mere workers a "dire consequence," even in a booming economy when incomes for the top 20% of Americans are skyrocketing.)

The only mystery—and the only "befuddlement"—about this scenario is why any economists with IQs over 80 were surprised to begin with. It is possible, I suppose, that mainstream economists have been so thoroughly brainwashed by America's right-wing think tanks that they have become incapable of interpreting what they read in their own financial publications. Their protestations of abysmal ignorance, in this sense, may be justified.

What's even more amazing are the protestations of ignorance by the Fed itself. A year after the *Journal* article, in May 1999, *Barron's* explained the bafflement of the Fed's braintrust about our "enviable" economy:

> It's the most intriguing question in modern economics: Can the United States' rule-shattering streak of torrid growth, minuscule inflation and roaring equities continue? Nowhere is it getting more attention than at the Federal Reserve Board, which nowadays might be thought of as the world's most powerful think tank. Its braintrust of Ph.D.s is struggling to figure out what's going on in the economy

and, more importantly, how to maintain its enviable performance....

The fact that inflation remains so tame at a time when unemployment is sliding and the pool of available labor is shrinking can't be easily explained away, she [Fed vice-chairman Alice Rivlin] explains.[2]

Can't be explained away? Given the Fed's chronic preoccupation with the fear that wages might be *about* to go up—and its publicly stated commitment to make sure that won't happen—the only condition that can't be explained away is why American workers continue to vote for the conservative politicians who deliberately created their wage stagnation.

It's all there, in *The Wall Street Journal, Forbes, Fortune, Barron's* and *Business Week,* among others. Daily, they clearly describe how financial conservatives have turned conventional economic wisdom on its head and prevented normal market forces from increasing working-class wages. There is absolutely no mystery about it.

A Guided Tour of Conservative Values and Strategies

Since those who are doing so well in our society refuse to be swayed by the documented, reasoned discourse of others, it's time to direct attention to their own words. This book is a guided tour of conservative America's financial values and strategies.

For those who are not regular readers of financial publications, it can be a starting point for understanding the massive amounts of material that say the same thing: Financial conservatives are ruthlessly taking unfair advantage of working Americans—and they are feeling virtuous about it.

Their concerted action is not so much a conspiracy as it is a religion, complete with its own set of values and moral standards. Today, the morality of any given action is to be judged solely by its impact on the bottom line. Greed, traditionally considered as one of the seven deadly vices, has now become a virtue. Our federal government's economic practices are to be judged by their adherence to the new conservative bible, rather than by their impact on society.

This bible consists primarily of five books:

- The Book of *The Wall Street Journal*
- The Book of *Forbes*
- The Book of *Fortune*
- The Book of *Barron's*
- The Book of *Business Week*

There are other, lesser books written by prestigious conservatives, but the above are the main ones. They are published on a daily, weekly or biweekly basis, and serve as a communication network for strategic planning. America's financial elite set common goals, coordinate activities, and morally rationalize their callous behaviors by constantly referring to their new testament and chanting its gospel:

- High incomes and tax cuts for the wealthy are good because they create jobs. Wage increases for workers are always bad because they cause inflation.
- Corporate profits are good. Legislative protections of working conditions are expensive, benefit primarily workers, and are therefore bad.
- Economic growth is good, as long as it increases corporate profits. Economic growth is excessive—and bad, if wages start to go up.
- The Chamber of Commerce and the National Association of Manufacturers are good for American workers. Labor unions are bad for them.
- And so on, as will be covered later.

Then conservatives proselytize each other and the general news media. They are exceptionally good at this, because they have huge sums of money to finance their activities, and they own most of the major TV networks and newspapers. They are even able to con many of their victims—working-class Americans—into voting for Republicans and conservative Democrats, and against their own best interests. These are the very same politicians who made the laws that led to the gross injustices described in the following chapters.

Schizophrenia of America's Right Wing

The Wall Street Journal, Forbes, Fortune, Barron's, and *Business Week* are first-rate publications. Each is outstanding in a different way. However, they also have a schizophrenic mix of qualities that is important to understand.

Their *factual* reports of news events usually meet the standards of professional journalists about as well as most good news publications. Their coverage of what is actually happening in business boardrooms, the manufacturing floor, international trade and so on, is often our best source of information.

Their editorial policies and their interpretations of news events, however, seem to come from right-wing-outer-space somewhere. They toss professional journalistic standards out the window and become pure propagandists for the rich and powerful. After reading their editorials, one has to wonder: Do the editors ever read their own news stories? How can they possibly believe what they are trying to get their own readers to believe?

Because of this schizophrenic mix, *The Wall Street Journal, Forbes, Fortune, Barron's,* and *Business Week* become valid, accurate and verifiable sources of two self-incriminating bodies of evidence. First, their editorials (and even a few of their news stories) present clear statements of the philosophies, goals, strategies, and biases of America's financial conservatives (fundamentally Republican and conservative Democrat, wealthy, formally educated, and/or powerful).

Second, their news stories present the undeniable disastrous results of those philosophies, goals, strategies, and biases on our society and workers—as conservatives themselves know them to be.

An appreciation of this journalistic version of a common mental illness should help readers understand how the following articles from the same publications contradict themselves. The combination of their accurate news reports, and their deliberately intended-to-deceive opinion pieces expose the true values and strategies of today's financial conservatives.

The Brief

Although this book is separated into nineteen chapters, in a sense it is one argument, broken into sequential parts. To facilitate easier understanding and to demonstrate the logical flow of the total argument, it is encapsulated in the next section, "The Brief."

Each point in The Brief is fairly complete in itself, but has a reference chapter that goes into greater detail. Each chapter presents a slightly different angle to an issue, or an added increment to an ongoing discussion.

The cumulative result of the evidence is indisputable: Conservatives, as a matter of policy and strategy, are waging financial warfare against working-class Americans, they are denying that they're doing it, and, so far, they've been getting away with it.

THE BRIEF

Financial conservatives have been waging class warfare against working Americans for more than 20 years. Actually, they've been doing it for the entire century but they've been especially successful in the past 20 years, so that's a convenient and relevant period for discussion. This is how they've been doing it, and why they've been so successful:

Chapter 1. Traditionally, conservative economists and politicians kept wages down by manipulating the prime interest rate. Whenever the economy grew to the point where unemployment went down and workers had the power to negotiate for more money, the Federal Reserve simply raised the interest rate.

This made it more expensive for businesses to borrow, the economy would cool down, unemployment would go up, and wages would stagnate or go down—just as the economists and politicians intended.

Chapter 2. Conservative economists and politicians explained that the reason for their actions is that rising wages cause inflation, which hurts everyone. Therefore, they should keep workers' wages from going up. In fact, whenever they refer to inflation, they make it a point to call it "*wage* inflation."

They totally ignored, however, the inflationary effects of the rising incomes of business owners, corporate executives, investors, etc. They also chose to ignore the fact that businesses could share more of their outlandish profits with workers without increasing prices. Indeed, for the past 20 years, it hasn't been wage inflation; it's been profit inflation.

Chapter 3. Now there is a great debate going on. Some still feel that the economic growth of the past 20 years should be slowed by raising the prime interest rate. After all, unemployment is at record low levels. Others feel it's no longer necessary to raise the prime, because wages can be kept down in other ways that are less detrimental to profits—such as exporting jobs overseas, destroying unions, using temporary or contract workers, and so on.

What's striking about this public debate is that all parties are arguing about the best way to ensure that investors, business owners, and executives get wealthier. Virtually no one is concerned about the welfare of the working-class Americans who are most directly and personally harmed by either of these strategies. Under either approach, workers make all the sacrifices, and investors and the rich reap most of the benefits.

Chapter 4. Among many of the empty promises made to workers is that their wages will go up if the economy grows. This is probably the most pernicious lie foisted onto the American voter when it comes time to cut taxes on the wealthy. Their propaganda spin goes like this: Cutting taxes will cause the economy to grow; added growth will lower unemployment; lower unemployment makes workers scarcer; and when workers are scarce, wages will go up.

Problem is, as the past 20 years have demonstrated, economic growth has little to do with higher wages. It's all about power and who has it. Right now, investors and the wealthy have all the power and workers have none.

Chapter 5. The biggest single reason economic growth hasn't increased wages is that conservatives have deliberately pitted American workers against brutalized workers in Third World countries, to drive down *all* wages in the U.S. Whenever unemployment goes down and workers start demanding more money, all a corporation has to do is threaten to close down operations and move overseas.

That usually stops any embarrassing discussion about higher wages—at a time of record corporate profits. And obviously, if employees refuse to be intimidated, companies actually carry out their threats to leave the country. Then, the workers who lose their jobs enter the marketplace and exert downward pressures on the

wages of other workers, even in the jobs that can't be exported to other countries.

Chapter 6. The "worker" classification is getting bigger. Jobs of engineers, Ph.D. scientists, computer specialists, etc. are now being sent overseas to people who make one-third as much. Today, it's more accurate to refer to *investors* and workers, instead of management and workers, professionals and workers, or even "skilled workers" and workers. Those who control the money can, and do, control everyone else—as low-level managers, doctors, engineers, architects, and other professionals are belatedly finding out. As political power shifts to investors, so does economic power.

And as their power increases, the economic system becomes increasingly biased in favor of those with money and against those who develop and produce the actual wealth of our country: land, buildings, products, and services.

Chapter 7. Conservatives proclaim in their talk shows and editorials that unions are bad for workers. On the other hand, in their news articles they cite the declining power of unions as a major reason for wage stagnation and poor working conditions. In fact, the declining power of unions is one of their most frequently used arguments for not having to raise the prime interest rate.

It's especially interesting to note that skilled professionals, such as doctors, dentists, and college professors, are beginning to discover the benefits, and the necessity, of collective bargaining. In the economy of today, power is everything. Justice and fairness, and even the long-term economic health of our society, count for absolutely nothing.

Chapter 8. After decades of economic growth, increasing worker productivity, technological development, and higher incomes for the wealthy, wages and working conditions have degenerated for the bottom half of Americans. Instead of getting better with all these advancements, as promised, the opposite has happened.

In fact, the United States has joined the Third World in victimizing workers. Many workplaces have become more dangerous, more likely to cause chronic disabilities and more dulling to the senses. For many workers, our country has regressed to the pre-1930 era.

Chapter 9. There is no mystery about why corporations and businesses have all the power today. The coalition from workers' hell, Republicans and conservative Democrats, made it happen. They destroyed much of the power of workers to organize by passing the Taft-Hartley Act in 1947. More recently—with the passage of NAFTA and GATT, and a host of anti-worker actions—they gave workers the *coup de grace* by making them compete with brutalized Third World workers.

As Newt Gingrich once claimed in *The Wall Street Journal*, the price of labor is now set in South China. It matters not to conservatives that American workers live in *this* country, with *our* standard of living, and *our* cost of living.

Chapter 10. If there is any confusion left about our present economy, it's why American working-class citizens have been so thoroughly conned into voting for the conservative politicians who made it all happen. The most plausible explanation is that there has been a proliferation of "think tanks" that are funded by wealthy right-wing zealots. With almost unlimited money, they are able to staff their organizations with people who are willing to intentionally distort the implications of financial data and economic events. Their most effective lies are those that use accurate data to lead to inappropriate and false conclusions.

Chapter 11. The 1993 Deficit Reduction legislation is a classic example of the kinds of factual distortions that enable conservatives to con voters into making false conclusions that are injurious to their own interests. Even *The Wall Street Journal* described how Republicans misled the public about whom the 1993 legislation would affect and how. Contrary to common belief, only the top 1.2% of Americans got any significant tax increases. And, as most people now know—and the *Journal* pointed out—raising taxes on the wealthy in 1993 is a major reason for the lower deficits of the late 1990s.

Chapter 12. There isn't the remotest similarity between those who the Republicans claim will benefit from their tax cuts and those who actually benefit. In fact, they deliberately deceive the public about the regressive nature of their specific tax changes on working-class Americans. They also ignore the loss of necessary government ser-

vices—which benefit mostly middle- and low-income workers—when tax cuts for the wealthy reduce government revenues.

Chapter 13. The privatization of Social Security is another conservative strategy that will benefit the wealthy at the expense of working Americans. Social Security was intended to ensure a safe retirement, financed by current workers making decent incomes. Despite articles describing stock fraud, "boiler rooms," insider trading—and how hard it is for anyone with less than $1,000,000 to get good investment advice—Republicans want workers to compete with the Wall Street sharks when they invest their retirement funds.

The sure winners in privatizing Social Security will be stock brokers, experienced investors, and the entire banking and investment industry. For workers who are unsophisticated in the economics of Wall Street, the future does not look good. The best we can hope for is that when they answer a cold call—during dinner, from a broker—the broker will be a conscientious representative with a reputable firm who is not under pressure from his boss to generate high commissions.

Chapter 14. Another major propaganda effort of conservatives is aimed at destroying Americans' belief in their own government. Central to this strategy is their incessant criticism of governmental officials, while claiming that private businesspersons would serve the public's interests much better. A review of the behaviors of American executives and businesspersons suggests that the opposite is true.

When you read about the antics of these people—in their own conservative publications—you have to ask the question: Can these corporate bureaucrats actually manage our economy and society better than "government bureaucrats"? The number of articles describing corporate greed, mismanagement, incompetence, and outright fraud—of huge proportions—is massive.

Chapter 15. Freedom is central to the success of our country. Problem is, which are the freedoms that really count? And who best protects the freedoms that really count? Corporations? Or democratically elected representatives? The number of examples of bad corporate behaviors in the absence of sensible regulations is over-

whelming. Well-financed conservatives use their money to buy the necessary politicians, judges and legislators to ensure that corporations and businesses have the freedom to take ruthless advantage of workers and the general public.

Chapter 16. Glorifying greed and materialism—and minimizing fairness and justice—has become a staple in the conservative arsenal for taking control of America's political base. Think about it. Many voters seem more concerned about the private sex life of politicians than about whether or not they lie to the public about economic and social issues.

For example, Bill Bennett's *Book of Virtues* is a great book, but he left out fairness and justice. He chose virtues that emphasize hard work and charity, but not fair treatment of workers. It's typical of the subtle conservative propaganda effort to equate wealth with virtue, and to relegate the concepts of fairness and justice into the dustbin of values.

Chapter 17. There is a growing new American royal class. Can working Americans afford to support all these people who are getting locked into an extravagant life-style? A style that can be maintained only if workers' wages remain low and taxes remain regressive. By cashing in the wealth that workers created from the 1940s to the 1980s, conservatives produced 20 years of prosperity for those who knew how to take unprincipled advantage of our new economic system. But we can't afford to continue this fire sale of wealth much longer before the bills come due.

Chapter 18. Time is getting short. The income and wealth disparity between the top 20% of Americans and everyone else is growing into a vast chasm. Having been conned by conservatives that "wealth is not a zero-sum game," voters assume that this growing problem will eventually be to their own benefit, since "wealth trickles down."

Big mistake. Wealth *is* a zero-sum game, at both the front end—in the allocation of income, and the back end—the spending of income. In effect, the more wealth other people have, the less you have. This becomes important in an economic downturn, especially for those who have not built up substantial savings.

And there are danger signs on the horizon: wages are starting to creep up, which, in this "new economy" that conservatives have created, threatens corporate profits, the stock market, and the economic and social health of our country.

Chapter 19. Workers of America, Unite!—Because Financial Conservatives Already Have, and They Own Congress and the Presidency. Never vote for a Republican. In the primaries, pick a liberal Democrat over a conservative Democrat. Always vote for a progressive populist—preferably one who is not having an affair with his secretary (but if that's your only choice, he's better than a Republican or conservative Democrat).

Progressive populists actually believe that we need government to protect the freedoms that count. An effective government—with honest, not-paid-for politicians—is our only defense against corporate executives who have no moral standards for the treatment of workers or the general public.

A Qualification and an Aside

Qualification: Copyright laws and limited space require the use of brief excerpts of often very lengthy articles. I did my best to fairly represent the sense of each excerpt quoted. However, if you question the accuracy or intent of the clearly footnoted excerpts in the following chapters, or my interpretation of them, you can easily look up the originals in the library. Or, better yet, you can do your own research. It's easy. Just:

1. Go to your local library and sit down at its computer.
2. On the opening screen, check "subject."
3. Look up the categories of: "prime rate," "Federal Reserve," "inflation," "unions," "tax legislation," and "wages," plus any other economic categories you are interested in.
4. Pick any time period since 1980.
5. Select articles that are from the same conservative financial publications cited in this book.
6. Read the actual articles.

Then note how, with monotonous repetition, financial conservatives describe how they are keeping wages from going up, getting

anti-labor legislation passed in Congress, destroying unions, pitting workers against each other and, in general, waging class warfare against American workers. Their policies always benefit corporations and the wealthy, and always at the expense of workers.

Aside: Anyone can say anything about anybody. Liberals call conservatives liars and demagogues, and conservatives call liberals liars and demagogues. But that doesn't mean that the truth is midway between the two. It only means that—with modern, sophisticated techniques of propaganda available to everyone—the voting public must develop the ability to see through the smoke and mirrors that are massively produced every day.

Consider this book a study guide for your own investigation. Decide for yourself what to believe about our economy, our elected officials and our political parties. Follow the steps above and do your own self-directed reading. You'll find that America's financial conservatives are saying exactly what I have reported in the following pages.

It's a matter of public record. There is no way they can cover it up.

CLASS WAR IN AMERICA

Part One

Class Warfare:
Strategies and Their Effects

Workers' fear of losing their jobs restrains them from seeking the pay raises that usually crop up when employers have trouble finding people to hire.

Even if the economy didn't slow down as he expected, he [Alan Greenspan] told Fed colleagues last summer, he saw little danger of a sudden upturn in wages and prices.

"Because workers are more worried about their own job security and their marketability if forced to change jobs, they are apparently accepting smaller increases in their compensation at any given level of labor-market tightness," Mr. Greenspan told Congress at the time.

—*The Wall Street Journal,* January 27, 1997, A1.

1.

Traditional Conservatism:

To Keep Wages Low, Quietly Manipulate the Prime

Conservatives pay more attention to the status of working-class wages than to any other economic variable. They know that wage increases reduce profits and, as a result, slow down the accumulation of wealth by corporate executives, business owners and investors.

Therefore, whenever workers become scarcer and start making more money, conservatives demand that their political representatives in Washington do something to stop the "free" market from working as it is supposed to. Their favorite strategy prior to 1996 was to keep the unemployment rate at least 6% or above.

So, as prudence would dictate, whenever it looked like wages might be *about* to go up, conservatives have traditionally

- raised the prime interest rate, which
- made it more expensive for business owners to borrow money, which
- slowed the growth of the economy, which
- created less demand for workers, which
- made workers compete more viciously with each other for jobs, which
- allowed the existing business owners to continue paying low wages to their workers—the ones who were making them rich.

This strategy of class warfare is still in use. In fact, many modern conservatives continue to speak of it with the reverence typically reserved for cherished traditions. Those who think that the term "class warfare" sounds too offensive should read what reputable, mainstream conservative publications have to say about the wages of working Americans.

Ugly versus *Beautiful Wages*

Forbes made it quite clear how investors view the possibility that workers might start to make higher incomes. Under the headline, "Wage Inflation Raises Its Ugly Head," it spread the alarm that

> ...the U.S. labor market has already tightened to the point where some wage inflation is sure to follow.... Increasingly, companies are giving hiring bonuses to attract skilled workers. This has a one-time impact and avoids raising actual wage rates.[1]

When wages go up, conservatives never admit that workers are getting a fairer share of the prosperity of our country. Instead, they just scream "wage inflation," which scares the hell out of everyone.

What's especially maddening is that, according to conservative politicians, wages of workers are *supposed* to go up as they become more skilled and as the economy gets better. Yet, when this actually happens, conservative economists raise the battle cry that something is wrong ("ugly") in the economy. Not only that, the wage increases for skilled workers that upset *Forbes* so much were only one-time bonuses—not regular, dependable income.

Forbes was somewhat relieved, however, because it went on to note that "Total employment cost inflation, as measured by the Employment Cost Index, is still declining. The reason for this is the drop in benefit cost inflation, especially for health care."[2] Remember: Republican Steve Forbes, editor-in-chief of *Forbes*, wanted to be president, and his magazine considers any increase in workers' wages as "ugly."

Now, compare the way *Forbes* viewed workers' ugly wages with the way it viewed, just a year later, the incomes of some of America's wealthiest people. *Forbes* is always at the forefront in beautifying

greed and materialism. Under the headline "America's Highest-Paid Bosses," it reported that

> A handful of chief executives were paid staggering amounts over the past five years. But the median five-year pay for 800 chief executives was just $6.9 million."[3]

Just $6.9 million. "Just" as in "only," or "a mere pittance" for the work that they do.

It doesn't matter to conservatives that this was at a time when workers saw their incomes go up less than 3% and had their health benefits cut, the S&P 500 went up 38% and investors became richer to the tune of $1.8 trillion. The fact that workers' pitifully low wages made it all possible is irrelevant. All that counts, as far as *Forbes* is concerned, is that the CEOs and the investors got incredibly richer.

Dual Blessings

Forbes is not alone in its one-sided sense of economic justice. In fact, it is standard operating procedure to manage the economy so that business booms and workers' incomes remain low. In 1994, a *Barron's* headline proclaimed "A Dual Blessing," and quoted economist Ed Yardeni, who said that it's the "best of all worlds: employment is booming; wage inflation remains low."[4]

Two years later, *Business Week* announced that the dual blessing continued. Under the head, "Wall Street Is Cheering More Than Just the Yankees, The Economy Should Snap Back—Without Triggering Inflation," it explained that

> What really turned Wall Street on was a surprisingly modest increase in third-quarter labor costs. The employment cost index, a measure of hourly compensation costs for wages, salaries, and benefits, rose only 0.6% for all civilian workers last quarter. ...the slowest quarterly pace in four years.[5]

This "dual blessing" and the source of Wall Street's cheers is no act of God. It's not the result of the movement of the stars or mere chance. Nor is it any mystery. In very deliberate ways traditional conservatives have blessed themselves by doing whatever it took to keep workers' wages from going up, although by this time they had

far more weapons than just manipulating the prime interest rate, as will be explained in later chapters.

NAIRU

In a headline, *Fortune* identified the foundation for this method of controlling wages as "The Jobs-Inflation Connection." It explained that "the non-accelerating inflation rate of unemployment (also known as NAIRU)... is one of the building blocks of the economic universe."[6] This building block assumes that if unemployment drops below a certain rate,

> ...employers bid up wages for increasingly scarce workers, driving up costs and setting off inflation. For some time, most mainstream economists agreed that America's NAIRU was probably about 6%.... Too-strong demand for workers begets inflation, so lenders demand higher interest rates to protect their returns, and central bankers tighten monetary policy, intentionally raising rates to slow the economy, which levers unemployment back up to its "natural" rate.[7]

Note the cold-blooded nature of this kind of manipulation of working Americans' lives:

- The "jobs-inflation connection" means that when workers' wages go up, the government must do something to stop them. On the other hand, wealthy conservatives shout from the rooftops that the government must never *ever* do anything to keep rich persons' incomes from going up. Conservatives say that when their incomes go up, that's just the result of the "free market forces." What they never admit, however—and what is demonstrated in this book—is that the market isn't free at all. Conservative politicians ruthlessly control those market forces.

- The "natural" rate of unemployment is when it is high enough to make workers feel lucky just to have a job. They won't risk being fired by asking for raises in pay. They will be more willing to accept intolerable working conditions and will not risk supporting a union drive.

- It's just a natural law of God: Workers should make just enough money to live and not consume excessively. Income increases are

38

the natural right of corporate executives and investors. They, after all, are the hard-working, virtuous ones.

Fortune was a bit on the theoretical side in explaining all this. *Business Week* was more descriptive in 1994 when it announced that "Wage Hikes Won't Wake The Inflation Beast Just Yet," and reassured its readers that

> Now as never before, labor costs are the key to inflation in this economic expansion.... But what makes this expansion different is the relentless downward pressure on labor costs coming from corporate restructuring, overseas competition, and efforts to boost productivity....
>
> But it's not just slower wage growth. Benefits, although they still are growing faster than wages, have slowed even more sharply.... The continuing slowdown in the growth of health- and workers' compensation-insurance costs accounted for much of the first-quarter slowing in benefits.[8]

Be forewarned: When conservatives say "inflation beast," they mean workers' wages are going up. Although they occasionally express concern about increases in the consumer price index, durable goods orders, non-farm payrolls, commodity prices, wholesale prices, residential construction levels, industrial output and, rarely, the level of the stock market—their predominant preoccupation is *always* labor costs.

Conspiratorial Conservatives

Financial conservatives aren't an official "conspiracy," but they *do conspire* with each other. Consider Gene Epstein's "Open Letter to the Fed's Boss" in *Barron's*:

> True, average hourly wages were up 0.5% in September. But the tiny increase only makes up a small portion of the ground that workers have lost to even the modest rise in prices over the past several years.... Tell the world that inflation is a fantasy in the New Economy, that a hike in the Fed funds rate would only do harm.[9]

This is an "open letter" that anyone can read, although most working persons never read *Barron's*. Epstein went on to explain that world competition would keep prices from going up and that corporations could "Give some folks a 3% increase and lay off others, cutting their salaries by 100%." Conclusion: wages are dead in the water; no need to raise the prime interest rate and risk cutting into corporate profits.

Discussions using the same kind of reasoning occur in country clubs, boardrooms, congressional hallways, and everywhere financial conservatives gather. In this letter, Epstein also

- pointed out that unemployment was at a seven-year low, thus raising fears that workers may *start* making more money,
- admitted that then-recent hourly wage increases made up only a small portion of the ground that workers had lost over the past several years,
- explained how conservatives have been able to keep wages down: cut staff and give a small raise to the remaining drudges,
- which, incidentally, also explains the number one method businesses use to increase productivity and, at the same time, cut wages: pressure fewer employees to work harder—for less money.

So what's the conclusion? Hey, we've got the workforce totally beaten. Conservatives have successfully created a New World Economy in which workers have lost all power to negotiate for higher wages. The Fed doesn't have to raise the prime interest rate to keep wages depressed.

Was Epstein right? Of course he was, because letters like his have been effective. Look at what the stock market did. Two months later, *The Wall Street Journal* asked the question, "Can Performance Withstand a Pit Stop?" and answered it with a resounding yes:

> It was off to the races for the stock market again last year. Even with the take-the-money-and-run sell-off on News Year's Eve, the Dow Jones Industrial Average climbed an impressive 26%. Added to the 33.5% gain of 1995, the Dow at year end is towering 68% above its level at the final bell of 1994.[10]

Still, despite the stock market's phenomenal rise, there were nagging concerns that just wouldn't go away. A month later, *The Wall Street Journal* issued the warning that "Greenspan Inches Toward Rate Increase":

> The Fed chairman also said he sees signs that the widespread fear over job security is abating. That is significant, he said, because worker insecurity has been restraining wages at a time of low unemployment and allowing the Fed to delay an increase in short-term rates.... [He hinted] that he is skeptical that corporate profits can benefit indefinitely from unusually slow growth in wage and benefits and ever-faster productivity growth.[11]

And that's the story of the first half of the 1990s, and most of our recent economic history up to that point. So much for the good old days.

The New Economy

Since the mid-'90s things have changed. There is no longer a magic unemployment number, like 6%, to guide the hand of the Fed. Now, it's almost anyone's guess how much unemployment will be required to keep workers' incomes from going up.

Although the magic number is still being debated, the worries are fundamentally the same and have continued through 1999. As *Business Week* put it, "A Fine Balance Should Keep This Expansion Aloft":

> The threat of wage inflation is easing despite tighter labor markets.... Wall Street knows all too well that low inflation is the butter on its bread. After growing fears that an overly strong economy would force the Federal Reserve to hike rates in order to preserve this Eden, the markets rejoiced over the seemingly benign employment report. The Dow soared ever closer toward 10,000...[12]

That was in March of 1999. In August, *The Wall Street Journal* reported that "Strength in Economy Continues," yet "Signs of Inflation Are Scarce, Report by the Fed Shows." It added:

"Widespread labor shortages persist in virtually every" one of the Fed's 12 districts, "but there have been only scattered reports of an actual acceleration in wages," the report said.[13]

The irony about reports such as this and the ones that preceded it is that, despite over 20 years of worker wage stagnation, record corporate profits and a record stock market, conservatives *still* consistently refer to inflation as "wage inflation." It demonstrates how utterly preoccupied and paranoid America's conservatives are about the possibility that workers may start to share in our country's prosperity.

How Low Can It Go?

So, what will be the new magic NAIRU number to guide the judgment of conservative politicians? How low can the unemployment rate go without triggering inflation? As of the end of 1999 it was 4.1% and still wages were tame. Judging from a May, 1999 article in *Business Week*, it is possible that there is no longer *any* magic number. In "Sweatshop Reform: How to Solve the Standoff," it described how difficult it is to put a floor under labor wages and conditions:

> The debate over sweatshop codes of conduct shows just how tricky it is to put a floor under global labor standards, even in a single industry. The apparel business involves hundreds of thousands of factories in widely disparate economies. Exposés have alerted U.S. consumers to abuses, yet consumers' desire for bargain goods means companies still face fierce competitive pressures. And it's unclear what the economic toll would be if anti-sweatshop efforts lift prices....
>
> A living wage, the most costly demand, possesses the greatest risk. "The worry is that a living wage might cause some workers to lose their jobs," says Dani Rodrik, an economist at Harvard University.[14]

This is the "new world economy" that conservative politicians are so proud of: a world in which American laborers must compete with workers who can't demand a "living wage" without fear of losing

their jobs. Any country that puts a floor under wages or working conditions will lose those jobs, because investors will put their money elsewhere. It's that simple.

Ironically, a following story in this same *Business Week* issue, "Catering to the Near-Wealthy," described how difficult it can be for newly rich investors to get decent financial advice:

> If the bull market, stock options, an inheritance, or plain old thrift has transformed you from an average investor into a millionaire, you probably need to do more with your money than just stick it in mutual funds. Incredible as it seems, however, $1 million no longer gives you entree into many of the most exclusive trust companies and private banks that cater to the very rich.[15]

What's sad about this horrific gap in living standards for two groups of people—victimized workers and wealthy investors—is that it was deliberately caused. It was brought about with the full know-ledge and cooperation of American businesspersons, our American president and Congress, a majority of the economics profession, the country's leading business schools and, of course, most investors, like those described in the preceding excerpt.

To get an idea of how preoccupied these people are with the status of wages in America, just read the tan-colored pages in almost any issue of *Newsweek*. Or go to *The Wall Street Journal*, on page A2. Readers regularly go to these pages to keep abreast of the merest possibility that wages may be about to go up, especially around the time the Federal Reserve is meeting, or labor statistics are being released.

Those who say that low- and middle-income Americans shouldn't be envious of the incomes of the rich are the same hypocrites who watch the incomes of workers like predatory hawks. Granted, maybe envy is bad for the mental health of the poor and they should avoid it. Instead, possibly they should get mad as hell and vent their feelings by voting for politicians who aren't bought and paid for by America's conservative elite.

Now it's time to take a closer look at how conservatives knowingly and deliberately perpetuate the "wage inflation" con.

2.

The "Wage Inflation" Con:

It's Not Wage Inflation, It's Profit Inflation

Many members of the American public have come to accept the manipulation of the prime interest rate as a necessary tool to curb increases in workers' wages. After all, as conservatives are fond of repeating, rising wages create a greater demand for goods and services, and a greater demand for goods and services raises prices—which hurts everyone, rich and poor alike.

What conservatives never acknowledge, however, is that when the incomes of *any* class of people go up, there is an inflationary result. Although the disastrous effects of inflation caused by the wealthy will be covered in greater detail in Chapter 18, it's sufficient to point out here that they have been driving up the prices of all manner of things, especially the depleting supply of desirable land and the consequent skyrocketing costs of homes and rent.

Conservatives also gloss over the obvious fact that inflation benefits those who are causing it and can stay ahead of it, which is what America's wealthiest citizens have been doing for more than 20 years now. And for those same 20 years, most workers' incomes have lagged behind the inflation rate. It's well past time for *their* rising incomes to cause a bit of inflation, although, as will be pointed out shortly, that doesn't necessarily have to be the case.

The Conservative Spin on Inflation

When conservatives try to justify the huge incomes of America's top 20%, they claim that "wealth is not a zero-sum game." In other words, there is an unlimited sum of money, and the more the wealthy make, the more money will "trickle down" to others when they spend it. Result: everyone benefits.

With no regard for logic, however, when they speak of inflation, they always call it "wage inflation." They reason that, if workers make more money, it has to come from a finite money pie—and that pie will have to be made bigger *via* higher prices. So, when it comes to worker incomes *versus* CEO and investor incomes, it's as zero-sum as you can get. The more the workers get, the less corporate profits and, hence, lower income for stockholders and the CEO.

Conservatives also never consider the possibility that corporations could accept lower profits, allow wages to increase, and still not raise prices. In addition, they ignore, at least in public, the economic benefits of "gush over-and-up" that occurs when workers make and spend more money in the marketplace.

Despite these realities, financial conservatives were able to sell the public on the idea that wealth is not a zero-sum game, that we need not worry about the skyrocketing incomes of the wealthy, and that we need worry only about minuscule increases in working-class wages. After that bit of sleight-of-hand, it was a simple matter to convince voters to elect politicians into office who had the "political courage" to keep workers' wages from going up.

To keep this hoary scam alive and kicking, *The Wall Street Journal, Forbes, Fortune, Barron's,* and *Business Week* never admit that the incomes of investors and corporate executives cause inflation—or that, in their opinion, workers shouldn't share in the prosperity of our country. They simply blame inflation on the "wage-price spiral."

Then they sadly shake their collective headlines and conclude that there's nothing that can be done about inflation, except to destroy workers' incomes. This has been their ritual for the past two decades, especially during the explosive economic growth of the 1990s.

The Wall Street Journal distorted economic realities when, contrary to all the evidence, it blamed inflation on workers' wages, instead of corporate greed. In a 1994 headline, it screamed that our economy was "Entering the Wage-Price Spiral." It explained the view of some economists about what can result when

45

...the demand for workers already exceeds, or is close to exceeding, the supply of people available to fill the jobs. When that happens, employers boost their pay offers, and a wage-price spiral may start. Since labor represents 70% of final product costs, inflation can result.[1]

The basic problem, as conservatives see it, is that there are simply too many workers for them to have a decent living. So,

- A "wage-price spiral" is when wages go up and corporations raise their prices in order to maintain the royalty status of their investors and executives. Conservatives never worry about inflation caused by the skyrocketing incomes of the wealthy, apparently because there are relatively few of them, say, the top 20% of Americans.
- But the large number of workers who produce America's wealth make up 70% of final product costs. Obviously, if our new class of American royalty shared the wealth with so many people, they wouldn't be royalty anymore.

Despite the *Journal*'s fears, we had three more years of record corporate profits and stagnating wages, when, in 1997, *Forbes* added its own spin to the "wage-price spiral." Its periodic column, "The Forbes Index," referred to comments of Anthony Chan, chief economist at Banc One Investment Advisors who was

...worried because, for the five quarters ended in September, average hourly earnings rose faster than the overall Employment Cost Index (wages plus benefits)—meaning nonwage benefits have been lagging. Chan expects these benefits to surge this year, driving up total compensation and forcing businesses to protect margins by raising prices.[2]

Realize what Chan is saying here: At a time when corporations and investors have been making outrageous profits—and not sharing any of the benefits with workers—future labor costs will *force* corporations to raise prices if they are to continue making huge profits!

Fortune also joined this unholy crusade—blaming workers for inflation—with the same perverted distortion: that an increase in

workers' wages, not corporate greed, is the primary cause of inflation. Under the head, "It's Fear of Inflation That's Spooking the Market," it repeated the same nonsense:

> With the unemployment rate already low, many traders and investors quickly concluded that companies bidding for scarce workers would start offering higher wages. Firms would then try to recoup by boosting prices, and we'd be back in the same inflationary inferno that's burned bond investors before. Stephen Roach, Morgan Stanley's influential chief economist, is even pushing a "worker backlash" thesis, arguing that after years of little real growth in wages, workers now have enough leverage to garner a bigger share of the pie.[3]

Not to be left out of this inspirational movement, *Business Week* joined the chorus under the head, "Inflation Is Still on the Mat— But Don't Count It Out Just Yet."

> The biggest concern for 1997 will be a tight labor market. Inflation has been down for so long, a few analysts have pronounced it dead.... To be sure, price pressures have been almost nil. Last year, slower growth in benefits offset bigger pay gains, even in a tight labor market.... The question is: Will inflation stay down? In 1997, higher labor costs will mean that many companies must either raise prices or watch their profits get squeezed.[4]

These publications were not referring to the then-*current* wages. They were referring to the *fear* of, or the *possibility* of, workers' wages going up! And they concluded that if wages should happen to go up, it would be fair and just—to our new American Royalty—to recoup their outrageous profits by raising prices. After all, corporations have no moral obligations to their employees or the public. Their obligation is only to their executives and stockholders.

Note also that an "inflationary inferno" is never due to obscene levels of profits. It is always due to the increase in workers' wages. Prior to this period, as noted in *Fortune*, "there had been years of little real growth" in workers' incomes.

The fraudulent nature of the "wage-price" con is especially evident when you read two articles that appeared in the same issue of *Business Week*. First was the traditional blame-the-workers nonsense under the head, "Trouble Ahead in the Battle to Contain Labor Costs."

> Companies can no longer rein in benefits to offset pay raises.... Rising labor costs mean that businesses will face a tough choice: Raise prices, if they can, to cover the added expenses and protect profits. Or hold prices steady, hoping that increased sales and productivity gains will save the bottom line. How the price-profit dilemma plays out will determine inflation's performance this year....
>
> Tight labor markets also mean that workers may begin to lose their "heightened job insecurity" that, in Greenpan's words, "explains a significant part of the restraint on compensation and the consequent muted price inflation."[5]

After thus claiming that companies will have to raise prices if workers get more money, *Business Week* then unwittingly gave us a classic description of greed and *profit* inflation in a following article of the *same* issue. Its headline revealed "An Enormous Temptation to Waste" for corporations and pointed out that

> U.S. companies are piling up cash.... "In company after company, we're seeing huge buildups of cash," says Jeffrey D. Fotta, CEO of Ernst Institutional Research in Boston.... All told, liquid assets held by U.S. nonfinancial companies hit a staggering $679 billion at the end of the third quarter, up 21.5% in a year.... But too much money creates a vexing problem: what to do with it. "Having that much cash is an enormous temptation to waste," cautions Steven N. Kaplan, a professor of finance at the University of Chicago's business school....
>
> The worry is that many companies are taking on cash so fast they can't spend it efficiently.... Some companies, such as Boeing Co. and the Big Three automakers, plan to keep huge cash reserves to see them through the next economic downturn.... "Can you ever have too much capital?" asks

Maurice R. Greenberg, chairman of insurance giant American International Group, Inc., who continues to add to his company's coffers. Like many executives, he thinks not.[6]

Could the hypocrisy of blaming inflation on workers' wages be clearer? After 20 years of warfare on the incomes of working Americans:

- Corporations now have so much money they have an "enormous temptation to waste."
- For years companies have told workers that they couldn't raise wages because "competition demands it." If we were to have a healthy economy, and remain competitive, companies had to reduce labor costs by firing employees, also called "restructuring."
- And what are American corporations doing with all the money that they got from the sacrifices they forced on working Americans? Simple. To hell with working Americans! They're going overseas where wages are even lower.
- General Motors made the headlines during this same time period, fighting the unions that wanted more investment in jobs in this country. GM's position: competition demands that we go overseas, that we continue to pay executives huge salaries, that we give outrageous returns to wealthy investors—and, by the way, whoever said the American employees who built this company had any rights?
- And if corporations spend their money so fast they can't "spend it efficiently"—hey, that's their right.
- Naturally, CEOs and wealthy investors must be able to make it through "the next economic downturn." How nice. Too bad the bottom 20% of working Americans aren't sure how they're going to make it through next week, even in this "prosperous" economy.

Take a look at two more revealing articles—again from the same issue of a single publication. On May 5, 1997, *The Wall Street Journal* made a detailed analysis of the possibility that working Americans may start making higher incomes. Under the head, "Economy's Hot Pace Will Cool a Bit," the *Journal* observed that

...it is hard to ignore the fact that the unemployment rate dropped to 4.9% of the work force in April—the lowest level since 1973—from 5.2% in March.... The question now is: How much will the economy slow?...

The economy may be slowing to a more-sustainable pace, as the Fed had hoped, but the jobless rate remains too low for the Fed's comfort.[7]

In another article of the same issue, the *Journal* proclaimed that "Corporate Profits Leap Unexpected 18%" in just one quarter of the year:

Companies' earnings surged a better-than-expected 18% in the first quarter, boosted by a surprisingly strong economy, slowing growth in worker-benefit costs and a renewed drive for more efficiency.... Most companies in industries ranging from autos and airlines to steel, semiconductors and pharmaceuticals beat Wall Street estimates of earnings growth.[8]

With both kinds of data hitting Republican and conservative Democrat politicians between the eyes daily—often in the same publication—you know that what they are doing to working Americans is deliberate.

The people who read these publications—politicians, corporate executives of all levels, investors, small business owners, inheritors of wealth, doctors, accountants, investment bankers and so on—*all* have to know that:

- Every piece of objective evidence shows that the income and wealth disparity between themselves and working Americans is becoming a vast chasm.
- Our present conservative economic policies ensure that this condition will continue; wages will stagnate and corporate profits will soar, at least until consumers run out of money.
- Corporations could share more of their bounty with working Americans without having to raise prices, if they would accept lower profits. And, in sum,

50

- They are enjoying their affluence on the backs of, and at the expense of, working Americans.

So the bad news for workers is that anytime their wages *start* going up, it will be a signal for conservative politicians to take additional action against them, even if corporate profits went up 18% in the previous quarter.

This period, from 1994 to 1998, is especially significant. There still was considerable doubt among conservative economists that working-class Americans had been entirely stripped of what little economic and political power they once had. Almost every issue of every conservative financial publication during this time had some reference to the state of wage increases across the country.

By mid-1999, at least some conservatives were beginning to breathe a bit easier. On April 30, *The Wall Street Journal* repeated its feigned mystery-that-defies-economic-theory with the somewhat optimistic head and sub-head, "Pace of Wage Growth Slowed in Quarter; Slowdown Defies Textbooks As Figures Come in Face of Tighter Labor Market." It went on to note that

> The news may not be great for workers.... But it's good for companies, and for investors and policy makers worried about the possibility of inflation. A slowdown in compensation helps explain why profits for many companies rebounded in the first quarter.[9]

Incredible. After more than 20 years of economic growth, ever-tighter labor markets, continuing wage stagnation, rising corporate profits and a soaring stock market—policy makers still "worry about the *possibility* of inflation." This, at a time when wage growth was actually slowing.

With these trends continuing well into 1999, one would think that conservatives could relax a bit about workers making more money. Not so. Three months after the above optimistic *Journal* article, in July 1999, *Business Week* resumed the worrisome trend and reported, "Good News about Jobs Is Bad News to the Fed":

> The Federal Reserve cannot come out and say it directly, but the main reason policymakers want to restrain eco-

nomic growth is to loosen up the labor markets. To admit that would be political suicide. But the Fed knows that, with markets already so tight, job growth must slow if the economy is to avoid a surge in wages that could trigger a rise in inflation.[10]

One wonders why *Business Week* thinks that the Fed can't "say it directly"—that our country's official economic policy is to keep working-class wages from going up. Greenspan has been making such public pronouncements for years now. However, possibly it would be political suicide to admit the *extent* to which Fed policy is overtly, consciously and blatantly anti-worker and pro-investor.

So far, we've been concerned with workers' wages, the prime rate and inflation. Now let's look at The Great Debate, in which America's modern barbarians speculate about the best way to destroy workers' incomes—without cutting into corporate profits.

3.

The Great Debate,
and a New Conservative Strategy

As of the end of 1999, wealthy conservatives could hardly believe their good fortune. It seemed too good to last. For the previous 20 years:

- The U.S. economy had been growing,
- Worker productivity had been going up,
- Corporate profits had been going up,
- The stock market had been skyrocketing,
- Unemployment had been going down, and
- To everyone's feigned surprise—workers' wages had been steadily losing pace with inflation.

Conservatives had told the public that, under these conditions, this last development was never supposed to happen. Thus, the great debate: Is this good fortune for investors too good to last without workers' incomes starting to rise?

Despite the recent consensus that there is less need now to raise the prime to control wages, it's instructive to review the debate as it has progressed over the years: Should the Fed raise the prime interest rate in order to slow the economy, drive unemployment up and, thus, stomp out even the remote possibility that workers' may begin sharing in the prosperity of our country? Or are there other ways to destroy workers' incomes without having to rely on manipulating the prime?

In the next few pages, note how our cold-blooded Wall Street barbarians have been debating the economic fate of working Ameri-

cans in the era of ClintoReaganonomics. In the view of today's financial conservatives:

- Workers are in a category that is no different from machinery or raw materials, therefore,
- They are an expense to be minimized—or totally eliminated if possible.
- The growing income gap between rich investors and executives—and middle- and low-income workers—is irrelevant.
- Conservatives also consider it irrelevant that:
 * Workers are human beings who are citizens of *this* country, with *this* country's standard of living, and *this* country's cost of living,
 * Workers have families to support,
 * Workers have medical bills, house payments and school expenses to pay, and
 * Workers built the very corporations that are now abandoning or victimizing them.

All that counts to America's financial elite are corporate profits and their own incomes. Therefore, the only consideration in this debate has been: What is the best way to keep working Americans' incomes from going up, *and* still continue the growing income and wealth disparity between the top 20% of Americans and everyone else?

The Wall Street Journal gave us a brief introduction to the debate when it reported that "Business and Academia Clash Over a Concept: 'Natural' Jobless Rate":

> Are too many Americans at work these days for the economy's own good? Absolutely says Martin Feldstein.... "We are...into the danger zone." "Nonsense," retorts Dana Mead.... "Economists who talk that way...don't understand how American companies have tied wage increases to productivity gains, shifted work overseas and learned to produce more with fewer people."[1]

Realize what these two modern conservatives are debating here. The "natural" jobless rate occurs when unemployment is high

enough to keep wages of working Americans from going up, but not so high that corporations can't make huge profits. Feldstein claimed that unemployment was getting into the danger zone (too low), and maybe the Fed should raise interest rates. Raising interest rates would slow down the economy, jobs would be scarcer, and wages would stagnate.

Mead disagreed: Because of our nation's conservative economic policies, corporations have better ways to put pressure on wages to keep them down—and still allow corporate profits to grow.

Business Week described Alan Greenspan's now-discredited 1995 view of the debate, under the head, "Can the Economy Stand a Million More Jobs?":

> Despite growing comfort at the Fed with the current jobless rate, Greenspan remains the biggest skeptic. Fed watchers say that he still doubts the economy can handle unemployment lower than 6% without triggering wage pressures.
>
> Greenspan hinted as much in an Oct. 19 speech, noting that while the downsizing trend has left employees docile, at some point "workers will perceive that it no longer makes sense to trade off wage progress for incremental gains in expected job security."[2]

Obviously, in Greenspan's view the economic welfare of working Americans takes a distant second place to high corporate profits. He isn't concerned about outrageous incomes of the wealthy; he is concerned only about microscopic wage increases of working Americans. He even took comfort in the fact that downsizing had kept workers docile. But he worried that their attitudes may change if they figure out that just having a job isn't enough, if their wages don't go up.

In 1997, after two more years of stagnant wages and soaring corporate profits, *The Wall Street Journal* described how Greenspan had changed his opinion. Under the head, "In Setting Fed's Policy, Chairman Bets Heavily on His Own Judgment," it explained that

> Despite a rebound in economic growth, wages and prices remain, so far, amazingly placid.... Mr. Greenspan [now]

has a different mantra: Workers' fear of losing their jobs restrains them from seeking the pay raises that usually crop up when employers have trouble finding people to hire. Even if the economy didn't slow down as he expected, he told a Fed colleague last summer, he saw little danger of a sudden upturn in wages and prices.

"Because workers are more worried about their own job security and their marketability if forced to change jobs, they are apparently accepting smaller increases in their compensation at any given level of labor-market tightness," Mr. Greenspan told Congress at the time.[3]

As all the major financial publications were pointing out, Republicans and conservative Democrats had created a new world economy. Workers' fear of losing their jobs prevented them from seeking pay raises, so, even if the economy didn't slow down, there was little danger of wages going up. Thus, Greenspan's "different mantra."

Barron's Op-ed Heavyweights

Now read what two economic heavyweights had to say in *Barron's* about the great debate. Under the headline, "Forget NAIRU" (Non-Accelerating Inflation Rate of Unemployment), Gene Epstein explained why the old "Goldilocks" theory of traditional conservatives is now invalid:

> Joblessness can fall without boosting inflation.... The idea of the NAIRU is based on the theory that there's a "Goldilocks" rate of unemployment—not too hot, not too cold—at which inflation will stabilize.
>
> The theory was sparked by concern that a low jobless rate can cause such an acute mismatch of geography and skills that wages start to rise, touching off an acceleration rise in prices....
>
> [Joseph Stiglitz, chairman of the Council of Economic Advisors]...implicitly gave advice to his colleague, Fed Chairman Alan Greenspan: Try easing interest rates and bringing unemployment down. Don't worry, because if inflation starts to jump, you can always retrace your steps and see it decline again.[4]

The reason Stiglitz was so euphoric is that highly skilled "Baby Boomers" were entering the labor force. They were more adaptable to new and different jobs, and were more willing to go to where the jobs were, thus increasing competition for high-skilled jobs. He also noted that the labor market was more competitive and less unionized, which forced unions to reduce their demands.

Translation: In the past, conservatives manipulated the prime to keep the economy hot enough to maximize profits, but not so hot that wages would go up (the Goldilocks strategy). But, by using other methods and because of other factors, they've been able to force unions to reduce their demands, thus removing a traditional upward pressure on the wages of everyone, even non-union workers.

And—here's the best part—if workers should accidentally start making higher wages, the Fed can always "retrace its steps and reverse its course" (by raising the prime, and, hence, increasing the unemployment rate).

Offering a contrary opinion, Charles Lieberman defended the more traditional way of keeping wages down by raising the prime. In a *Barron's* headline, he asked "Is Inflation Dead?" and warned that "In fact, it may be right around the corner":

> The service sector now accounts for 80% of total non-agricultural payroll employment in the United States, and these jobs are exposed to little international competition. If there's a shortage of truck drivers who travel between Boston and New York, the availability of unemployed truck drivers between Rome and Milan, or Tokyo and Yokahama, or Santos and Sao Paulo, is totally irrelevant....
>
> Low value-added manufacturing like that of clothing, toys and shoes long ago mainly moved to low-wage countries. There is nearly an unlimited supply of such products and they can be imported at low prices. But importing them doesn't relieve any manufacturing capacity problems here because the U.S. no longer makes many of these items.[5]

Lieberman went on to disagree with his optimistic colleagues who felt the prime rate didn't need to be raised because foreign labor has become a satisfactory substitute: The U.S. can't count on "low value-

added manufacturing" imports to continue to lower wages, because we gave away those industries long ago! They're history and no longer relevant.

Lieberman also wrote that "much of our labor force is in the service sector and not subject to international competition." He was clearly wrong on that point. Three years after his op-ed piece—and as recently as May, 1999—service sector employees were still suffering from a severe case of creeping wages. As *Business Week* put it in its "All This and Low Wage Pressures, Too":

> Productivity is up, unemployment down, and the Fed can bide its time....
>
> Given the solid growth in service jobs, it is remarkable that service companies are not bidding up wages faster. The explanation may be that, the low unemployment rate notwithstanding, the demand for labor across the entire economy may be easing and the supply is rising.
>
> How so? First of all, the loss of 407,000 factory jobs during the past year creates a fresh supply of workers for the service sector.[6]

The working Americans who lost the jobs that went overseas are now quite willing to fill any demand for service jobs, as well as any "shortage of truck drivers who travel between Boston and New York," who, incidentally, have seen their hourly income drop from $16 to $9 an hour.

The Great Debate Continues

No matter how much wages stagnate—and due to the chronic insecurity of greedy and materialistic conservatives—the great debate will likely continue *ad infinitum.* As recently as December, 1999, *The Wall Street Journal* proclaimed that "Even-Lower Jobless Rate May Not Ignite Inflation," and cited a Department of Labor study which suggested that

> The national unemployment rate—already at 4.1%, a 29-year low—might safely sink even further without dragging the economy into an inflationary spiral....

A few economists have abandoned the idea of a safe floor for unemployment altogether. Many others have retained the idea of a safe floor and simply lowered it.[7]

So, again, the great debate among modern economists has nothing to do with the welfare of American workers. It's still about the best way to make investors richer by keeping wages from going up. All that seems to change in this controversy is that the "safe floor" for an acceptable level of unemployment keeps ratcheting lower.

To get a better understanding of why lower unemployment in a growing economy doesn't cause wages to rise higher than inflation, or even as high as inflation, consider another wrinkle in the conservative con: The stealth Catch-22 and why economic growth no longer counts.

4.

Economic Growth:
The Conservatives' Catch-22

For sheer hypocrisy, nothing can match the Republicans who claim that we should reduce taxes on rich people because that would result in more jobs and higher wages for workers.

Their propaganda spin goes like this:

- The U.S. should reduce inheritance taxes, capital gains taxes and income taxes on rich people so they can have more money to invest.
- Greater investment means greater growth in the economy.
- Greater growth in the economy creates more jobs and a greater demand for workers.
- Greater demand for workers gives workers more power to negotiate for higher wages. And presto,
- Workers' incomes go up and they get a bigger share of the wealth that *they* actually produced.

Undoubtedly, some politicians who make this decrepit argument actually believe it. It's been repeated so often and so loudly that those who don't read our best conservative financial publications assume that what they've heard on their corporate-owned TV stations is true. You'll have to decide yourself after you read the following pages, which politicians are deliberately dishonest, and which ones are simply stupid.

There is a Catch-22 to promises that economic growth will create higher wages. True, in the past, the best climate for wage growth has been when the economy was growing. The Catch-22: modern conservatives have learned how to allow the economy to grow to the extent that it increases profits, but, also, how to slow growth when it starts to cause higher wages.

Readers of our premier financial publications know that, as soon as growth reaches a point at which workers begin to benefit, Wall Street will scream bloody murder and demand that their congressional stooges in Washington do something to cool off the economy.

Economic growth does not determine wages—*power* determines wages. Since Republicans and conservative Democrats got control of our federal government, corporations and investors have all the power and workers have none.

Conservative politicians know damn well that if they really wanted to stimulate economic growth in the United States, they would protect workers' abilities to earn higher incomes! In fact, as the excerpts throughout this entire book demonstrate, higher wages always result in a greater demand for products, a growing economy and, mostly because of corporate greed, inflation. When this is *unintentionally* allowed to happen, conservatives call it "excessive growth."

On the other hand, when the wealthy make more income, either through tax breaks or increased profits, they will invest it in whatever part of the world most brutalizes workers. That's usually not the U.S.

Note how *Barron's* described growth—to the point where wages might increase—as "something wicked this way comes." Under the head, "Investors Beware: It Seems Inevitable That Greenspan & Co. Will Pull the Trigger on Rates," it warned investors

> ...to dust off their copies of Shakespeare's *Macbeth*, because something wicked this way comes: tighter Fed policy....
>
> In recent months, Fed officials have made it clear that they have been placing their bets on slower growth in the second half. But the economy continues to grow faster than the Fed would like, a predicament that may fan smoldering fears that inflation will rise later this year.[1]

When does the Fed's trigger finger start to itch? Easy. When the rate of growth starts to increase the wages of working Americans! It's automatic:

- Whenever wages ("something wicked") start to go up ("this way comes"), the Fed must satisfy the corporate financial supporters of Republican and conservative Democrat politicians—and raise the prime.
- You see, the economy wasn't following the script. Despite the 1993 tax increases on the wealthy, the U.S. had a robust, growing economy for the rest of the decade.
- Unemployment was still going down, which means that working Americans might actually start to benefit—as conservatives had always promised—from increasing economic growth.
- As usual, good news for workers about the "health of the labor market" is bad news for investors.
- And when those investors realize the "predicament" they are in (wages going up) and the economy is growing faster than the Fed would like, it's time to "pull the trigger."

Under the head, "This Slowdown May Be Short-Lived," *Business Week* warned its readers that they "had better take a closer look," at the seemingly favorable economic growth figures (slower) and favorable unemployment figures (higher). Although the economy seemed to be slowing at the time, "cheers could quickly turn into boos" if it didn't slow *enough* to stop workers' incomes from going up:

> The markets had better take a closer look. First of all, while nonfarm employment growth slacked off last quarter, other key labor-market statistics give no indication that slower economic growth will continue into the fourth quarter.... Even if the slowdown were lasting, it would take time for worker shortages to ease and the upward pressure on wages to abate....
>
> The economy is slowing and so is inflation. But if the emerging trends in wages and labor costs continue, those cheers could quickly turn into boos.[2]

The tone of the previous articles is as important as their substance. *Feel* how these financial conservatives are talking about the lives of working Americans: Their incomes, their standard of living, and their ability to make it through this decade of the conservative revolution. Wall Street likes it when the economy slows enough to force working Americans into unemployment:

- They "applauded" the news that nonfarm payrolls went down by 40,000 live human beings—fellow citizens of this country.
- But, "take a closer look" investors, a warning is in order. Even if the bad news for workers is real, it would take time for the "upward pressures on wages to abate."
- Still, *Business Week* cited other good news: Fifty-seven thousand workers got fired the month before. A mixed blessing though, because the factory workweek rose, and overtime remained high.
- So, contentment for Wall Street is: stagnant wages, record profits, a skyrocketing stock market, growing income disparity—and Republicans and conservative Democrats in control of the political process. What a great new world conservatives have created.
- But, again, the warning: if workers, despite all the power aligned against them, start getting better incomes, then "the cheers become boos."

Joining this hysterical anti-too-much-growth frenzy, *The Wall Street Journal* made the crucial distinction between a merely "sizzling" economy and an "overheating" economy. Under the head "Economy Warms, but Isn't Overheating," it reported that

> The economy continued to sizzle last month, but cast off few sparks indicating overheating.
> And with Mr. Greenspan having told Congress earlier in the week that he continues to remain vigilant for any warning signs that might force him to boost interest rates later this month, the markets were examining the tiniest details of Friday's releases for any glimpse of inflation....
> [Indications that "raises aren't escalating and are quite possibly decelerating"]...isn't enough to pacify anti-inflation hawks. They look for advance signs that wage increas-

es will begin. Mr. Greenspan, for one, scrutinizes worker insecurity. He has said in recent remarks that he believes a pervasive fear of unemployment has kept wage demands modest, but he is worried that the robust labor market would soon embolden workers to demand more.[3]

The economy "sizzles" when investors get wealthier. But the economy "overheats" when workers start to participate in its benefits.

A General Truth versus a Deliberate Lie

It is important to distinguish between a general truth and a deliberate lie. When Republicans and conservative Democrats say that most economists agree that a growing economy will bring about higher wages for working Americans—they're telling what *should be* a general truth.

However, that general truth becomes a deliberate lie when those same politicians know full well that they will use their power to prevent the general truth from functioning—if economic growth should actually start to improve wages.

In fact, wages don't even have to *begin* affecting inflation. All they have to do is to give warning signs that provide, as the *Journal* put it, a "glimpse of inflation." Most Republicans and conservative Democrats could rest assured at this point in 1997, however. Because, despite the booming economy:

- It looked as if wages were "quite possibly decelerating."
- Still, that's not enough for "anti-inflation hawks" who don't want increases in wages to even begin, let alone catch up with inflation.
- Horrors! Workers may become emboldened enough to ask to share in our country's growing prosperity.

It's not a debatable issue: Through their economic policies, conservatives force huge financial sacrifices onto working Americans. And *The Wall Street Journal* clearly described who benefits from those forced sacrifices. Under the head "The Great Divide," it reported that

CEO pay keeps soaring—leaving everybody else further and further behind. The earnings gap between executives at the very top of corporate America and middle managers and workers has stretched into a vast chasm. Last year, the heads of about 30 major companies received compensation that was 212 times higher than the pay of the average American employee…. That's nearly a fivefold increase since 1965, when the multiple was 44…. Meanwhile, U.S. wages and benefits climbed just 2.9% last year. That was the smallest advance in 14 years.[4]

Under the head "Executive Pay," *Business Week* also presented a clear picture of the growing income gap between working Americans—and wealthy investors and the executives who work for them:

Few doubt 1996 was a stellar year. The Standard & Poor's 500-stock index rose a stunning 23%. Corporate profits rose, too—an impressive 11%….

For 1996, CEO pay gains far outstripped the roaring economy or shareholder returns. CEOs' average total compensation rose an astounding 54% last year, to $5,781,300…. That largess came on top of a 30% rise in total pay in 1995—yet it was hardly spread down the line.

The average compensation of the top dog was 209 times that of a factory employee, who garnered a tiny 3% raise in 1996.[5]

All these articles appeared in roughly the same time period, 1996-1997, thus removing any doubt that those in power knew exactly what they were doing. People who read these publications know these things all go together: "just-right economic growth," stagnant wages, record corporate profits, soaring executive incomes, and a skyrocketing stock market. These articles also are typical of the entire two decades of the 1980s and 1990s, and continued to be published in late-1999.

At the time of the last draft of this book, conservatives were *still* debating about whether economic growth was merely sizzling or "dangerously" overheating. In "Which Mask Will Greenspan Wear Next?" (November, 1999) *The Wall Street Journal* reported that

For three years now, Alan Greenspan has morphed back and forth between the New Economy's most powerful advocate and its most menacing skeptic. With the recent revival of the on-again/off-again debate about whether the U.S. is growing too fast for its own good, the Federal Reserve chairman once again is forced to make a choice: Does he want to play Santa Claus this year, or Scrooge?[6]

As usual, in the very same *Journal* issue, there was the almost daily celebration of a skyrocketing stock market. Under the head, "Stock Market Regains High Spirits After Shaking Off October Demons," it observed that

> Stocks are skyrocketing. Amid signs that inflation is weakening and that interest rates could stop rising, the Nasdaq Composite Index, heavy in technology stocks, already has soared back [after an October sell-off] into record territory....
>
> Coming right after labor-cost and economic-growth data that suggested strong growth and low inflation, the comments [by Greenspan] fueled hopes that the Fed would step aside and let the stock market surge again.[7]

Two days after the previous two articles came out, November 3, 1999, the Nasdaq composite stock index closed for the day above 3000 for the first time in history and was up 113% from 13 months before. In other words, in 13 months, passive investors more than doubled their wealth without doing a lick of real work. These are the people who panic if workers—who made it all happen—see their incomes start to rise at a rate of just 3% per *year*.

Record stock market; wages, adjusted for inflation, still below the 1973 level. Getting monotonous, isn't it? But it's not surprising and it's no accident. Very simply: Conservative politicians always appoint Federal chairmen who will control the labor markets and fine-tune the growth of the economy—not too hot, which would allow workers to benefit—but not so cold that corporate profits would be hurt.

These actions over the past 20 years have allowed CEOs, investors, and the established wealthy to get much richer. They are the same people who

- lecture American citizens about why *workers* must make wage sacrifices—so our corporations can remain competitive with foreign corporations,
- blame any price increases, that *they* implement, on labor costs—the old "wage-price spiral,"
- sit in on each others' companies' boards of directors and vote themselves huge income increases, and promote anti-worker managers to positions of power,
- support politicians who promise to do all they can to destroy labor unions,
- blame complaints about poor working conditions on the lack of a "work ethic" among working Americans,
- support politicians who will allow them to do whatever they wish with the environment or to the American public, and
- promise voters that they should continue to put Republicans and conservative Democrats into Congress, because they are the ones who gave us this fantastic economy.

Now it's time to look at how these paragons of virtue, *via* their personal political representatives, were able to create this kind of an economy. Without a doubt, the biggest weapon in the conservative class warfare arsenal is the myth of unmanaged "free" trade.

5.

Unmanaged "Free" World Trade

By passing NAFTA and GATT, the Republican Congress and our conservative President Bill Clinton ratcheted class warfare up another notch. Despite their promises, unmanaged free world trade has been a disaster for working Americans.

"Free" international trade means that investors are free to pit workers of the world against each other by putting their money into whatever country has the lowest standards for protecting the environment, and for protecting worker incomes and job conditions.

When investors close a manufacturing plant in the U.S., it hurts not only the workers who lose their jobs; it hurts *all* workers. It's not just 5% of our workforce who suffer, it's 100%. For two basic reasons:

1. The workers who actually lose their jobs in a plant shutdown enter the competitive labor market and adversely affect the wages of others who still have jobs.
2. Other workers in the U.S. who still have jobs now know that their employer's threat to leave the country is real. If they cause trouble or join a union, they may well be "downsized."

That is why unmanaged world trade hurts workers even in jobs that can't be exported from the U.S.: trucking, retail, construction, the service industry, etc. Since conservatives have put so many people out of work, individual non-union workers have lost the power to negotiate for higher wages. If workers collectively try to form a

union, they get fired. If they're already in a union, the union can't press for higher wages because the corporation might close down the plant and move elsewhere.

So, investors and corporate executives are screwing working Americans both individually and collectively.

Conservative economists and politicians who profess surprise that wages haven't kept pace with inflation—while the economy and profits soar—have to be lying. Their duplicity and their denial of reality were, in essence, reflected in *Business Week*'s question when it asked in a headline, "NAFTA: A New Union-Busting Weapon?":

> Since the North American Free Trade Agreement took effect, U.S. employers have routinely threatened during union elections to close plants and move production to Mexico or elsewhere, says a new study commissioned under NAFTA....
>
> The report, based on union elections from 1993 to 1995, indicated half of the employers threaten to close plants when facing a union vote....
>
> When employers lose, 7.5% go ahead and close the plant—triple the level in the pre-NAFTA 1980s.
>
> "NAFTA created a climate that has emboldened employers," says Kate Bronfenbrenner, a researcher who headed up the study for the U.S., Canadian and Mexican governments. She agreed to release the report after the Labor Dept. balked.[1]

Because of articles like this, the real intent of unmanaged free trade is becoming obvious to everyone. The daily news accounts can't be covered up, even by conservative journalists. Only an orthodox hypocrite could claim that corporate CEOs didn't intend to use "free trade" as a cover for being able to "routinely threaten" their own workers. "If you unionize, we'll abandon you and your community and 'move production to Mexico or elsewhere.'"

The major intent of unmanaged free trade was never revealed to the American public. *Business Week* further reported that the U.S. Labor Department sat on the study out of fear the report would fuel skepticism toward expanding NAFTA. No wonder. Think of it:

- In half of the union drives, working Americans were threatened with job loss—the "job insecurity" that Greenspan is so proud of. Also bear in mind that figure represents only those situations that the researchers found out about.
- It takes only a few employers, 7.5%, to actually carry out their villainous threats to close down a facility and make "insecure" the entire 100% of working Americans.
- Given this sledgehammer over the lives of working Americans, is there any possible doubt about how our "emboldened CEOs" have been able to rape their own employees—even in a booming economy?

If you don't want to admit the validity of this study, consider that *Barron's* lays bare all pretenses—when communicating to fellow conservatives—about the strategy and results of unmanaged free world trade. Under the head "Not To Worry: Even If the Jobless Rate Shrinks a Lot, Labor Is in Weak Position to Boost Inflation," it bragged that

> The 'Nineties, need we remind you, are a period of insecurity and cost control, a time when workers feel lucky to have a job, let alone one that pays well.
>
> And consider another reason for believing that labor is in no position to impose "cost-push" inflation on the economy: the rise of Global competition.
>
> Domestic producers won't permit labor to raise costs faster than productivity. If this were allowed, plenty of foreign producers could outstrip U.S. companies.
>
> If American labor sought inordinate increases, manufacturers could simply move production abroad and employ foreign labor at a far cheaper rate.[2]

The legitimate benefits of free trade give Republicans and conservative Democrats yet another opportunity to tell an obvious lie—under the guise of a general truth. They sell American voters on the true advantages of free trade, but then insist that it be unmanaged. Unmanaged trade isn't free—it is ruthlessly controlled by conservative politicians and international corporations.

This means that employers can do whatever they want to employees—in this country or elsewhere—without adhering to *any* moral standards as to their treatment. What kind of morality allows corporations, through their paid conservatives in Congress, to create a climate in which working Americans feel "lucky just to have a job, let alone one that pays well"? In addition:

- The rise of global competition isn't "another reason" working Americans are in this "period of insecurity." It's the *main* reason!
- Labor costs—wages—haven't kept up with productivity for 20 years. It hasn't been allowed, and because conservative politicians have sold out working Americans, they won't allow it in the future.
- In the view of conservatives, *any* increase in wages is an "inordinate" increase.

For insights into the kind of competition our "moral values" conservatives have forced on working Americans, look at Indonesia. It is no longer considered one of the worst abusers of workers, because it is in the process of becoming a more humane country—very, very slowly.

The Wall Street Journal admitted in a headline that "Indonesia Is Striving To Prosper in Freedom, But Is Still Repressive." After it described a 24-year-old watch-factory worker who was murdered because she thought she deserved more than a dollar a day and was organizing a strike to get it, the *Journal* noted that

> Average annual incomes [in Indonesia] have spurted to $650 a person—twice what they were a decade ago—as gross national product has expanded at an average clip of 6.8%.[3]

What a jewel corporate America has in Indonesia:

- Want to get rid of a union threat? Then murder the organizers who are demanding outrageous wage increases—more than a dollar a day.

71

- If murder is too gross for you, the *Journal* also noted that, "bribes and connections can help corporations clamp down on labor activists."
- Still, despite its poor record in its treatment of workers, one must admit, wages have gone up in Indonesia, just as our conservative politicians have promised. They have spurted to $650 a year. And, damn, that's twice as much as they made ten years ago. At that rate, they'll catch up to working Americans' wages in, say, another two centuries.

When you review the above article (readers who insist on believing that the Indonesians are still better off, despite deplorable working conditions, should go to their library and read the entire article), remember—American corporate executives

- know these conditions exist,
- actively seek out countries in which these conditions, or worse conditions, exist,
- preach to working Americans that they must compete with workers under these deplorable conditions. And, worst of all, they
- demand unbelievably high incomes for themselves for their own roles in instigating this immoral process.

For a better example of conservative hypocrisy when it comes to free trade, look to this country. One of America's most conservative groups betrayed its feelings about foreigners who compete with them and who threaten to lower their own standards of living. According to *The Wall Street Journal*, "Medical Groups Propose Restrictions on Foreign Doctors to Stem Oversupply":

> The U.S. is creating a doctor glut that should be fixed in part by making it harder for foreign physicians to gain advanced training in this country, according to a panel of medical experts....
> "We're on the threshold of a gross oversupply of physicians," said Jordan Cohen, president of the Association of American Medical Colleges.[4]

Doctors, traditionally a very conservative group, overwhelmingly support the principle of free world trade in the abstract. But not, of course, for themselves:

- Interns shouldn't have to face a "doctor glut" when they graduate. After all, their parents spent a bundle on their education and, unlike persons in chicken-processing plants, they had to work hard to get their degrees.
- It's especially bad if the glut is caused by "foreign physicians," who are used to a lower standard of living and would be glad to work in this country for much less.
- And what's this about physician "oversupply"? Isn't one of our biggest looming problems the large number of aging baby boomers who will require medical care? According to free market theory, shouldn't we reduce costs by allowing the market to glut itself with foreign doctors if that's what "the free market" wants to do?

Count on it: If the jobs of CEOs, bankers, economists, etc. could be done by qualified foreigners who would work for one-tenth of the money—just like our doctors—their cherished theory of unmanaged free trade would die in a heartbeat.

If free trade is to function as intended, it must be managed so that investment goes to those parts of the world that have the best economic advantages *and* that respect workers as human beings with fundamental rights.

In other words, investments should be made in those parts of the world that

- have the best access to raw materials (despite the protestations of Republicans and conservative Democrats, human beings are *not* "raw material"),
- have the best location in the distribution chain,
- have developed the best technology,
- have trained the best managers and workers, and finally,
- offer the best product at the lowest price.

The free market should not reward those immoral competitors who would compete purely on the basis of their willingness to treat their workers the most brutally. As it's now designed, that's exactly what it's been doing since its inception, and it's continuing today. Under the head, "In the Wake of Nafta, A Family Firm Sees Business Go South," *The Wall Street Journal* reported that the exodus of industry from the U.S. was continuing unabated into 1999:

> Nafta removed quotas limiting how much clothing could come into the U.S. from Mexico. (The rest of the world, except for Canada, is still subject to quotas.) The accord also has lowered tariff rates more than 50%.
>
> The result is that many designers have been shifting the bulk of their sewing to Mexico, where labor costs are about one-seventh of what they are in the U.S....
>
> "It's obvious: You either go to Mexico—or you die," says Mr. Mehserjian's brother Harry.[5]

All these jobs going from the U.S. to Mexico should at least be good for Mexicans, right? Well, it depends upon which end of the Mexican society you look at. As of early 1999, workers don't seem to have fared very well. In a separate article, the *Journal* asked the question, "Is the Mexican Model Worth the Pain?" and answered it this way:

> Mexico is coming off one of its best years in a decade. The economy grew at a rate of 4.8% last year, adding 100,000 new manufacturing jobs. Production of television sets, auto parts and clothing set records....
>
> Yet, according to a new study by the United Nations Development Program, while just one of seven Mexicans lived in dire poverty before the crisis [peso devaluation], two years later the proportion was one in five. Adding those a rung up—workers living in "moderate" poverty, with daily incomes of $3—almost two-thirds of the citizenry is considered "poor" today. Fewer than half fit that description before the crisis.[6]

Despite articles like these, economists still claimed to be "puzzled" about why wages were continuing to stagnate in 1999. In another of its periodic denial-of-class-warfare attempts, the *Journal* again reported that the "Job Market Stays Tight, Fed Finds; More Bonuses Paid, but Few Workers See Big Raises in Wages":

> ...despite labor shortages, companies overall still aren't feeling pressure to raise salaries significantly to attract and retain workers, a fact that continues to perplex economists. "It is a puzzle, and I'm not sure that any of us has satisfactory answers," said Stephen D. Silfer, chief U.S. economist with Lehman Brothers....
>
> "Businesses are behaving differently today than at any other time in my career," said Mr. Silfer. "This is making [economists] think about this new world and how it's operating."[7]

Again, what the hell is the "puzzle" about all this? Conservatives have totally and deliberately destroyed American workers' power to negotiate. No contest. That's it. Period. For god's sake, they should quit being hypocrites about being so "perplexed" at their extreme good fortune.

And if most professional and highly skilled people in the U.S. are not all that concerned about what's happened to working-class Americans—and even think that conservative economics might be a *good* thing—they had better watch out. As we'll see in the next chapter, they might be next to join in the fun of unmanaged free trade.

6.

Guess What: You* Are Now a "Worker"

*Engineer, Ph.D., computer programmer, professional, scientist—and the usual others

Columnists and management professionals used to write about "management and workers," "professionals and laborers," and "salaried and hourly." These terms distinguished between different categories of corporate personnel and they had implications for a person's position in the organizational hierarchy, as well as for income level, job security, and position in society.

Professionals, managers, and salaried persons tended not to identify with the interests of workers and laborers. When bad things started happening to workers, the elite considered it a sad result of poor education or unfortunate circumstance.

Too bad. What has been happening to workers is the result of a planned strategy, and that strategy is now being applied to everyone who does the hands-on work of our country.

We'd better start thinking in terms of "wealthy investors" (people who don't work, yet make huge amounts of money) and "everyone else" (people who work because they have to make a living). Worldwide, wealthy investors are increasing their power to control the incomes of virtually everyone who has to work to support his family, whether at the poverty level or the luxury level.

Regardless of his category—scientist, truck driver, assembly line worker, doctor, engineer, teacher, or what have you—every worker

had better inherit money to invest, or have some strategy in mind to *get* large sums of money to invest. If he doesn't, he's going to find it increasingly difficult to have a decent future in the United States—a country whose leaders believe that actual work deserves no more than a marginal income.

For example, conservatives have found creative ways to force U.S. Ph.D.s to compete with scientists from Third World countries and their lower standards of living. Under the head "Give Me Your Huddled...High-Tech Ph.D.s," *Business Week* reported a study by the Center for Immigration Studies, which wanted limits on immigration. It concluded that "11.7% of America's scientists and engineers in 1990 were foreign-born professionals—naturalized U.S. citizens and foreign nationals."[1]

The "National Science Foundation, a neutral source, concurred, reporting that foreigners made up 49% of Ph.D.s in computer science in 1993, up from 35.5% in 1983."[2] *Business Week* concluded that

> In theory, this explosion of foreign high-tech talent shouldn't be a threat to Americans. By law, employers can't petition for either temporary or permanent immigration visas for foreign workers if they can find a qualified U.S. citizen for the job.
>
> But it's widely known that employers often get Labor Dept. approval by tailoring job descriptions to a particular foreign candidate to make sure that no U.S. candidate can fill the slot.
>
> The most well documented abuses of the visa system occur in more routine software programming, where foreigners on so-called temporary H-1B visas clearly have undercut some U.S. engineers.[3]

For the past 20 years, Republicans and conservative Democrats have been telling us that getting an education and the new information age technology would save American citizens their standards of living. Therefore, we shouldn't worry about losing manual labor jobs. Not true. Wealthy conservatives have proved that they can destroy or put a lid on *anyone's* income.

Conservatives will correctly argue that scientists, engineers, Ph.D.s and those in the information industry are among our highest paid professionals. They are, but relative to the people who hire them, they are poorly paid. As with other industries, investors and top executives are the ones who benefit most from the competition they create for their own workers.

How do they do it? By "using loopholes in the law," and classifying jobs in such a way as to make sure that no U.S. candidates can fill the slots. So, the boss manipulates the labor market, keeps a lid on salaries (high as they are), and gets incredibly, fabulously, richer.

And you can count on it: if the technology industry tanks—or our country goes into a serious recession—those who will lose their jobs, or suffer serious income reductions, will be the Americans who actually built the industry to begin with.

The picture gets worse when American corporations totally abandon operations in this country and contract high-skill projects out to Third World countries. *The Wall Street Journal* was brutally frank when it reported that "High-Tech Firms Shift Some Skilled Work to Asian Countries; Like Blue-Collar Employees, West's Professionals Face Competition Abroad":

> American multinationals such as H-P come to Malaysia mainly for low wages. But in the process they have bred a fast-growing class of cosmopolitan professionals [in Malaysia]...who have the kind of high-skilled jobs Americans covet....
>
> It means that some of America's most skilled workers are likely to face the same punishing competition and wage pressures from abroad now felt by blue-collar workers....
>
> This shift is sending billions of dollars of capital to countries like Malaysia from the U.S. and Japan, fueling the growth of high-paying jobs overseas.[4]

Conservative economic policies always benefit wealthy investors first—with only the promise of "trickle-down" to workers sometime in the vague future. Problem is, conservative politicians always change the rules to keep the promised future from happening.

Unmanaged free trade was supposed to eventually benefit workers, especially those with high skills. Americans would do the skillful

work of the future, and Third World countries would provide the manual labor. But then, as international trade increasingly became a reality,

- Third World countries began to train masses of their own citizens in the same skills that Americans were famous for. American corporations then began to shift operations overseas, and used their low wages to intimidate the skilled American workers who invented and perfected the skills to begin with.
- So, skilled American workers sacrificed their wages while waiting for the promised long-term benefits of international trade. As trade became very real, they were told: "Whoops! Who could have guessed? The international picture has changed!"
- In the future, skilled workers will likely face the same kind of competition as the blue-collar workers have been facing for 20 years.

If you ever thought that wealthy investors would be grateful to skilled workers *after* they had benefited from their skills, just look at *Business Week*'s description of "High-Tech Jobs All Over the Map":

> One of the less-heralded developments in the emergence of a global economy is that there is an increasingly better balance of skills in the world...in fields ranging from product development to finance and architecture....
>
> What's more, dizzying advances in telecommunications are making these workers more accessible than ever. As a result, just as Westerners learned in the 1970s and 1980s that manufacturing could be moved virtually anywhere, today it is getting easier to shift knowledge-based labor as well....
>
> "Just as with the move of manufacturing overseas, you're going to see an increasing flux of technical jobs out of the U.S.," predicts Intel Corp. Chief Operating Officer Craig R. Barrett. "We don't have any protected domains anymore."[5]

The people who legislated us into unmanaged free trade made sure that they immediately received almost all of the benefits of the process. During this 20-year period, most highly skilled workers got

moderate income increases, while the ones who manipulated their employment market got incredibly rich. Now that international trade is maturing:

- Those who were, or became, wealthy investors will continue to benefit big time—and skilled workers will, in the words of *Business Week*, "be left behind." Translation: Forget our promises that skill will be your job security. Investors now have all the power, and we don't have to lie to you anymore to keep you working productively.

- "A better balance of skills in the world" means that investors can now pit skilled workers against each other, just as they have been pitting manufacturing blue-collar workers against each other for this entire century.

- Forget loyalty. Forget fairness or justice. Forget who designed and built our country and made investors wealthy to begin with. All that counts in a world designed by conservatives is "price," whether for coal, steel or skilled human beings.

- Blue-collar workers haven't had any "protected domains" for at least twenty years. Now skilled workers don't have any protected domains either. Who does our federal government protect? Wealthy investors with their bank accounts. The new world order was designed for investors, at the expense of all who work.

It may come as a surprise to skilled workers, but in the future they may be worse off than unskilled workers. Under the head "Like Factory Workers, Professionals Face Loss of Jobs to Foreigners; American Firms Are Hiring Highly Skilled People Abroad, for Lower Pay," *The Wall Street Journal* reported that

> U.S. companies are increasingly hiring highly skilled workers in Asia, the former Soviet bloc and Europe to perform jobs once reserved for American professionals....
> The availability of low-paid professionals in Malaysia, Hungary, China, Indonesia and elsewhere calls into question the idea, popular in the Clinton Administration, that U.S. workers can raise their own wages or job prospects by acquiring more skills.

"A professional can have his skills moved around the world very easily today, so he ought to feel even less complacent than a low-skilled person, whose job may be tied to a locale," says William J. Schroeder, vice chairman of Conner Peripherals Inc., a maker of computer disk drives.[6]

When Republican and conservative Democrat politicians sold American voters on the idea of an unmanaged free world trade, they promised that it would eventually be good for everyone. Since this has proved not to be the case, conservatives have justified stagnant wages on the pretext that working Americans lacked the skills to compete on the world market.

Heaven forbid—it wasn't because conservatives had sold them out! They excused their deplorable behavior by promising U.S. workers that they could raise their wages or job prospects by acquiring more skills.

It was hypocritical then, and it is painfully, obviously, hypocritical now. The way things are going, skilled working Americans "ought to feel even less complacent than a low-skilled person, whose job may be tied to a locale"! At least *some* manual-labor jobs must be done in this country. What a break for those lucky Americans who work as manual laborers.

Don't expect relief from this attack on the incomes of skilled workers any time soon. In June, 1999, *The Wall Street Journal*'s periodic column, "Work Week," reported that

> Companies relying mostly on Asia and Europe for skilled workers will now look to Canada, says Greg Osberg, president of Kaplan Professional, a New York provider of information-technology career fairs. Under Nafta, Canadians can easily get U.S. work visas. About 2,500 U.S. employers attend the 34 fairs Kaplan holds in Canada yearly.[7]

This was just one of the more recent of a continuing series of articles describing how the lid can be placed on the incomes of even high-priced talent. It also explains one of the factors that allowed William Gates III to become worth $85 billion, instead of, say, a paltry $40 billion.

Those who hope that this situation will change soon should heed Greenspan's words. The *Journal*, in "Notable & Quotable," quoted his testimony before House Banking Committee on July 22, 1999:

> I've always thought that under conditions that we now confront, we should be very carefully focused on the contribution which skilled people from abroad [as well as] unskilled people from abroad…can contribute to the country, as they have for generation after generation….
>
> If [the] pool of people seeking jobs continues to decline, at some point it must have an impact. If we can open up our immigration rolls significantly, that clearly will make [the unemployment rate's effect on inflation] less and less of a potential problem.[8]

Translation:

- "conditions we now confront" Damn! Incomes for skilled workers are going up.
- "contribution of skilled people from abroad [as well as] unskilled people from abroad" The U.S. government should enable corporations to pit skilled foreign workers against skilled American workers, just as they been able to pit unskilled foreign workers against unskilled American workers in the past.
- "will make [the unemployment rate's effect on inflation] less and less of a potential problem" By putting a lid on the incomes of skilled workers, corporations can continue to make record profits and the stock market will continue to soar.

Americans, by and large, already realize that conservatives have used unmanaged world trade to destroy working-class incomes. However, only a relatively few realize the extent to which the same strategy is now being applied to professionals and skilled workers. So far, it has only affected

- those whose entire departments have been contracted out to other countries,
- those who have become "temporary" employees,

82

- those who got downsized in cost reduction efforts and have had to enter the job market again as a "new hire," and
- those who get relatively small salary increases at their own level, even in companies making record profits.

It will probably take a major economic downturn to make believers out of the rest of our presently well-paid skilled workers. But it is surely going to happen. Conservatives have bloated our population with far too many people chasing too much economic growth in a finite world.

Just what are our politicians going to do when multiple levels of our citizens—and millions of new immigrants—suddenly discover they cannot maintain their present life-styles within our nation's borders?

Still to come is voter realization that conservatives have also done their very best to destroy one of the most important protections of working Americans at all levels—unions.

7.

All Power to Investors; Absolutely None for Workers

If lying is a sin, most Republicans are surely going to hell—for saying that unions are bad for workers. They deliberately distort reality when they claim that union members are worse off than nonunion because:

1. Union members have to pay their own money (dues) to the unions that represent them.
2. Union leaders are interested only in their own incomes and not in the workers' welfare.
3. Union dues are used to support political candidates that some members may not support.
4. Workers would lose their "right to work" if they had refused to join a union in the first place.

Of course, it is true that:

1. Union members pay dues. They have to because it costs money to protect the interests of workers—to hire lawyers, gain public support, research the issues, finance a strike, etc. Whereas companies have almost unlimited resources to fight against the interests of workers—unions have virtually no financial resources to defend their interests, except for dues.

2. It's unfortunate, but true: Some union leaders are selfish and interested only in their own welfare. But the same can be said about executives in corporations, officers in the military and clergymen in the church. Any large human organization is going to have corrupt persons in it. But still, unions are the only organizations specifically dedicated to protecting the interests of workers.

3. It's also true that union dues are used to support specific political candidates. If workers' interests are to be represented in Congress, even a little bit, funds must be raised to fight the conservative politicians that free-spending corporations have already bought off.

4. When all workers in a company must join a union because the majority voted for its representation, it doesn't mean that some workers lose their "right to work." It just means that the lackeys of management who don't want to pay union dues—yet, by law, still receive all the benefits of a union—lose the right to destroy their coworkers' collective bargaining power.

If working Americans don't have collective power, they have no power. Because of conservative anti-labor legislation and the appointment of conservative judges to the courts, American corporations have been able to ensure that there is always a supply of hungry unemployed workers who will sabotage the efforts of those who have guts enough to unite and demand something more than a poverty wage.

The only reason working Americans experienced wage growth and improving working conditions from the late 1930s to the mid-1970s was that they had power. The increase in wages during those good years were not:

- The result of a growing economy (which we also have had for the past 20 years of stagnating wages).
- The result of growing productivity (again, which we also have had for the past 20 years).
- The result of increasing work skills (workers also have been developing their skills over the past 20 years).
- The result of low taxes on the wealthy (to the contrary, taxes on the wealthy from the 1930s and prior to 1982 were the *highest* in our nation's history).

It's only because working Americans had *power* between the mid-'30s and the mid-'70s, that they were able to form strong unions and, as a result, had significant clout with Congress. Through legislation, unions were able to get the 40-hour workweek, the 8-hour workday, overtime pay, medical insurance, pension benefit protection, and a host of safety protections in the workplace—for *all* workers, non-union as well.

Even today, after 20 years of Republican attacks on unions—and their resulting declining power—union members still make more money than nonunion workers. According to the Bureau of Labor Statistics, in 1998 union members' total compensation in private industry was $23.59 per hour; non-union workers was just $17.80.[1] What makes these figures even more significant is that the incomes of non-union workers would be even lower than they are now if it were not for the upward pressures that unions exert on all wages.

For the real reasons financial conservatives are against unions, read the following pages. Their own words, in their most prestigious conservative financial publications, prove beyond any doubt that

- unions protect their members from the predatory instincts of investors and corporate executives, and
- unions cause the wages and working conditions to improve even in nonunion corporations and businesses.

Of course, conservatives deliberately hide these observations when they communicate about unions for widespread consumption. For a classic study of demagoguery, no publication quite matches the editorial pages of *The Wall Street Journal* when it discusses unions. Under the head "Time to End Compulsory Unionism," the *Journal* opined that

> The political power brandished by the union hierarchy grows directly from the federally sanctioned privilege of compelling millions of Americans to accept union "representation" they do not want, and then to pay billions of dollars into union treasuries, or be fired.[2]

The *Journal* then went on to attack the Republicans who opposed a National Right to Work Act, which would have repealed "the few lines of federal law that make compulsory unionism possible."

Collective bargaining is the worker's only source of power. And unions can't bargain collectively if corporations are able to import desperate people who will underbid those who insist on making decent wages:

- "Compulsory unionism" is actually the right of workers to unite and collectively bargain with corporations.
- Traditionally, those who did "not want union representation" were desperate workers who were willing to take the job of another worker—one who had guts enough to stand up for his or her rights.
- Most Republicans would love a "National Right to Work Act" because that would finish the job of destroying the unions. They would be able to pit worker-against-worker for the crumbs of employment throughout the entire U.S., and not just in the southern and western states that enacted "Right to Work" laws.

The True Conservative View of Unions

Conservatives betray what they really think about unions when they explain why wages are stagnating or working conditions are deteriorating. In reporting "Why Inflation Isn't Sprouting in Mr. Greenspan's Neighborhood," *Business Week* noted that "Puny pay gains among union members make it hard to see how any upward push on wages will gel among workers generally."[3]

Under the head "Shaking the Blue-Collar Blues," *Fortune* observed that

> Even many who stayed in manufacturing lost ground when they were squeezed out of lucrative union jobs, such as those in autos and steel. Columbia's Bloom says that in 1980 only 47% of high school graduates over 25 and 40% of dropouts held union jobs. By 1988 only 31% of graduates and 25% of dropouts were paying dues.
>
> As membership dwindles, union settlements no longer piled up wages at non-union shops. "The ethos that drove employers to treat workers more or less equally has weak-

ened," says Brookings Institution labor economist Gary Burtless. With competitive pressures growing, companies drove wages down.[4]

Contrary to its previous editorial, *The Wall Street Journal* lived up to professional journalism standards when it accurately described the deteriorating and unsafe job conditions for truck drivers, and why "Trucking Firms Find It Is a Struggle to Hire And Retain Drivers":

> What caused truck drivers' work lives to deteriorate, trucking executives say, is cost-cutting forced by intense competition. After deregulation opened truck routes to new entrants in 1980, carriers turned to cheaper, nonunion drivers and employed no-frills trucks.[5]

Compare these three articles with the previous *Wall Street Journal* editorial:

- Even *Business Week* recognized that when unions have power they can cause an "upward push on wages to gel among workers generally." In other words, even nonunion workers benefit from unions.
- The ultra-conservative *Fortune* considered union jobs to be "lucrative."
- Again, note that "union settlements" created upward pressures on "nonunion shops." As unions lost their power, and became less of a threat to nonunion employers, those employers felt less pressure to pay their own workers "more or less equally."
- And what caused the truck drivers' lives to "deteriorate"? Companies destroyed their unions. When workers lose their collective power—pay, working conditions, safety, you name it—it all deteriorates. If companies can save money by pitting individual workers against each other, no matter how unfair or immoral, they'll do it. If a class of worker is getting decent pay (union drivers)—then corporations will abandon them for whoever is desperate enough to work for less (nonunion drivers).

This deterioration in moral standards has been a conscious conservative strategy: Destroy workers' power to collectively bar-

gain—and, as *Business Week* explained under the head "Sweeney's Blitz," get at least two decades of wage stagnation and heightened inequality:

> Today, though, workers may be receptive to labor's renewed message, coming as it does after two decades of wage stagnation and heightened inequality. In the 1980s, for example, the 10-year average earnings of the bottom fifth of male wage-earners plunged by 34%. Now more than half of families say two members must work to make ends meet. And constant downsizing has chewed away at pay and job stability, even among professionals....
>
> If unions do regain power, Corporate America is certain to feel the squeeze. With just a tenth of private-sector employees in unions today, most employers have had a free hand to hold down labor costs. Reunionization would force up pay and benefits, which typically are 20% higher among union members....
>
> Globalization and the growth of services, too, will continue. Employers still have the upper hand in most unionization battles.[6]

In a rather comprehensive and succinct way, *Business Week* here summarized why conservatives hate unions, why conservative politicians enact anti-union legislation and appoint anti-worker judges to the courts, and what these actions have resulted in:

- Corporations and businesses have been able to achieve two decades of wage stagnation and heightened inequality.
- In our glorious Reagan '80s, the 10-year average earnings of the bottom fifth of male wage-earners plunged by 34%.
- More than half of families say that two members must work to make ends meet.
- Constant downsizing chewed away at pay and job stability, even among professionals.
- A flat-out admission: Corporate America was able to achieve these feats by, among other things, taking away union power—they've had a "free hand to hold down labor costs."

- Another F.O.A. (flat-out admission): If workers could unionize, it would force up pay and benefits, which typically are 20% higher among union members.

How clear can it be? The future of workers' pay, benefits and working conditions depends upon who controls our government: Anti-worker Republicans and conservative Democrats, or liberal Democrats and independent Populists. As usual, it's all about money and power, and right now Republicans and conservative Democrats have almost all of it.

Those who fail to appreciate the degenerating effects of anti-unionism should look at the new conservative model for capitalism as described by *The Wall Street Journal* under the head "Threat of Cheap Labor Abroad Complicates Decisions to Unionize":

> "You all knew what the job paid when you applied for it," Edward Hakim, president and co-owner of Monroe Manufacturing Corp., reminds about 200 workers—almost all earning around the minimum wage of $4.25 an hour—gathered on the plant floor. "There are no chains on your legs. You can go. Go ahead."
>
> Silence. Some look down. One woman, sitting at her machine, gnaws nervously on her knuckle. No one budges. "Listen," Mr. Hakim continues, "if I can't compete in America with American workers, I'll take your jobs overseas where we can be competitive!"[7]

The *Journal* went on to report that Monroe Corporation was able to gain market share by underpricing its competitors, who were mostly unionized and offered workers health plans, pensions, and unbelievably high wages of $7 to $9 an hour. In addition, Mr. Hakim told his workers that if they ever struck they would be permanently replaced, that the union was racist (the work force is predominantly black) and that his company was bankrupt.

But in an interview, Mr. Hakim said that Monroe was "strongly profitable, virtually debt-free," and that millions spent on new machines in the past two years "came straight out of profits."

When Republicans and conservative Democrats create conditions where workers cannot unionize—or if they are unionized and have no power:

- Workers must "agree" to whatever pay and working conditions our modern barbarians offer.
- The recurrent threat, and the theme of the last two decades: "I'll take your jobs overseas where we can be competitive!" Of course, "competitive" means that *workers* must compete (by sacrificing their incomes)—so that business owners and corporations can have outrageous profits.
- The conservative principle: Enable the barbarians to destroy work standards and pay levels, and thus lower costs for everyone. His "lower costs" force moral competitors to do the same or they lose market share and, eventually, go out of business. Result: Conditions and pay for all workers deteriorate.
- There are no moral restrictions on employers when they resist the efforts of workers to bargain collectively. Employers can threaten them with the loss of their jobs ("permanently replaced"), they can lie about the union being racist, and they can lie about their own financial condition.
- And the owner's increasing millions that came "straight out of profits" are irrelevant to workers' low pay and deplorable working conditions.

Lack of union power *always* results in lower wages and worse conditions for working Americans. Another *Journal* article, under the head "With Housing Strong, Builders Often Find Skilled Help Lacking," reported that

> But during the 1970s and 1980s, those traditions [well-paid construction jobs] began eroding as major corporations and other customers, in a quest for lower building costs, awarded more jobs to non-union contractors.
>
> As unions' market share dwindled, cutthroat competition among such firms drove down wages. In some regions, especially the right-to-work Southwest, construction wages fell even further for experienced workers, into the $12-to-$15-an-hour range with no benefits.

By last year, even the Associated Builders and Contractors, whose members are primarily nonunion, was sounding the alarm. In one newsletter, Mr. Bennett, the trade-group executive, wrote that many construction workers could no longer afford homes or health insurance.... "When you squash down, year after year, on wages, you don't attract a good person into the industry," he observes.[8]

Although the subject here was union *versus* nonunion, remember the issue that is always in the background: The workers who lost jobs in manufacturing immediately become competitors for construction jobs, especially the nonunion jobs. Conservatives are pitting worker against worker from *many* directions. It's automatic:

- As unions' market share dwindles, cutthroat competition becomes the norm and the downward spiral of wages is assured. Workers at nonunion companies see that union sympathizers are fired with impunity, and there are plenty of workers who are desperate enough to work without a union contract.
- This excerpt is a classic illustration of why Republicans love "right to work" laws. Wherever unions are weak, employers have virtually all of the power. Even experienced workers must compete with each other for the constantly lowering levels of pay and benefits, or no benefits.
- Conservatives sometimes go too far. In this case, even nonunion construction workers began to lose their enthusiasm for work when the pay was so low that they could "no longer afford homes or health insurance."
- What an admission: The people who loudly proclaim that unions are bad for workers are the same ones who cynically "squash down, year after year, on wages" when they know workers are defenseless.

Under the head "Inequality," England's prestigious conservative financial publication, *The Economist*, gave its analysis of why the rich got richer, and the poor got poorer in the '80s:

All countries have been buffeted by the forces of changing technology and stronger global competition. So why should wage differentials in most of continental Europe have changed by much less?

The answer is that deregulation in America and Britain has allowed market forces to do their work, whereas in continental Europe powerful trade unions, centralized wage bargaining and high minimum wages have propped up the wages of the low-paid.

Indeed, pay differentials narrowed through the 1980s in western Germany, where trade-union membership has held steady at around 40% of workers over the past 20 years; in America, membership has fallen from 30% to 12% since 1970. A study by Richard Freeman of Harvard University confirms that, in general, wage inequalities are smallest in highly unionised countries.[9]

Again, a conservative publication tells us that global "free trade" and weakened unions are major reasons for the income and wealth disparity between the rich and everyone else. A "lightly regulated labour market" means that the government has given corporations the freedom to ruthlessly control wages and working conditions.

Republicans have convinced working Americans that the biggest reason they are losing the race with inflation is that the government is taxing them too much. It's true that conservatives have shifted the tax burdens from the rich to middle- and low-income Americans.

But, as *The Economist* points out:

- The major reason for the wealth disparity between rich and poor is "wage differential." Not surprisingly—and despite Republicans blaming the financial problems of the poor and middle class on taxes—*income* is the primary determinant of financial health.
- "Market forces doing their work" in America and Britain means that conservative politicians passed laws that gave corporations the power to relentlessly control those forces.
- The governments in continental Europe, on the other hand, allowed workers to organize ("powerful trade unions"), to bargain collectively ("centralized wage bargaining"), and to insist on "high minimum wages" for workers.

• Want more proof that unions help minimize income and wealth disparity? *The Economist* gives it, *via* Harvard University: "Wage inequalities are smallest in highly unionised countries."

Today's Union Members

Look at who's organizing today. Under the head "Joe Hill Takes On Joe College," *Business Week* noted that college professors and students are "feeling squeezed" and are turning to unions:

> And as old definitions of teacher and student change, profs and grad students alike are turning to unions for help in keeping up salaries and benefits and negotiating job security. About 40% of all faculty are organized today, up from about a third in 1982, making higher education a key growth area for white-collar union organizing....
>
> So far, most of the activity has occurred at public universities, where state laws make unionization easier. Now, the trend could spread to private universities as well—at least among graduate students (federal law largely prevents unionization by professors at private universities).[10]

The Wall Street Journal also cited a traditionally conservative group that experienced a surprising change of heart in its attitudes toward unions. Under the head "Doctors' Union Interests Become a Spreading Syndrome," the *Journal* described how some of the most powerful professionals in the country suddenly found collective power to be necessary:

> About 2,100 doctors, part of doctor-owned MDNY Healthcare Inc. on New York's Long Island, affiliate with the Office and professional Employees International Union, which already represents 8,000 podiatrists in Northeastern states.
>
> "There's no doubt that physicians' interests in unions are rising across the country," says Dr. William Mahood, a trustee of the American Medical Association.[11]

The new conservative values of corporations—greed and materialism, to the exclusion of virtually all other values—have only one antidote: employee collective bargaining power:

- In universities, the administrators, athletic coaches, and funded "stars" get unending raises in their incomes. On the other hand, those who do the intended work of the university, professors and grad students, must turn to unions to protect their "salaries and benefits and job security."
- Whether or not anyone can organize depends upon the laws in effect. Right-to-work laws and the "federal laws governing private universities" are conservative tools to destroy collective bargaining rights, and to give all the power to investors and their administrators.
- Doctors—traditionally a very conservative group—are beginning to see how the philosophy of greed and materialism will impact their professional standards. At this point, doctors' concerns appear to be less about wages than about doing the work of their profession. They are finding out that when cost cutting becomes the dominant criterion of managers and their investors, profit becomes more important than the original purpose of the organization.

In both cases—professors and doctors—the ones who are committed to doing the intended work of the organization are the ones who must make all the sacrifices. Those who profit most are those with the power: administrators, bosses, and investors.

America's Third-World Values

It's a shame what has happened to our country. The U.S., traditionally a leader in the moral treatment of workers, is now the world leader of greed and materialism. *The Wall Street Journal* inadvertently highlighted what is happening as the United States sells-out its workers. Under the head "In Employment Policy, America and Europe Make a Sharp Contrast," it explained that "U.S. spawns jobs, but often ill-paid; Germany offers high pay, few openings":

> Although there are poorly paid workers everywhere, only the U.S. tolerates having millions of its people accurately

classified as "the working poor." On the other hand, chronic unemployment is an enormous problem in Europe but less of one in the U.S.

Thus, in confronting a common problem—waning demand for low-skilled workers—the U.S. and Continental Europe have responded in very different ways.

The U.S. creates lots of jobs. But by weakening unions and failing to adjust the minimum wage for inflation, it has allowed the wages of those at the bottom to fall. The result is companies that are more globally competitive, but also a widening gap between rich and poor and an uncomfortably large number of workers living in or near poverty.[12]

Continental Europe is now the defender of the values of fairness and justice for workers, and the United States has become one of its major anti-worker antagonists:

- The *Journal* subhead, "Spawns jobs, but often ill-paid; Germany offers high pay, few openings," indicates that Germany and Continental Europe are losing the "jobs war." Does that mean that the U.S. is doing it right?

- No, the opposite is true: *The United States is the one that sold out its workers.* The U.S.—along with such morally principled countries as Indonesia, Guatemala, Mexico, China, Haiti, and other Third World countries—undercut the moral positions of the governments of Germany and Continental Europe in order to rob them of their exportable jobs.

- It's the same old story: Immoral businesspersons—or countries—will drive moral persons, or countries, out of the job market. When greed and materialism are the only criteria, anything goes. Those who most brutalize workers get the jobs.

- The *Journal*'s observation that "By weakening unions and failing to adjust the minimum wage for inflation, (the U.S.) has *allowed* the wages of those at the bottom to fall"—isn't the half of it. Republicans and conservative Democrat politicians *deliberately caused* wages to fall! And destroying unions was a significant part of their strategy.

Although President Clinton has, by and large, betrayed his populist supporters, in some cases "The White House" has attempted to defend the rights of working Americans against the Republican onslaught. It proposed new rules that would allow the government to reject contract bids from companies with unsatisfactory employment practices, and would bar the government from reimbursing contractors for the costs of fighting off union organizing drives. *The Wall Street Journal* reported that the "White House Plans Rules for Firms To Protect Unions":

> In a nod to organized labor, the Clinton administration will issue new guidelines requiring companies doing business with the government to maintain good relations with their workers and the unions that represent them....
>
> At the U.S. Chamber of Commerce, Jeffrey H. Joseph, vice president for domestic policy, said the new rules almost certainly would raise the ire of congressional Republicans. "Obviously, the Congress is not going to stand still for this kind of stuff," he said. "It's just like trying to hang out a red flag in front of a bull."[13]

Working Americans should read *The Wall Street Journal* every day. It's a textbook illustration of conservative propaganda techniques, and it clearly describes which politicians actually fight for their rights. According to the *Journal*:

- Protecting workers is never "protecting workers," it is a "nod to organized labor." This automatically leads the reader to react emotionally to union "bosses," dues, and all the other phony distractions that have been created by the Republican right wing.

- Do congressional Republicans believe that companies should be able to have an unsatisfactory record of employment practices— and still get government contracts? Of course they do. Because then, unscrupulous businesses, by ruthlessly cutting labor costs, will either get all the government contracts, *or* they will drive down wages generally. Either way, our richest citizens will save on taxes and wages—and the only persons to suffer will be the workers.

- The *Journal* and the Republicans not only want to allow unscrupulous businesses to get government contracts, they want to have the government finance their fights with the unions!

One would think that the massive leverage corporations now have over unions would allow them to relax a bit their hell-bent single-minded urge to totally destroy them. Sadly, not so. In a commentary for *Business Week*, Aaron Bernstein updated the 1999 conditions for union certification, and explained why "unions only win half the elections held at private companies, but are voted in 85% of the time by public-sector employees":

> What is the probable cause? The increasing use of anti-union tactics by private employers. According to analyses of data from the National Labor Relations Board (NLRB) by labor researcher Kate Bronfenbrenner of Cornell University, companies are increasingly using every weapon—legal or not—to thwart attempts to organize their workers.
>
> A third of the companies in the NLRB study illegally fired union supporters during elections, Bronfenbrenner found. That was up from a mere 8% in the 1960s. Half threatened to close facilities if the union won...[14]

American corporations have found—after over 20 years of conservative legislation and the appointments of conservative judges to the courts—that present pro-labor laws have no teeth, and the courts are decidedly biased in favor of business. The penalties for firing union sympathizers are incidental and quite affordable, and the new free trade laws allow them to threaten workers with impunity.

Even with their severely reduced power, unions are still feared by America's conservatives—and their publicly stated fears prove the positive effects that unions still have on workers' lives. In September, 1999, *Barron's* was still warning its readers about how unions might increase wages:

> Then there are the recent rumblings on the organized labor front. After years of defeat and paltry wage gains, some unions are winning hefty pay increases, raising the specter

that our historically tight employment markets may finally cause wage inflation.

In one marquee-caliber victory, machinists at Boeing won a 10% bonus and annual salary increases of 4% for two years and 3% in the third year. In another, Northwest Airlines offered flight attendants pay raises averaging 25% over five years and an average 80% boost in pension benefits.[15]

The articles quoted in this chapter represent a tiny fraction of hundreds of similar articles that explain why the Fed doesn't have to raise the prime interest rate to keep wages from going up. In almost every case, the weakening of unions is listed as a major cause of wage stagnation and the deterioration of worker protections—and the record corporate profits—for the past 20 years.

While conservatives delight in their victory over American workers, they are often remarkably frank in admitting the unfairness of it all—"years of paltry wage gains." They chalk it up to the nature of free markets, totally ignoring the fact that they strictly control those markets.

Despite the fact that conservatives and their corporations have gained overwhelming power over unions, our "family values" Republicans in Congress continue to attempt to further weaken the power of workers to collectively bargain for fairer pay and more humane working conditions.

Now it's time to look at the results of the conservative attacks on working Americans that were described in this and the previous six chapters: the victimization of American workers.

8.

The Victimization of American Workers and the New American Morality

Beginning in the 1930s, and into the '40s, '50s, '60s, and '70s, working Americans had some semblance of power because unions were gaining strength, trade with other countries was managed so as to protect American jobs from unfair labor competition, and in the U.S., greed was still considered a vice and fairness a virtue.

Since workers had power, investors—through their corporate executives—had to get what they wanted from workers by persuasion and by making promises. They said:

- Work with us.
- Be loyal to us and we will be loyal to you.
- Give us your best ideas.
- Help us develop our technologies.
- Make us more productive and profitable.
- Make this nation the best in the world.
- We will enter a new era together, in which
 * you will share in our prosperity,
 * wealth will "trickle down" to you,
 * we will all be better off, and
 * technology will free us all from drudgery, give us more time for recreation, self-development, education, and quality family time.

These promises appeared genuine. After all, during those years most persons considered the U.S. to be a Christian nation with high moral standards. You can trust people with high moral standards, so American workers cooperated and made this country the most competitive and most prosperous in the world.

Workers mined the metals, made the machinery, produced and serviced the products and sold them. They not only did all the "hands-on" labor, they willingly contributed their creative talents to give us the world-best production techniques and processes. What they didn't have in great abundance, however, was the money to buy politicians.

Wealthy investors *did* have the money. And by spending huge sums of it for propaganda, they began their rise to power. Republicans and conservative Democrats gained control of our government, and all their promises to workers—the people who built this country—were forgotten.

Once investors and corporate executives got control of the political process, their attitudes changed drastically. They didn't have to make false promises anymore. They could openly proclaim that:

- Fairness to workers is no longer a moral standard. All that counts is "the bottom-line"—profit for investors.
- Only investors and business owners have rights; workers and their communities have none.
- The cutthroat competitive environment for workers in the Third World is now the new standard for American workers also. To give this new standard a positive spin, modern management gurus call it "empowerment," which, of course, translates to "ferocious competition between individuals," both within this country and with other countries.

The materials to follow—from our most respected, conservative financial publications—clearly describe the conditions that Republicans and conservative Democrats now consider normal for many working Americans.

To their credit, most of these publications, *The Wall Street Journal* and *Business Week* especially, must have a few editors with the traditional journalistic standards for objectivity. Many news items, and a

rare editorial, sometimes suggest that unbridled capitalism simply doesn't work for the bottom 40% of America, and to some extent, even the bottom 80%.

For example, notice how *The Wall Street Journal* quoted an economist who said that "capitalism is getting meaner" in the way it keeps inflation low. The article, "Inflation Stays Low, with Aid of Some Luck," presented a somewhat soulless definition of luck:

> There is another explanation for the surprisingly small increase in wages: Workers are so traumatized by downsizing, outsourcing, layoffs and the waning power of unions that they aren't demanding raises.
>
> "Capitalism is getting meaner," suggests Princeton University economist Alan Blinder.... When shortages of entry-level workers and a higher minimum wage push up wages for some, employers may be stingier with raises for others.... And when given a choice, workers prefer job security to bigger paychecks.[1]

Again, in the *Journal's* view, outrageous corporate profits don't cause inflation—it's those damn working Americans who would like to make enough to support a family without having to work two jobs. But, American corporations have created a bit of "luck":

- Downsizing, outsourcing, layoffs and the waning power of unions have traumatized workers so much they are afraid of pressing for higher wages. Luck has nothing to do with it. Republicans and conservative Democrat politicians have deliberately brought about the conditions described in the first seven chapters of this book.
- Our country's values are different now. Conservatives have made "mean" synonymous with our new version of capitalism. Contrary to the way it was in the 1930s through the '70s, capitalism no longer considers manual labor to be worthy of a decent income.
- If you ever doubted the need for unions to defend the interests of working Americans, just look at what the *Journal* thought, with amazing frankness, about the sense of fairness of American employers: if employers have to raise minimum wages, they'll make it up by being "stingier with raises for others."

When corporations get meaner, they implement today's management philosophy: Let's cash in the value that employees have been building into the corporation since its beginning—and don't share *any* of the profit with them. *Business Week* described the trend-setting CEO Al Dunlap, known as "The Shredder":

> After less than two years' work [downsizing Scott Paper], Dunlap walked away with nearly $100 million in salary, bonus, stock gains, and other perks....
>
> Because Dunlap openly revels in his "Chainsaw" sobriquet and loudly trumpets his slashing tactics, he is helping change the norms of acceptable corporate behavior, argues Peter D. Cappelli, chairman of the management department at Wharton. "He is persuading others that shareholder value is the be-all and end-all. But Dunlap didn't create value. He redistributed income from the employees and the community to the shareholders...."
>
> "At the employee meetings, he spoke about building the company," recalls a former marketing executive. "But by the end of 1994, it just became a volume-driven plan to pretty up the place for sale."[2]

Nothing new here. Working Americans are the ones who create value and wealth. CEOs and wealthy investors merely suck it up. How much they are able to suck up depends on how much power they have and how little power the employees have. It isn't just Chainsaw Dunlap's employees who suffer from this kind of downsizing. It affects all employees who fear their own CEOs will do the same thing. It's the "insecurity" that Greenspan is so proud of. Note that

- Even if, even *if,* Dunlap did something that needed doing at Scott Paper, is anyone worth $100 million for two years' effort?
- Every management consultant in existence has come across managers who, in the words of former Scott Paper executives, "sacrificed the long-term health of the corporation" in order to reap personal gain.

- Dunlap isn't "helping change the norms of acceptable corporate behavior." Chief executive officers like Dunlap *already have* established the predominant norms for corporate behavior.
- It's the new fashion: To get workers' cooperation, the CEO promises them that they can count on him. Then, after they deliver what is requested—conditions mysteriously change—and new circumstances demand that he reluctantly sell them out.

Selling out employees can be discussed very cold-bloodedly. Many have forgotten, or never realized, that, at one time, most working-class women didn't have to work for their families to have a decent income. In one of its periodic paranoid analyses of the remote possibility that wages might go up, *Barron's* described the 50% increase of women in the labor force since the mid-1960s:

> Notwithstanding the impression given by September's employment numbers, the labor market is far tighter than is generally realized.... First, the steady increase in labor-force participation has flattened out. This is most notable among women, whose participation rate has plateaued at 60%, after having risen steadily from 40% in the mid-1960s....
>
> Corporations, for their part, are likely to hold labor costs in check in two ways. If compensation rises, they may well react with more staff cutbacks.... Alternatively, with the U.S. economy at full utilization of its resources, it could draw further on those abroad.[3]

When conservatives brag about the rise in average family income, they leave out the fact that there are far more two-earner families in our country. Dunlap's behavior and *Barron's* warning that too many Americans have jobs for the good of the stock market have several implications:

- Conservatives have always tried to create new sources of labor to compete with, and drive down the wages of, existing jobholders. One of the ways to do this has been to keep wages so low that both spouses had to work to make ends meet. Conservatives have put workers into a double bind: Women entering the workforce

create more competition—keeping wages low—yet those same low wages make it necessary for them to work in order to maintain their families' standards of living.

- Since that source of additional labor (women) may be drying up, an increase of a mere 1½% annual job growth rate might possibly cause wages to go up.
- But, *Barron's* consoled, there are other ways to stop wage increases that wouldn't affect corporate profits or a skyrocketing stock market. Corporations could just make "more staff cutbacks." With hundreds (thousands?) of Chainsaw Dunlaps out there, it should be easy to do.
- Or, if employment is as high as it can go without wages going up, corporations could just "draw further on those abroad"—ship more jobs overseas!

Of course, the victimization of working Americans isn't related just to job security and financial well-being. Actual working conditions are degenerating. Among the conservative financial press, *The Wall Street Journal* has probably done the best job of describing what it has called the consignment of "a large class of workers to a Dickensian time warp."[4] The following excerpts all came from separate articles on the front page of the *Journal*, and represent only a small sample of what could have been included:

In "These Six Growth Jobs Are Dull, Dead-End, Sometimes Dangerous; They Show How '90s Trends Can Make Work Grimmer for Unskilled Workers" the *Journal* described how jobs in six growing industries, such as chicken processing, environmental clean-up and nursing-homes, forced workers to work

> ...not just for meager wages but also under dehumanized and often dangerous conditions. Automation, which has liberated thousands from backbreaking drudgery, has created for others a new and insidious toil in many high-growth industries; work that is faster than ever before, subject to Orwellian control and electronic surveillance, and reduced to limited tasks that are numbingly repetitive, potentially crippling and stripped of any meaningful skills or the chance to develop them.[5]

"At Nordstrom Stores, Service Comes First—but at a big price; Retail Clerks Work Overtime for No Pay, Are Pressured to Meet Selling Quotas" described how Nordstrom Stores,

> ...renowned for its pampering of customers, expects its sales-clerks to work many hours without pay in an environment of constant pressure and harassment that incites employees to prey on each other, according to nearly 500 complaints filed with the workers' union and interviews with several dozen employees in stores from Seattle to Los Angeles.... Just as retail chains of all kinds—from Bloomingdale's to Macy's—are rushing to duplicate the Nordstrom commission system, the stories of unhappiness at the company are spreading.[6]

"A Town in Iowa Finds Big New Packing Plant Destroys Its Old Calm; Housing and Crime Become Headaches As IBP Hires Jobless from Far Away" describes how Columbus Junction, Iowa, discovered that corporate values can be destructive to "small-town values":

> Columbus Junction has learned that giant corporations can treat workers, and towns, like interchangeable parts.... The intangibles that defined the heartland town—stability and continuity—have begun to die. Since IBP came to town, crime is up 400%.... Junior-high and high-school pupil turnover hit 25% last semester alone.... The plant has become the tail that wags the dog.... "[It's] hard for anybody with a family to make a living at IBP, which is a pretty sad commentary," says the Rev. Stephen Ebel, a Catholic priest. Highly efficient and aggressively anti-union, IBP is driving older Iowa packing plants over the edge.[7]

"Once the 'Rust Belt,' Midwest Now Boasts Revitalized Factories; But Wages Tend to Be Low" punctures holes in the claim that the new world economy is good for workers because it creates jobs:

> The heartland's manufacturing renaissance comes at a price. The typical wage of $8.60 an hour at the reopened Cummins plant is half that at the company's main heavy-duty engine

plant in downtown Columbus.... In Milwaukee, Briggs & Stratton Corp. is threatening to move jobs south unless it gets additional breaks from its unionized workers.... Brooke Tuttle, president of the Columbus Economic Development Board, figures that the area has lost 5,700 jobs at the major employers that paid $12 to $15 an hour. At the same time, it has gained 6,000 new jobs, partly by promoting the wages of $6 to $8 an hour to business prospects. "You don't have to be a rocket scientist to know we're still losing our standard of living," Mr. Tuttle concedes.[8]

These excerpts were selected because they represent a cross-section of an entire genre of news items that document what is happening to workers and working conditions throughout the United States. Americans, especially those at the bottom 40% on the income scale, are forced to endure increasingly degenerating work and pay conditions. Not just in the retail industry, not just in chicken processing or the trucking industry—but in virtually every industry in which people do "hands on" work.

These and similar articles demonstrate that:

- Workers not only don't benefit from technology and automation—they suffer because of it. They now are more like machines than they were before—and they are expected to work even faster than before.
- "Corporate values are not necessarily small-town values." How about: modern corporate values aren't even traditional *American* values?
- Today, American workers and *towns* are treated like "interchangeable parts," again, like machinery. They are without rights, without souls, without futures—to be used up and discarded without a second thought.
- Corporate profits, not "stability and community," are now the controlling forces of society. A lack of a sense of community has always been associated with a rise in crime rates, divorces, drug use, and all kinds of social problems. Yet the leaders of our country choose to remain blind to the results of legislation that turns control of our society over to corporate executives who

107

have no moral standards—other than greed—to guide their behaviors.

- Corporations no longer serve the community; instead they become "the tail that wags the dog." The tail gets all the nourishment, the dog makes all the sacrifices.

- "Aggressively anti-union" companies will drive unionized companies with good wages and working conditions "over the edge"—if there are inadequate *national* protections of workers' rights to organize.

- The ultimate medical and psychological costs of creating working conditions that cause problems such as "ulcers, colitis, hives and hand tremors" are transferred to individual workers, and omitted from corporate profit-and-loss statements.

- Unscrupulous corporations drive moral corporations out of business if they don't also "rush to duplicate" their lower standards for the treatment of workers. It takes only one unprincipled corporation to cause the standards of an entire industry to degenerate.

- If local residents will not accept brutalizing work conditions, desperate people from other parts of the world will. By abandoning their communities, corporations repeatedly prove to the locals how unwise it is to expect to be treated like human beings.

The key, the indispensable element that caused this degenerating trend—is that Republicans and conservative Democrat politicians deliberately and consciously glorified the values inherent in a Dickensian mentality. They brag about how their policies have made our economy grow, made our corporations more productive and more profitable, and have benefited customers in the process.

However, they never talk about those who made all the sacrifices that were required to achieve these goals. Conservative "family values" have returned us to the work standards of Charles Dickens' 1800s—when the royalty of society lived like, well, *royalty*. And workers at the low end of society were treated less well than machines. (Employers took reasonable care of their machines.)

The infamous tobacco industry's moral standards of deceit, and their sanctimonious protestations of virtue, are now characteristic of corporate executives generally. How else could these practices be tolerated without any hint of complaint from the spokespersons for

American industry? Where is the U.S. Chamber of Commerce? Where is the National Association of Manufacturers? Where are the members of Personnel Associations all across the country? Where is the Christian Coalition?

The people who run these organizations read the *Journal*, as well as *Forbes, Fortune, Barron's* and *Business Week*, which also occasionally publish similar articles. They are unequivocally *not* members of "the biased liberal news media." The members of Congress also read these conservative financial publications. Yet Republican politicians resist every effort to protect workers in manual labor jobs. They know these things are going on! How can they *possibly* claim the "family values" label?

Republicans want "states' rights" because, without national standards, each state is forced to lower its standards for workers to the lowest possible level in order to compete with the least progressive state in the country.

By destroying what few national standards we have left—"giving power back to the states"—Republicans ensure that workers will eventually have *no* protections. This, in a nutshell, is the Republican strategy:

- Pit southern workers against northern workers,
- Pit non-union workers against union workers,
- Pit nonunion ("right-to-work") states against states that will allow workers to form unions—and if all that fails,
- Pit brutalized workers in other countries against working Americans.

And "you don't have to be a rocket scientist" to know that, as a planned result of all this, working Americans are losing their standard of living.

So, who changed our country into a nation that no longer values hands-on, non-investment, non-inheritance "work"? Read on.

9.

The Coalition from Workers' Hell: Republicans and Conservative Democrats

When Harry Truman campaigned for president in 1948, he beat a coalition of Republicans and rebellious southern conservative Democrats by asking voters: "How many times do you have to be hit on the head before you find out who's hitting you?"

Of course, he answered the question and won the election, despite the common assumption that conservatives had been able to convince voters that they would be better for the economy and, therefore, better for workers.

That same coalition had previously passed the Taft-Hartley Act in 1947 over President Truman's veto. Taft-Hartley allowed states to pass "right-to-work" laws, which made it almost impossible for unions to gain a foothold in them. The southern and western states that passed these anti-worker laws were then able to attract industry from other states that didn't offer corporations a union-free environment, with its guaranteed low wages and draconian working conditions.

Thus began the exodus of industry from the North to the South, and the degeneration of pay and working conditions in the North. This very same coalition, Republicans and conservative Democrats, has done it to workers again. NAFTA and GATT are today's equivalent of the Taft-Hartley Bill of 1947. Except now, the strategy of pitting workers from different states against each other has been extended to the world "free market." Apparently, today's voters have

been conned into believing that it is a good idea to pit workers of the world against American workers.

Clinton: A Moderate Republican

Truman also attacked Wall Street, and "the profiteers and the privileged class." "Those Republicans are cold men...they want a return of the Wall Street economic dictatorship." He referred to them as "selfish men who have always tried to skim the cream from our natural resources to satisfy their own greed."

Contrast the worker's spokesman, Truman, with President Clinton, the new Republican who won the presidency again in 1996. Since the Republicans also won Congress, the continued growth of the wealth and income gaps between the rich and middle-and-low-income Americans was assured.

Those who think it's a stretch to say that Clinton is a Republican should go to the November 7, 1996 issue of *The Wall Street Journal.* According to A.B. "Buzzy" Krongard, Chairman of the Securities Industry Association and head of Alex Brown, Inc.: "We have a great Republican president now."

In the same *Journal* article, read the opinion of Hardwick Simmons, Chief Executive Officer of Prudential Securities Inc.: "Here we are dead set in the center with a big long leash around President Clinton."

According to our number one daily conservative financial newspaper, voters wanted Clinton to balance the extreme tendencies of both the Republicans and the Democrats in Congress.

In other words, *The Wall Street Journal* and America's right wing have successfully changed our definitions of balance and moderation. Traditional "Eisenhower republicanism" (Clinton) is now considered moderation and is almost nonexistent in the Republican party. Traditional "Truman liberalism" is now considered extremist and is increasingly rare in the Democratic party.

This means that corporations, Republicans and conservative Democrats (i.e., "big money") have been able to convince the American voter that:

- Workers' wages are low, not because they lack power, but because they are uneducated and poorly trained, and our economy isn't growing fast enough.

- Labor unions are bad for workers, the economy and the country.
- Unmanaged free trade will eventually benefit all Americans.
- The growing wealth and income gap in our society is good because it is fair (the wealthy work harder, have more talent and better genes), and it will eventually benefit everyone.
- The more money our richest citizens take out of our corporations and our society—and invest overseas—the better off everyone will be.
- High taxes on our richest citizens are unfair and would cause the economy to slow down and would destroy jobs.
- And, in general, people who don't believe these absurdities are socialists or even worse.

If current trends continue, America's investors will continue to get richer, they will give even more money to their propagandistic think tanks, and America will continue its drift to the far right.

Always Two Parties in the South

Contrary to popular belief, there have always been two political parties in the South.[1] Prior to the 1960s, the two southern parties consisted of the "Bourbon" Democrats and the liberal Democrats. The Bourbon Democrats represented the interests of the land owners, the big farmers, the corporations and the wealthy in general.

The liberal Democrats represented the interests of working-class Americans and were more receptive to civil rights. The real election in the South was not the national election; it was the primary election when voters chose which kind of Democrat would represent the party.

In the '60s, to take advantage of southern resentment, Republicans correctly blamed civil rights legislation on liberal Democrats. To defend themselves against such attacks—even to *join* in the attacks—the Bourbon Democrats became Republicans and the national shift to conservatism began in earnest.

Not surprisingly, many of the liberal Democrats who supported civil rights lost their elections. By turning workers against the "biased liberal news media" (who were supposedly telling lies about the deplorable conditions for blacks in the South), "pointy-headed-

liberals," and the liberal Democrats who supported civil rights, conservatives were able to sweep the South.

Unfortunately, too many workers failed to realize that the politicians who fought for the rights of minorities were the same ones who had always fought for pro-worker legislation. Republicans and Bourbon Democrats—who had always supported anti-worker, pro-investor legislation—became the workers' newly adopted anti-civil-rights heroes.

As a result, many of today's southern Republicans used to be Bourbon Democrats, and many conservative "Democrats"—who never switched parties—are closet Republicans. They talk "worker" in their speeches, but they practice "wealthy investor" in their legislation and their policies.

In the areas of the financial markets, some aspects of big business and free world trade, Clinton is a classic example of a closet Republican. *The Wall Street Journal* reported on a meeting of frustrated Republicans who met in January, 1999 to seek "a message and a messenger":

> Imagine Republicans' funk. From all the states, party leaders have come here this weekend seeking a message and a messenger, only to find that the closest they can get is: President Clinton.
>
> "He has co-opted so much of our agenda," bemoans Michael Hellon, Arizona's state party chairman and member of the Republican National Committee. "You might say he's the most articulate spokesman we have for Republican issues."[2]

On other popular 1999 issues, such as the environment, worker health and safety, gun control, education, and social security, Clinton acts more like a traditional Democrat. For example, while he supports more funding for government programs such as OSHA, the Republicans continue their strong opposition. Under the head, "Business Groups and Allies in Congress Seek to Block OSHA Ergonomics Plan," *The Wall Street Journal* reported that:

> Mr. Ballenger, [R., NC] a business owner who heads a House subcommittee on workforce protection, said he and

other House Republicans would vigorously fight the OSHA plan unless "sound research" is presented to justify such a move....

From 1996 to 1998, congressional Republicans had passed spending restrictions prohibiting OSHA from studying, drafting or implementing an ergonomics standard.[3]

So, while the Republicans are, and it looks like they always will be, *totally* Republican—Clinton is wrong only half of the time. Of course, in the case of OSHA it was an easy slam-dunk for him to be a traditional Democrat. After all, OSHA was proposing the humane, moral, and economically sound protection of an estimated 25 million workers in production jobs, as well as an undetermined number of secretaries, data processors and others who work at keyboards.

And the Republicans—after having denied the agency funding for research, then opposed its ergonomics plan because of a lack of research—raised the standard for sanctimonious hypocrisy to a world-record high.

Still, despite their obvious anti-worker biases, Republicans and conservative Democrats dominate American politics. How they've been able to appeal to working-class voters and get them to vote against their own best interests is a classic study of the demagogic effectiveness of deliberately deceptive propaganda—and the subject of Part 2.

Part Two

The Conning of America

In his cheerful, confident, radical, professorial way, Gingrich explained that to do what he wanted, government first had to be completely discredited—ethically, programmatically, managerially, philosophically....

Once Washington-based government was totally discredited, hard-right conservatives could then sweep to power.[1]

—Richard Darman, George Bush's Budget Director, who also served under Nixon, Ford, and Reagan

10.

How Conservatives Lie with Statistics

Regardless of political ideology, the never-ending columnists and talking heads always seem to find data from impeccable sources to support their positions. With the constant barrage of arguments and statistics cascading upon the American public, no wonder people are cynical. Since claim and counter-claim on a given issue appear to be a toss-up, how can anybody judge one way or another?

Therein lies the great harm that well-financed propagandists do to our ability to solve national problems. When they deliberately distort the reality of what is happening in our society, many voters conclude that it is fruitless to make the effort to find out who is telling the truth and, as a result, drop out of the political process.

As people disengage from the political process, right wing conservatives fill the vacuum and get their favored politicians elected. It's a vicious cycle. With more conservatives in Congress, they are better able to further propagandize and confuse the public.

Conservatives also get vital help from well-financed think tanks like the American Enterprise Institute, the Heritage Foundation, the Free Congress Foundation, Empower America, the Hudson Institute, and a host of others. In addition, popular conservatives like Rush Limbaugh, Oliver North, and George Will breathe new life into the same old clichés that periodically have gotten us into trouble throughout our history: wealth trickles down, higher taxes on our richest citizens cause joblessness, wealth is not a zero-sum game, government regulations destroy the free market, unions are bad for workers—and on and on.

Just as the tobacco industry delayed the public's appreciation of the known dangers of tobacco for decades, financial conservatives are doing all they can to delay the public's appreciation of the disastrous effects of the past 20 years of ClintoReaganomics.

The Distorted Statistics of ClintoReaganomics

Understandably, most right-wing propagandists masquerade as journalists-with-principles and they can be found in virtually all the mainstream media. To demonstrate that fringe-element conservatives have infiltrated so-called moderate publications, this discussion will begin with Marc Levinson's *Newsweek* article headlined "Hey, You're Doing Great."[1]

He made a Herculean effort to demonstrate to the public that the 1980s were great for most people, and contended that middle-class Americans were doing better than they think. He claimed that "Three out of five Americans are in households that many experts consider middle class." But then he offered the most preposterous definition of "middle class" that one is apt to find.

To begin with, he defined middle class as those who were making between $25,000 and $100,000, which amounted to 53.8% of households. That certainly would be close to the percentage one would expect to represent the middle of any statistical distribution.

Problem is, that definition starts *above* the bottom 40.3% of Americans whose household income was under $25,000. And it says that persons would have had to make over $100,000—and be in the top 5.8% of households—to be above middle class. To give his contentions the aura of credibility, he pointed out that the basic data (but *not* the definition of middle class) came from the U.S. Census Bureau.

Levinson's "many experts"—and their tortured definition of middle class—could have come only from the paid hacks at one of America's right-wing think tanks. As soon as the U.S. Census Bureau releases such data, these unscrupulous mercenaries find ways to redefine them to fit their own political objectives.

So, to Levinson and his right-wing friends, the middle class extends from *above* the bottom 40.3% of Americans and *up to* the top 5.8%. With this one quick twist of a definition, they thus eliminated the top half of the bottom 40% of Americans from the middle-class category. With these perversions of data, the statistics for the "aver-

age" American look a lot better than the raw data from the Census Bureau would suggest.

Incredibly, Levinson's definition of "upper middle class" was from the top 12.5% of Americans to the top 5.8%, or from $75,000 to $100,000. This, at a time when the median income for all Americans was just $35,000.

Like the above, the most effective propaganda spins are the absurd conclusions based on accurate data. For another example, consider John Weicher, right-wing propagandist for the Hudson Institute, who demonstrated how to use accurate statistics to support misleading conclusions. Under the head "Getting Richer (At Different Rates)," Weicher admitted that the rich got richer when Reagan was president, but

> ...so did the middle class and the poor, to about the same extent....
>
> The surveys (by Federal Reserve Board) show, first of all, a huge increase in the total real wealth of American households (from 1983 to 1989)—to $16.8 trillion in 1989 from $12.7 trillion in 1983. The wealth of the average household rose by about 20%, to $181,000 from $151,000.... Average wealth increased for every type of household except one—single women with children....
>
> (Table: Married couples with children saw their income go up 33%, from $132,100 to $175,100 between 1983 to 1989. Single women with children saw income decline from $36,200 to $32,200.)
>
> Did the rich get richer and the poor get poorer during the Reagan years? No, or at least not much, if at all. The distribution of wealth hardly changed.[2]

As soon as unfavorable news (growing income disparity) hits the media, conservative think tanks start damage control—and suddenly, remarkably creative analyses appear in conservative financial publications. This is how you distort data effectively, while telling a literal truth:

• Use a reputable source: The Federal Reserve Board, the Labor Department or the Census Bureau.

- Distract the reader with some very favorable news that has nothing to do with the premise: rising *average* income based on the total income of *all* persons.
- Make your conclusions more believable by citing the exception—the lowered median income of single mothers with children (understandably, irresponsible people of low morals).
- Analyze data in a way that has nothing to do with how the income was distributed *between* the rich and poor in each category. Sure, average income increased in the categories of total wealth, income of married people, and income of single people—but *most* of the increase came at the top of the distribution in each category, while income at the bottom of each category decreased or remained the same.

Michael Novak, right-wing hatchet man for the American Enterprise Institute, also demonstrated how conservatives can creatively report statistics. He asked the question, "Middle-class 'meltdown'?," and made the erroneous contention that "The simplest way to test the thesis that the middle class declined in the 1980s is to check what happened to median income."[3]

Novak used Census Bureau data to claim that

> ...real incomes of every class of Americans went up during the 1980s....
>
> As Reagan took over in 1981, the median income for American households was $26,251, as measured by the Census Bureau in 1989 inflation-adjusted dollars. By the same measure, the median income in 1989 was $2,655 higher, or $28,906....
>
> Each of the four lowest fifth (of families) showed higher income in 1988 than in 1980. The top limit of the lowest fifth jumped (in constant 1988 dollars) from $14,767 to $15,102; of the second lowest, from $24,966 to $26,182; of the third, from $35,361 to $38,500; and of the fourth, from $49,580 to $55,906.[4]

Although a median statistic tells you what happened at the exact middle of a category, it tells you absolutely nothing about what happened at each end. The shrinking of the middle class consisted of the

middle-class-rich getting richer, and the middle-class-poor getting poorer—with the median increasing slightly. Novak's data are not only irrelevant, they totally distort the reality of the issue being discussed.

Notice that Novak then selected the rising top limit of each distribution to expand his point. In each category, the bottom limit undoubtedly remained the same or went down, but we can't tell because Novak chose to keep that data to himself.

Also note that the increase in income for the *highest* of our lowest paid workers "jumped" only $335. That's just a bit more than 2% over an *eight-year* period!

On the other hand, the increase for the next-to-the-top income category, from $49,580 to $55,906, was a much more substantial $6,326, almost 13%. Novak chose not to report the change in incomes of the top fifth of income earners—the real champions in the earnings race. Now, why would he do that? As everyone now knows, that increase was very impressive indeed.

The Reality of ClintoReaganomic Statistics

In 1994, *Business Week* compared the incomes of rich and poor in a way that actually added to our understanding of the economics of the '80s. The article, "Inequality," demonstrated how income inequality becomes obvious when you actually compare top earners with bottom earners, instead of just looking at distorted averages or medians:

> …import competition and the decline of unions have left families in the bottom quarter—whose breadwinners often dropped out or stopped after high school and earn less than $22,000—stranded in low-wage limbo.
>
> This has led to the widest rich-poor gap since the Census Bureau began keeping track in 1947: Top-fifth families now rake in 44.6% of U.S. income, vs. 4.4% for the bottom fifth. As recently as 1980, the top got 41.6%, the bottom 5.1%.
>
> Even as a good education has become the litmus test in the job market, moreover, the widening wage chasm has made it harder for lower-income people to get to college. Kids from the top quarter have had no problem: 76% earn

bachelor's degrees today, vs. 31% in 1980. But less than 4% of those in bottom-quarter families now finish college, vs. 6% then.[5]

By the time of this article, the growing disparity in income and wealth between rich and poor had become an obvious and accepted reality. Prior to that, and all during the 1980s, conservative commentators did everything they could to delay this understanding by the American public:

- Although inequality began expanding in the late 1970s, it exploded in the 1980s, and it has been expanding ever since.
- Again, a conservative financial publication cited unmanaged world trade and the decline of unions as major causes of the income decline of American workers.
- The rich-poor gap has been growing and is the biggest since the Census Bureau began keeping track of it. This was an unvarnished, no smoke, no mirrors, presentation of Census Bureau data.
- Between 1980 and 1992, the number of children in the top quarter who got bachelor's degrees more than doubled, from 31% to 76%. In the bottom quarter, the number went down by a third from 6% to 4%. This is a truly meaningful way to compare the effects of income disparity between top and bottom.

Three years after the *Business Week* article, there were some indications that the growing economy might still cause wages to go up. Indeed, for an almost optimistic report in 1997, look at how *The Wall Street Journal* described its interpretation of "how the economic expansion is indeed filtering down to the average consumer's pocketbook." Under the upbeat headline "Household Income Rose Again in 1996," the subhead told the real story: "Poverty Rate, Income Inequality Were About the Same." Its understated conclusion put things into proper perspective, as far as the working poor and the middle-class were concerned:

The Census Bureau's annual poverty and income report also showed that the number of Americans living in poverty last year was about the same as in 1995 and that income inequality didn't shift for the better.... So why

didn't the poverty rate improve, despite the increase in median earnings? Because the wealthiest Americans grabbed most of the income gains. Average income for the poorest 20% of the population slid 1.8% in 1996, while average earnings for the wealthiest 20% climbed 2.2%....

Indeed, Americans didn't divide the fruits of prosperity any better last year than in 1995. The wealthiest 20% of Americans were raking in nearly half of all household income, about the same as in 1995. That is nowhere near sharing the pot equally, but it is better than in previous years, when the rich grabbed increasingly larger shares at the expense of the poor and middle class.[6]

This headline and subhead demonstrate the chronic two-faced nature of conservative economics: average incomes keep going up, but, surprise, poverty and income inequality stay the same or get worse:

- The nature of the statistics that financial conservatives like to brag about continued from the late 1970s to 1997: *Median* incomes kept going up.
- But there was no change in income inequality.
- In fact, as of 1997, the poorest 20% were worse off than for the year before—by 1.8%—again.
- Talk about "redistribution of wealth." Usually it's Republicans complaining that Democrats want to transfer wealth from rich to poor. Obviously, that hasn't been a problem for the past 25 years, in which the rich have been grabbing wealth from the poor and middle class.

Two years later, in September, 1999, the trend was continuing. *Business Week* asked the question, "The economy is booming, profits are soaring—so why isn't everyone riding high?" Under the head, "The Prosperity Gap," it distinguished between the "new economy" and the "old economy":

If you stay at a job in an Old Economy industry, you are destined to become relatively poorer and poorer in a richer

and richer society.... Compared with 1988, real wages are down by 4.5% in Old Economy industries....

Indeed, based on current trends, the wage gap between New Economy and Old Economy workers seems likely to widen for years to come....

The latest data show wage increases actually decelerating across much of the economy, outside the New Economy industries.[7]

Of course, workers in the "Old Economy" industries are the ones described in Part 1 of this book—the ones that conservatives sold out to investors. Workers in the "New Economy" are in industries that are still growing and that haven't yet been hit by the kind of ruthless competition that has been forced on Old Economy workers. (But their day is coming.)

Business Week wasn't covering any new ground here, except to update the income and wealth disparity problem, and to clarify the segments of the society that are most affected. Similar articles were being published regularly in the mainstream press.

When articles like this come out, it triggers an automatic response from the right-wing cranks in charge of damage control. Edwin Rubenstein (research director of the Hudson Institute) was remarkably open about his desire to reduce any feelings of guilt in the readers of *Forbes*. In his article, "Inequality," he went through incredible gyrations to demonstrate that it really wasn't a problem that anyone should feel guilty about:

> There it was in the Oct. 1 *Wall Street Journal*: A chart demonstrating that income inequality has been rising in the U.S. The chart said that the highest quintile (which it defined as a fifth of the population) commands 49.2% of the nation's household income, compared with 3.6% for the lowest quintile....
>
> Taken raw, the income statistics could certainly induce guilt among readers of the *Journal* or of *Forbes*, since they tend to fall in the high-quintile group....[8]

Rubenstein went on to make the most absurd rationalizations about why "the raw income numbers exaggerate inequality":

124

- The Census Bureau quintiles represented not fifths of the population but fifths of the total count of households, and well-off households have more people in them than poor households.
- The more affluent half of the population works more hours than the less affluent.
- The poor get health benefits and non-cash government transfers like food stamps.
- The rich pay higher taxes.

These selective interpretations of facts are literally true, but they are used to confuse the issue of income disparity—to the point where the readers of *Forbes* can feel justified in dismissing more down-to-earth interpretations of contradictory facts.

Again, outright lies are relatively rare in our most respected mainstream conservative publications. It's the deliberate misinterpretation of reality that is the culprit. This is why the public needs to be forewarned that Republicans always try to cut the funding of our best sources of objective financial information, under the pretense of "getting government out of our lives."

In 1996, *Scientific American* alerted the American public that the Republican Congress wanted our government to be, as the headline stated, "Flying Blind":

> In an era when Congress may ask schoolchildren to skip lunch to help balance the budget, it sounds eminently reasonable that bureaucrats at arcane federal agencies such as the Bureau of Economic Analysis (BEA) or the Bureau of Labor Statistics (BLS) should share in the general pain.
>
> The same logic might lead a skipper trying to lighten an overburdened ship in the middle of the ocean to jettison sextant, chronometer and compass. Economists worry that, without social science data to measure their effects there may be no way to tell whether the various policy experiments now being enacted are succeeding or failing.
>
> The status of U.S. economic statistics is already "precarious," says Alan B. Krueger of Princeton University. He notes that the BLS has reduced the size of its statistical samples (thus compromising accuracy) and dropped many kinds of data entirely. Even such seemingly basic informa-

tion as manufacturing turnover—the rate at which people quit factory jobs and companies hire replacements—is no longer available....

If proposed House and Senate budget cuts go through, international price, wage and productivity comparisons will have to be scrapped, forcing U.S. policymakers to rely on dead reckoning when they try to compare domestic workers with their European or Asian counterparts.[9]

The Bureau of Economic Analysis and the Bureau of Labor Statistics are two of our best sources of objective, comprehensive information about what is going on in our economy. So why do the Republicans in Congress want to cut their funding?

Simple. Less accurate economic and labor data would cut the workload of conservative think tanks. They wouldn't have to go through such hypocritical gyrations to explain away the bad news about the failures of their economic experiments on working Americans.

For example, "manufacturing turnover," and "international price, wage and productivity comparisons," among other basic data, are embarrassing and hard to explain away for those who claim that the rising economic tide will lift all boats.

When "dead reckoning" is all the public has to go on, the highly financed marketing of special interest distortions-of-reality holds sway over unavailable facts and common sense. And when money is more persuasive than reason, conservative think tanks and their politicians win more elections.

Now, check out how Republicans can be exceptionally creative when they talk about taxes.

11.

Taxes, and the 1993
Lesson in Econ. 101

When conservatives argue that raising taxes on rich people is bad for the economy or that it costs jobs, don't make the usual responses that the country needs the money, the rich can afford it, and it won't hurt them as much.

Republicans like Bill Archer, Phil Gramm, Dick Armey, Trent Lott, Tom Kasich, and the general run of right-wing spin-doctors love to attack reasons like these. It gives them an opening to criticize higher taxes on the rich as a matter of fairness, since the wealthy already pay so much more tax than poor people do. Their hypocrisy knows no bounds.

It would be much better to point out that our richest citizens have benefited the most from the economic policies of the past 20 years. The wealthy not only *caused* these policies, but they knowingly *forced huge sacrifices* on working Americans as a result of them.

It's only fair that they return to society, in the form of tax payments, some of the money they extracted from the incomes of working Americans and to compensate, at least a little, for the deplorable working conditions that resulted from their skullduggery.

Then point out that never in recent history has raw greed been so richly rewarded. Between 1942 and 1962, the income tax rate for our richest citizens was at least 88%, and as high as 91%. It's no accident that this was probably the most prosperous period in our nation's history for working-class Americans.

In those days, when a CEO considered firing thousands of workers for a million-dollar bonus, the moral condemnation didn't seem to be worth it. After taxes, the bonus amounted to, say, only $120,000.

Today, when a CEO fires thousands of workers, he gets a ten million-dollar bonus and he gets to keep five million of it. Suddenly we're talking serious money here. When he retires he can move to one of our country's guarded communities—with his millionaire cronies—and he gets virtually no moral condemnation from his golfing buddies.

We need to go back to the tax rates we had for our richest citizens between 1942 and 1962. Or, we could go to the rates we had from 1962 to 1982, when it was at least 70%. Those weren't the best of times for workers but they were a hell of a lot better than the 1980s and '90s.

And by the way, over that period of forty years between '42 and '82, none of the bad things that conservatives warn about happened. We didn't have massive unemployment, we didn't stifle innovation or economic growth, and, above all, we didn't become communists.

Of course, history, facts, and reason mean little to modern conservatives. Just look at how the Republicans deceived the public about the 1993 deficit reduction package and what they said it would do to the economy. Even *The Wall Street Journal* couldn't avoid describing how the Republicans "misled" the public about it.

Under the head, "A Vote for Clinton's Economic Program Becomes the Platform for Often-Misleading GOP Attacks," the *Journal* explained that

> Contrary to Republican claims, the 1993 package with a $240 billion tax increase is not "the largest tax increase in history...." Moreover, except for a small gasoline-tax boost and an increase for the best-off Social Security recipients, the tax increases in last year's bill mostly didn't touch the middle class but hit the wealthiest 1.2% of Americans.
>
> GOP candidates also ignore the bill's tax cuts for individuals and businesses, and nowhere do they describe the plan as a $433 billion, five-year deficit-reduction package.[1]

"Often-Misleading GOP Attacks." That's about as close as the *Journal* will ever come to calling Republicans liars. "Contrary to Republican claims" is another way of saying the same thing.

Not only was the 1993 package not the biggest tax increase in history, it was a $433 billion, five-year deficit-reduction package that, unlike the tax bills of the 1980's, *actually worked!* Three years after the 1993 tax-on-the-wealthy increase, the *Journal* followed up with an article titled, "Scary Deficit Forecasts for Clinton Years Fade As Tax Revenue Grows," and concluded that

> Clearly, a stronger-than-expected economy has a lot to do with it. The tax increases in the 1993 deficit-reduction package that Mr. Clinton pushed through get credit as well. And, to a lesser extent, so do the spending cuts engineered by the Republican Congress....
>
> By the CBO's analysis, just over half of the $97 billion increase beyond projections is due to tax boosts in Mr. Clinton's 1993 antideficit plan. The rest is due to a variety of factors.[2]

Year later, same story. Four years after the 1993 legislation, the deficit was continuing to go down and the economy was still booming at an alarming rate. In the article, "Tax on Wealthy Is Boosting U.S. Revenue; Treasury Says 1993 Increase Is Helping Cut the Deficit," the *Journal* again described who the tax increases in 1993 actually affected—the wealthy and corporations:

> President Clinton sold the 1993 income-tax increase as a way to shrink the budget deficit at the expense of the rich.
>
> Republican adversaries predicted it wouldn't generate much revenue because the rich would work less and take bigger deductions. Now there's growing, if still tentative, evidence that Mr. Clinton may have been right after all....
>
> "The available data suggest the surge in tax collections has come from the taxpayers with high incomes, who were the only ones affected by the 1993 changes," says Deputy Treasury Secretary Lawrence Summers.[3]

Republicans are the guardians of working Americans and they're concerned about their jobs, right? And what scary forecasts did they make about the 1993 deficit reduction package?

> "Clearly, this is a job-killer in the short-run. The impact on job creation is going to be devastating.... Who can blame many second-earner families for deciding that the sacrifice of a second job is no longer worth it?"
> —Rep. Dick Armey, (Republican, Texas)

> "The tax increase will...lead to a recession...and will actually increase the deficit."
> —Rep. Newt Gingrich (Republican, Georgia)

> "I will make you this bet. I am willing to risk the mortgage on it...the deficit will be up; unemployment will be up; in my judgment, inflation will be up."
> —Sen. Robert Packwood (Republican, Oregon)

> "The deficit four years from today will be higher than it is today, not lower."
> —Sen. Phil Gramm (Republican, Texas)

The 1993 deficit reduction legislation got not a single Republican vote. And the economy has been booming so much ever since, their conservative financial backers have been trying to figure out ways to slow it down, without cutting into corporate profits.

As you read the following comments—and given the verifiable details of the 1993 Deficit Reduction legislation and its known re-sults—you have to wonder about the motivations and honesty of these two prominent Republican leaders:

Senator Robert Dole, January 25, 1994, Republican response to President Clinton's State of the Union Address:

> The President promised a middle-class tax cut, yet he and his party imposed the largest tax increase in American his-tory. We hope his higher taxes will not cut short the eco-nomic recovery and declining interest rates he inherited....

Instead of stifling growth through higher taxes and increased government regulations, Republicans would take America in a different direction.

New Jersey Governor Christie Whitman, January 25, 1995, Republican response to President Clinton's State of the Union Address (this address was after the 1994 *Journal* article described how the Republicans had misled the public about the 1993 legislation):

While at times some of the President's ideas sounded pretty Republican, the fact remains that he has been opposed to the balanced budget amendment, he proposed even more government spending, and he imposed the biggest tax increase in American history.

For added insights into the conservative mentality, look at the *Journal*'s take on the 1993 legislation five years after the 1993 tax-increase-on-the-wealthy. Under the head, "Again, the Rich Get Richer, but This Time They Pay More Taxes," it noted that

The rich are paying a lot more taxes. In fact, an unanticipated flood of revenue from upper-income taxpayers—particularly from those cashing in stock options, enjoying hefty bonuses or taking stockmarket profits—is a big reason the federal deficit has vanished.... Those well-off Americans did pay $18 billion more income tax in 1995 than in 1993, but their total incomes rose by a whopping $57 billion....

[Republican House Majority Leader Richard Armey of Texas, "one of the loudest critics of those increases"] says tax-increase supporters lack "the ability to see what might have been had we not created this folly"—in his view, an even stronger economy....

Call it envy or call it fairness, many Americans still don't think the rich pay enough.[4]

You can't find a more credible source: *The Wall Street Journal* leaves no doubt that taxes on the wealthy not only reduced the deficit, but

also had no negative effect on the economy—which not only grew, but exploded.

For those who worry that our mistreated rich citizens are suffering an unfair tax burden, note that:

- While they paid $18 billion more in taxes, their net income went up three times as much. Approximately 98.8% of Americans—the ones whose sacrifices made it all possible—would love to change places with them.
- The data also demonstrate the absurdity of Republican claims that raising taxes on the wealthy destroys their desire to become richer by working harder.
- For full-fledged, genuine, world-class hypocrisy, nothing can match Armey's canned reply from the Republican play-book: "Workers would have been better off if we had stimulated the economy even more by not raising taxes on the wealthy." Armey and his fellow conspirators know damn well that their biggest concern for the previous five years was that the economy was growing *too* fast—with the accompanying danger that wages might start to go up.
- "Call it envy or call it fairness." How about calling it *anger* and fairness? "Envy" suggests sniveling wimps huddled in a corner, resentful of others' success—and is one of the right wing's most popular hot-button words. Righteous anger, on the other hand, describes the feelings of those who understand the gross injustices that the past 20 years of economic warfare have imposed on working Americans.

Getting back to whom the 1993 legislation really affected, even *Forbes* told it like it was, in the context of complaining about the injustice of it all. In a whining article entitled, "Taxing the Rich," it acknowledged that

> [The "1993 Clinton income tax hike"] fell almost entirely on the top 1% of income earners (taxable income above approximately $200,000), and was retroactive for that year.[5]

132

Lars-Erik Nelson summed up the Republican hypocrisy best when he made the following observations about how "Tax-cut politics wins votes":

> In his acceptance speech, [Bob Dole] accused "some genius in the Clinton administration" of raising taxes so that "somewhere a grandmother couldn't afford to call her granddaughter, or a child went without a book, or a family couldn't buy that first home because there just was not enough money to make the call, buy the book or pay the mortgage."
>
> Poor grandma had to be making over $50,000 a year, including her Social Security income, if she got hit by the Democratic increase in taxes on Social Security benefits. The kid who couldn't afford the book and the first-time home buyer had to be in a family earning more than $143,000 if they were touched by Clinton tax increases.
>
> In fact, Clinton cut taxes for the working poor by expanding the Earned Income Tax Credit.[6]

Compare *Forbes*' and the *Journal*'s descriptions of the effects of the 1993 legislation—with the phony sob story that Bob Dole fabricated for public consumption.

The shame of it all is that many of the middle class and the working poor were convinced by Dole and his fellow Republicans that they had been personally hurt by the 1993 legislation. Certainly—judging from letters to the editor, callers to talk-radio and talk-T.V.—most members of the middle class felt that they had become significantly worse off.

The inescapable fact is that most Republicans systematically and deliberately deceived the American public about the 1993 deficit reduction legislation and its effects.

Now let's look at what they've been up to since then.

12.

Taxes, Republicans, and Working Americans

Oookaayy. In 1993, Clinton and the Democrats in Congress raised taxes on the top 1.2% of Americans, left the middle class largely untouched, and gave economic benefits to low-income Americans and small businesses. Contrary to Republican warnings, the economy not only grew, it grew so fast that conservative economists complained that it might be overheating.

Beginning in 1999, to the surprise and displeasure of conservatives everywhere, wages of some low-income Americans began to creep upward for the first time in 20 years. Naturally, this led many of them to call for the Fed to slow economic growth by raising the prime rate. This is the same crowd that convinced many gullible voters in 1994 that they wanted to cut taxes on the rich so that economic growth could speed up, thus raising wages.

Since Republicans couldn't stand this hint of good news for average Americans, they have been doing everything they possibly could to reverse the effects of the 1993 legislation. Although their record has been consistent for the past two decades, their tax proposals for the past five years reveal whom they're actually working for, and which "working Americans" benefit from their policies.

The following excerpts clearly demonstrate how Republicans have conned the voting public into supporting their scurrilous tax proposals by

- artfully covering up who benefits most from their proposed tax changes,
- outright lying about the regressive nature of specific tax changes on working-class Americans,
- ignoring the loss of necessary government services—which benefit mostly middle- and low-income workers—when tax cuts for the wealthy reduce revenues, and
- deliberately causing the public to lose confidence in the Internal Revenue Service itself.

To get an idea of the chronic Republican mind-set when it comes to taxes, consider how *The Wall Street Journal* described the aura that surrounds the Republican strategy about taxes. Under the head, "Anti-IRS Frenzy Gives Republicans a Chance to Road-Test Plans," it revealed how two Republican stars, Dick Armey (R.-Texas) and Billy Tauzin (R.-Louisiana), tried to whip up voter support for tax changes, *via* the flat tax and/or the retail-sales tax:

> The flat tax would levy a single flat rate on individuals' wages and business cash flow, but exempt individuals' interest, dividends, capital gains and inheritances.
>
> The retail sales tax would get rid of the individual and corporate income taxes altogether, and levy a large sales tax—Mr. Tauzin says 15%, but experts say it would have to be much higher to cover anything close to the current cost of government—in its stead.
>
> Both would have characteristics that would be lightning rods for criticism. Both, for instance, would lighten the tax burden on the best-off Americans and shift the tax burden to everyone else.[1]

The Republican tax strategy: Whip up anti-IRS sentiment so that the public will be receptive to *anything*—no matter how absurd—as long as it is a change. The only thing that could stop the flat- and sales-tax scams is their transparent unfairness, which would become

"lightning rods for criticism," that even *The Wall Street Journal* predicted.

In either case, the Republicans' real intent is to benefit the wealthy by replacing a progressive tax system with a regressive tax system. Their flat- and sales-tax proposals are so obviously outrageous, one wonders why they didn't stick to their more devious, yet effective, ways for screwing working Americans.

For example, look at the budget plan they came up with in 1995. *The Wall Street Journal* gave the true scoop about Republican day-to-day tax scheming, using non-exotic, standard procedures. Under the head, "Figuring Winners, Losers in Budget Plan of GOP Hinges on Tricky Judgments," the *Journal* concluded that

> The poor will get little direct benefit from the tax breaks: The poorest one-third of American children won't benefit from the $500-a-child tax credit because their parents don't owe enough taxes to apply the credit to. And furthermore, cutbacks in the earned-income tax credit will hit some low-income families.
>
> And some provisions benefit the wealthy almost exclusively, such as changes in the estate tax that benefit only heirs to estates worth more than $600,000 and a phase out of a luxury tax on cars costing more than $32,000....
>
> Nearly $300 billion in reductions in projected spending would come from programs aimed directly at poor and lower-income Americans—such as Medicaid, cash welfare, and food stamps.[2]

The *Journal* contrasted the results of the tax cut proposals as reported by the Congressional Joint Committee on Taxation, and the Treasury Department, which also included cuts in corporate and estate taxes in their analysis.[3]

The Congressional Joint Committee indicated that those making under $30,000/year would get less than .4% (that's four-*tenths* of a miserable one percent) of the total tax cut. Those making $30,000 to $50,000 would get 28%, those making $50,000 to $100,000 would get 49%, and those making over $100,000 would get 24% of the total tax cut.

The Treasury analysis indicated even greater benefits for the very wealthy: Those making under $30,000 would get 1% or less of the total tax cut. Those making $30,000 to $50,000 would get 12%, those making $50,000 to $100,000 would get 39%, and those making over $100,000 would get a whopping 47% of the total tax cut.

The only thing "tricky" about analyzing this Republican plan is deciding the extent to which working Americans were getting screwed:

- Remember how Republicans say their tax cuts will help "working Americans"? By either Congress's or the Treasury's analysis, those making under $30,000 a year, or approximately 46% of Americans, would get 1% or less of the benefits of the tax cut.
- On the other hand, those making over $100,000, the richest 5.8% of families, would get 24 to 47% of the benefits, depending upon whether you use Congress's or the Treasury's numbers.
- And those who choose to use the Congress's figures have to omit two of the most important benefits the wealthy would receive from the Republican tax plan: cuts in corporate and estate taxes. Republicans, of course, believe that the income people get from being born, or from effortless investments, shouldn't be taxed as much as income from manual labor.

As the wise statistician once said: "Figures don't lie, but liars can figure." Despite the "figuring" of Republican politicians, look at what their figures actually meant for the working poor:

- The $500-a-child tax credit—one of the most ballyhooed Republican gifts to working Americans—ends up not touching the poorest third of American children. The same could be said for cuts in luxury and estate taxes.
- The earned-income tax credit—designed to make up to working Americans for the sacrifices forced on them by the new conservative economy—was reduced for our lowest income families.
- Surprise. Most of the reductions in spending in the Republican plan—to finance these tax cuts mostly for the wealthy—would come out of the hides of those who have suffered most from this new economy: working Americans who most need the benefits of Medicaid, cash welfare, and food stamps.

The Republican budget plan of 1995 clearly exposed their loyalty to the wealthy. A look at more recent tax discussions shows how they con the public into buying into their devious goals. It only takes a few wealthy people—with the right connections—to change tax laws to their advantage. *The Wall Street Journal* described how "Washington Is Moving to Alter the Certainty of Death and Taxes" by lowering the "death" taxes that only the top 1% Americans pay:

> About 1% of Americans who die each year—31,564 in 1995—leave their heirs with the burden of estate taxes. Individuals with estates of less than $600,000 and couples with estates of less than $1.2 million are exempted entirely.... Republicans are trying to sell the idea of estate-tax repeal as a populist one: the taxes, they argue are a penalty on the American Dream of working hard to get rich....
>
> Mr. Lott acknowledges that most of his...constituents won't get hit by estate taxes. "But," he says, "just the idea of a death tax infuriates people in the real world."[4]

To hear the Republican complaints about the onerous "death tax" on working Americans, one would think that they were talking about *average* Americans. But only 1% of our richest Americans are affected. However, because of the way our Congress can be bought, that 1% can be influential enough to change tax laws for our entire nation.

When Republicans cite the "American Dream" of getting rich through work, they appeal to the strong emotions of most citizens. Yet their elimination of the estate tax would mean that large numbers of people would become rich by *not* working. All they would have to do is be born, and then live like royalty for the rest of their lives.

Meanwhile, to give them their tax break, Americans who truly work for their incomes would have to make up for the lost taxes by paying more themselves. Even in Republican Trent Lott's own district, most people wouldn't leave enough money to their descendants to be affected. Of course, *everyone* dies, but only 1% leave taxable estates. Therefore, Lott and his cronies appeal to the public biases by referring to estate taxes on the wealthy as "death" taxes on everyone.

To get an idea of the consistency of the Republican strategies, look at the tax legislation discussions in 1997. The 1997 tax budget discussions mirrored the discussions of 1995: Massive tax cuts for the rich, and relatively few for the middle class and poor. *The Wall Street Journal* laid open the fact that "Top Earners Will Get the Biggest Slice Of the Tax-Cut Pie, New Analysis Shows":

> Even without effects of the estate tax, the Treasury analysis said 50.3% of tax cuts would flow to the top 20% of earners—or families making at least $93,222—by the time the full package takes hold by 2007.
>
> In fact, 14.4% of the cuts would flow to the top 1% of earners, or families making $408,551 or more, and 21.9% to the top 5%, or families making $170,103 or more, the Treasury estimated.
>
> The share of benefits going to the top 5% is just slightly less than the 23% of benefits going to the bottom 60% of earners, or families making less than $54,758.[5]

Getting monotonous, isn't it? By sheer dogged persistence, Republicans are determined to get their way with the American public. Year after year, by chipping away at our formerly effective progressive tax system, they are rewarding greed and penalizing genuine work. In reviewing these figures, remember that the tax cuts are simply the more recent stages of a string of benefits for the wealthy that have been occurring for the past several decades.

Chief among them are the changes in economic policies, described in Part 1, that tremendously benefited the wealthy and forced huge sacrifices on working Americans.

Now, instead of making up for these past injustices, wealthy Republicans are exacerbating them by cutting benefits and protections for those same workers, and allocating the tax savings to themselves.

To get a better idea of the extent of Republican hypocrisy and the actual effects of recent tax changes, look at their propaganda—given in press releases, speeches, and interviews—and the actual results of their tax legislation. First, the propaganda:

The Spin

News release by Republican National Committee Chairman Jim Nicholson, July 1, 1997:

> I am pleased President Clinton has finally made restitution to Americans for imposing the largest tax increase in history in 1993, by joining with Republicans in the effort to cut taxes....
>
> However, Clinton is playing a dangerous game by attempting to instigate class warfare in his rhetoric charging—erroneously—that the Republican tax cuts favor the rich.

Haley Barbour, (then) Republican National Committee chairman, August 8, 1996:

> We are going to get into the real issues, and the first of those real issues is taxes and spending. This will be a huge issue for three reasons. The first is that lower taxes means more jobs and higher take-home pay....
>
> We Republicans know, if you are concerned about take-home pay—stagnant incomes—the fastest and most effective way to raise somebody's take-home pay is to cut their taxes. This isn't rocket science....
>
> Republicans are for cutting taxes. Bob Dole has proposed a 15 percent across-the-board tax cut because we believe the people who work and earn the money ought to earn more and keep more of what they earn. If they could keep more of what they earn, they could do more for themselves. They could do more with their children, their churches and synagogues and their communities.

John Rowland, governor of Connecticut, speech at the 1996 Republican convention:

> All across America, people are working longer and harder.
>
> Americans are coming home to their families tonight, trying to balance their checkbooks, and they're wondering:

If I'm working so hard, why is it so tough to make ends meet? Where does all the money go?

...The average family now spends more on taxes than it does on food, clothing and housing combined. To restore the Dream for all Americans, we've got to dramatically reduce the Government's share of our paychecks.

Rep. John R. Kasich, ranking Republican on the House Budget Committee, "Putting Families First: Why the American Dream of Financial Independence and Security Turned Into a Nightmare of Taxes," in *Rising Tide*, May/June 1994:

High taxes also rob families of the resources they need to care for their children. Equally important, for many families, higher taxes have forced into the workplace those parents who would prefer to stay home and raise their children. That's not what my father had in mind when he talked about the American dream....

In addition to the $500-per-child tax credit, our plan offered important changes in IRAs to help families save for the future.

The 1996 Republican Platform, Adopted August 12, 1996:

BUILDING A BETTER AMERICA

American families are suffering from the twin burdens of stagnant incomes and near-record taxes. This is the key cause of middle-class anxiety. It is why people feel they are working harder, but falling further behind; why they fear the current generation will not be as successful as the last generation; why they believe their children will be worse off; and why they feel so anxious about their own economic future.

Newt Gingrich, radio address on tax cuts, June 21, 1997, Washington, D.C.:

It has been sixteen long years since the working American taxpayer had something to cheer about. For sixteen years,

taxes have increased, government has expanded, bureaucracy has grown, and our weekly paycheck has dwindled....

This is tax relief for every taxpayer at every stage of life. It will help children and strengthen families. It will ease the expense of an education and increase the number of jobs.

These tax cuts are targeted to America's working families and small businesses. A whopping 71% of these cuts go to families making less than $75,000 per year. That's real tax relief for America's middle-income working families.

Bill Archer, Republican chairman, House Ways and Means Committee, press release, July, 1999:

> The American people will be the big losers if President Clinton vetoes our commonsense plan to let them keep more of their own money. With each new day and each new veto threat, it's clear that all the President wants is to spend the taxpayer's money on more government programs. It's too bad the President seems more interested in hoarding excess tax dollars for Washington bureaucrats rather than returning them to American families and workers on Main Street.

Republican Sen. Phil Gramm, November, 1999 press release:

> What our colleagues on the left would like to do, in following the president's proposal, is to take the tax cuts away from a working couple, both of them working full time, making a total of $54,000 a year, and instead give it to people who do not pay any income taxes.

Sen. Trent Lott, Republican Senate Majority Leader, Associated Press news release, November 13, 1999:

> America's families don't need higher taxes. They need a tax cut. America's workers deserve a tax cut. And America's leaders should grant a tax cut.

Rep. Tom DeLay, Republican Majority Whip, Republican press conference, November 18, 1999:

> We're very proud of what we've been able to accomplish over the past 5 years. It is absolutely amazing. When I first ran for Congress, I wanted to...relieve the tax burden on the American family.

Rep. J.C. Watts, House Republican Conference chairman, press release, September 1, 1999:

> I trust that my constituents can do the right thing with their [tax refund] money, and if they want to buy their kids school clothes, if they want to buy a much-needed household appliance, new tires for the car, whatever—allow them the opportunity to spend their money the way they need to spend it and not the way that Washington, D.C. would like to spend it.

Review the comments of Republican leaders on the preceding pages. Can you see *any* resemblance between who the Republicans *say* will benefit from their tax cuts, and who *really* benefits as disclosed in the following excerpts of articles from our foremost conservative financial publications?

The Reality of Republican Tax Cuts

The following excerpts, each from a separate article, describe the results of enacted or proposed Republican tax legislation. The vast majority of benefits obviously go to the special interests and the affluent—to those who enjoy capital gains, and to those who are able to use a variety of sophisticated financial and accounting procedures to take advantage of the Republicans' complex legislative provisions:

"Tax Bill Could Mean a Windfall for the Well Off ...Don't do anything yet, but start salivating. The tax bill passed yesterday by the House of Representatives could turn out to be the biggest tax-saving bonanza in years for upper-income Americans.... *The Bill's Goodies*: Capital-gains tax cut; Tax-exempt American Dream Savings Accounts; $500-per-child tax credit; Rollback of higher tax on upper-

income Social Security recipients; Marriage-Penalty tax relief; Bigger estate-tax exemption."[6]

"The [Republican] chairman of the House Ways and Means committee unveiled a tax bill that provides smaller tax breaks for education and the working poor than President Clinton wanted, and large tax breaks for estates and capital gains."[7]

"Estate-Tax Relief: Guess Who Gets the Breaks? A sure way to win sympathy from Congress is to cast two icons of the American economy—small businesses and family farms—as victims of a rapacious federal government.... The trouble is, the big winners from this rewrite of the federal estate-tax law would be wealthy investors, not small-business owners or family farmers."[8]

"Ready, Get Set...Here's How to Profit from a Big Cut in Capital-Gains Taxes ...The gap [between capital-gains and ordinary-income rates] would create 'an enormous advantage to emphasizing capital appreciation over income,' says Thomas Ochsenschlager, a partner at Grant Thornton in Washington."[9]

"The deep cuts in capital-gains taxes under the law signed yesterday by President Clinton provide a bonanza to employees who are paid with stock options."[10]

"Rich-Poor Gap in 401(k) Plans Widens ...The gap between the rich and poor in 401(k) plans is growing.... Of course, it isn't a big shock that lower-paid workers are less likely to participate in retirement plans. They may not feel they can afford to;...they may not understand the plan.... The Labor Department's 1993 Current Population Survey shows that 70% of the 2.2 million workers earning more than $75,000 are offered a plan, while only 10% of the 15 million workers earning under $10,000 are offered a savings plan."[11]

"Where There's a Tax Cut, Wall Street Finds a Way ...Just over two months ago, in an effort to reward long-term investors, Washington enacted a cut in the tax rate for long-term capital gains. Now Wall Street is already marketing a device aimed at extending that same tax cut to certain wealthy investors whose short-term trading gains weren't supposed to benefit."[12]

"The Republicans are in danger of shooting themselves in the foot again with the tax bill. They're offering a $500-per-child tax credit but not to the poorest working families, who need it most. The reason? The poor already receive an Earned Income Tax Credit or a Child Care Tax Credit. Conservatives figure these families get

enough government money and want to give the credit to higher-income families who need it less."[13]

"Proposed New IRAs May Benefit...Oops...the Rich ...At first blush, the tax legislation being debated in Washington, D.C. appears to offer a wealth of IRAs for a broad swath of investors in a bid to bolster savings rates. But a look at the fine print suggests that the swirl of new IRAs could create opportunities primarily for upper-income Americans to shift large chunks of their assets into tax-free accounts where they would be beyond the reach of Uncle Sam. Forever."[14]

"IRA Loopholes for Rich Retirees Beat That Needle's Eye ...Starting this year, affluent retirees are among those with the most to gain by putting money into individual retirement accounts."[15]

"More Tax Breaks for special interests surface in the GOP tax-cut bill. Oklahoma Sen. Nickles wins a provision to protect Excel Legacy in San Diego from a proposed tightening of tax benefits of closely held real-estate investment trusts. [more examples]"[16]

"Much of Savings in GOP Tax-cut Bill Would Go to Those With Huge Estates ...Much of the savings in the $80 billion tax-cut bill before Congress would go to taxpayers with huge estates, under-cutting the Main Street image House Republican leaders have promoted for the measure."[17]

"[Corporations] indulge in tax shelters so complex government auditors can't always understand them. They shift profits to low-tax countries by manipulating prices when doing business with their own overseas branches. And they take full advantage of the tax breaks that Congress has awarded over the years, while dispatching lobbyists to plead for still more."[18]

"Tax Bill Is a Boon for Corporate America; GOP Courts Business Allies on $792 Billion Package ...It's payback time for the business community, as Republican leaders look for its support in the escalating partisan battle over the massive tax-cut package cleared by Congress. Corporate America is amply rewarded in the 10-year, $792 billion bill."[19]

"Sheltering the Tax Shelters ...Indeed, GOP tax bills include provisions that tax-shelter critics say will expand tax-avoidance opportunities, especially for multinational corporations."[20]

"House Bill: Tax Cuts for You, Me, and Forestry ...The polished marble hallways outside the influential House Ways and Means

Committee are filled with well-heeled lobbyists, and the $863.9 billion tax-cut bill approved by the committee this week shows once again the power of special interests."[21]

"To the Campaign Contributors Go the Tax-Cut Spoils ...The National Restaurant Association asked for the moon in the tax bill. But, as one of their lobbyists told the *New York Times*, they got the 'sun, moon and stars....' As Senate and House negotiators struck a final deal this week, they made sure to protect most of the special-interest bonanzas for generous campaign contributors."[22]

"The top 1% of households (average income of $833,000) would get tax cuts averaging $20,697, according to Citizens for Tax Justice. The top 10% would get 62% of all the tax relief. And the bottom 60%, those with household incomes of less than $38,000, would get tax cuts averaging just $99. And 48 million taxpayers would get no tax cut at all, according to the Congressional Joint Tax Committee.... The GOP's proposed [10% across-the-board] tax cut would cost the Treasury nearly a trillion dollars over 10 years."[23]

"GOP Budgeteers Try to Delay Tax Credits to Poor ...House Republicans are considering a plan to delay billions of dollars in tax-credit payments to poor families to help offset spending elsewhere for education and social services next year.[24]

In one way or another, for the past two decades, leading Republicans have done everything they could to distract the voting public from the real results of their tax legislation. Review the quoted comments of Republicans described earlier. Note how they *claimed* they wanted to cut taxes to benefit:

- "America's workers."
- "Every American taxpayer."
- Those whose incomes came almost entirely from "take-home pay."
- Those with "incomes that have stagnated" for the past 20 years.
- Those whose work demands on both spouses take "time away from their children, their churches and synagogues, and their communities."
- People who wonder: "If I'm working so hard, why is it so tough to make ends meet? Where does all the money go?"

- Parents who are forced to work and who "would prefer to stay home and raise their children."
- Families who need help "to save for their future."
- "Every taxpayer at every stage of life."
- "America's middle-income working families."
- "Workers on Main Street."
- "A working couple making $54,000 a year."
- People who "want to buy their kids school clothes, if they want to buy a much-needed household appliance, new tires for the car."

The above words certainly describe the majority of voting Americans, which is why the Republicans use them to describe their legislation. But their actual legislation doesn't come remotely close to giving such people any appreciable benefits, and in many cases, it makes their tax burdens worse—or reduces their governmental benefits.

Taxes in Perspective

When conservatives are confronted with these facts, they have a pre-planned response: The rich deserve more of the tax breaks because they pay more taxes to begin with. So far, their efforts to put a guilt trip on the American public has worked. It shouldn't.

Don't sweat the fairness issue. To put taxes into proper perspective, look at *Business Week*'s frank explanation of why the wealthy are paying so much in taxes. Under the head "Rich Man, Taxed Man," it recognized what we already know—that America's richest are paying the lion's share of taxes. However, it went on to inject a little realism into the issue:

> At first glance, the data suggest that the wealthy are being asked to shoulder an inordinate share of the tax burden....
>
> The catch is that the rich are getting a lot richer. The top 1% took in $524 billion, or 14.2% of total adjusted gross income in 1992, up from 8.9% in 1982. Meanwhile, the income share of the lower 50% fell from 17.7% to 14.9%. Thus, the top 1% now rake in almost as much as the entire bottom half of earners.[25]

The kinds of numbers that conservative think tanks spew out to the public are, indeed, "first glance" numbers, and they suggest that our country has placed an inordinate tax burden on the wealthy. In absolute terms, the wealthiest Americans pay, by far, the largest percentage of our nation's collected taxes. Superficially, to require 1% to pay 27.4% of all taxes seems excessive. But, more importantly:

- The conservative economic policies of the past 20 years are what enabled the rich to get fabulously, incredibly richer,
- to the point where, as of the time of this article, the top 1% took in as much as the bottom 50% of earners. These are the more important numbers to consider. They represent a deliberate, planned transfer of wealth from working Americans to investors, business owners and corporate executives.

The next time Republican politicians talk about the fairness of their tax reduction proposals, remember: Regardless of how you slice it—no matter how "unfair" it is to tax abused rich people—the members of the top 1% are the ones who got rich from the conservative economic policies of the 1980s and '90s. And in the process, they forced huge sacrifices onto the bottom 40-80% of Americans who enabled them to become wealthier.

In 1983, the top 1% owned 31% of all wealth in the U.S. In 1989 it rose to 37%. At last count, they owned over 42% and their percentage was growing. Something is going in their favor, and it sure as hell isn't that they work harder than workers do, or that they work harder than the wealthy did prior to 1983.

Now look at the Republicans' more recent strategy to transfer wealth from workers to America's richest: their attack on one of the most efficient programs for workers yet devised—Social Security.

13.

The Conservative Takeover
of Social Security

Consider this. If an American worker

- has a high school degree or less, and has worked hard all his life, or he
- has a Ph.D. in physics, but he's fifty and suddenly finds that his job has been subcontracted out to India, or he
- is an engineer who has been "downsized," and has spent his life's savings to find a new job and to put his kids through college,
- he can still count on having at least a bare-bones income for retirement because of our present, *reliable* Social Security system.

Social Security is an effective, efficient system for ensuring a decent retirement income for working Americans. Fundamental to its success is its philosophy that hard work is honorable, it contributes to our nation's prosperity, and those who do it should be able to count on, at least, a minimally comfortable old age.

Under our present system, those who work hard don't have to have greed or materialism as their primary or even secondary motivations. They don't have to spend significant amounts of their time studying ways to get wealthy, to play the stock market, or to hoard real estate.

They can focus their efforts on their life's work, whether that work is designing bridges, healing the sick or collecting garbage.

Workers "invest" in the future by inventing, building, and maintaining this country—usually for relatively low incomes—and by having a Social Security system that properly recognizes their right to a decent income after they retire.

Our system also assumes that today's workers will be able to make enough money to provide a retirement for those who preceded them—just as those who preceded them had paid for the retirements of their predecessors. Of course, trust funds have to be built up during prosperous times to make up for anticipated imbalances that may occur because of changing birth and retirement rates.

Conservatives want to change all that. The greed and materialism inherent in their philosophy places a premium on inherited wealth, investment income without work, and the manipulation of the markets that restrict workers' wages. That is the way they "invest" in the future—for themselves and their own descendant royalty.

The most immediate beneficiaries of their transparent plans for "saving Social Security" will be Wall Street brokers, bankers, lawyers, everyone associated with the securities industry, and all those who already own massive amounts of stocks and bonds. If Alan Greenspan thought the market was overvalued in 1998 and '99—wait until billions upon billions of government sponsored dollars hit the stock markets. The wealth of the already wealthy will soar as never before.

As is well known by now, the top 1% of Americans own 46.2% of all stocks and 54.2% of all bonds. The top 10% of Americans own 90% of all stocks and bonds. The bottom 70% of Americans own from $0 to $2,000 in securities; in today's economy, that effectively translates into virtually no appreciable investment in today's stock market.

Raising hypocrisy to a new level of sophistication, conservatives have gained respectability for privatizing Social Security by saying that workers should have the same opportunities to invest in the stock market as rich people do, and to realize the same benefits.

But what conservative politicians really want is to

- provide vast sums of money to propel the stock market to ever higher levels, thus making present stockholders (themselves) even more wealthy,
- return favors to many of their biggest campaign contributors—the securities and banking industries,

- force people who don't know the difference between a stock and a bond to compete in the financial markets with those who have made Wall Street, and the accumulation of money, their life's work, and to
- politicize the Social Security process; that is, enable politicians to decide which of their friends will handle workers' investment money.

In other words, conservatives want to create a new Social Security system with horrendous service charges (Wall Street firms, lawyers, brokers, analysts, investment bankers, advertising executives, accountants, etc.) for what is probably the most cost-efficient governmental system in our country. In 1997, Social Security paid benefits of $362 billion. The cost for administering the program was $3.4 billion, or only about .9% of benefits paid.

This is not to say that the system itself couldn't make better investments than in conservative government bonds. However, whatever changes are made should give the same guarantees to retirees as they now have—and the Wall Street sharks should be kept out of the process as much as possible.

Carrying their blatant attack on working Americans further, Congress has raised the retirement age to 67 years, and some want to increase it to 70 years. This, at a time when the bodies of many manual laborers wear out before they are 60.

Naturally, those who are best able to work until they are 70 are those who never really worked with their bodies to begin with: investment bankers, college professors, stockbrokers, management consultants, corporate executives, lawyers, accountants, and so on. These are the very same people who paid their politicians to raise the retirement age, instead of raising taxes on themselves—the ones who are benefiting most, and sacrificing least, in today's economy.

To get a better understanding of this subject, consider what our most prestigious conservative financial publications have to say about the nature of investing in Wall Street. If Social Security is privatized, it won't be easy for workers to be successful, especially for those who lack a good financial education.

On the other hand, it will be incredibly easy for them to get taken for a disastrous ride by the army of stockbrokers who will crawl out from under the rocks to partake of this new bonanza.

Look, for example, at two articles from the well-regarded investment publication, *Fortune* magazine. Under the head "Even If You're a Millionaire, Good Advice Is Hard to Find," it gave an unvarnished assessment of what it takes to make money on Wall Street:

> Arthur Pergament's family did him in. He was just 27—a scion in place in his ancestral business—when his father and uncle sold Pergament Home Centers to a leveraged buyout firm in 1987.... In practice, Arthur Pergament was left without a job. In fact, all he had left was his family's millions in cash....
>
> Nine years later he still steams with memories of how big-money managers proposed to treat his precious stake. "When you've got $10 million or less, you deal with some guy making $60,000 who's trying to institutionalize you," he says.... "You get lost in the soup."[1]

A month later, *Fortune* expanded on the "it's-hard-to-get-good-investment-advice" theme by describing "How to Pick Your Advisers":

> Don't leave it to luck. To keep your retirement plan from becoming a financial nightmare, start assembling your financial experts now. Here's how.... Personal finance has gotten so complicated that no one can hope to prepare for retirement without employing a large and rather expensive advisory team. Says Roy Ballentine, a consultant who assembles such teams: "We long ago concluded you'll never find a single expert with all the answers."[2]

If sophisticated readers of *Fortune*, with excellent financial backgrounds, need to be concerned about how to invest for retirement, what does this suggest for those who cannot afford to make any mistakes at all?

So what's a typical worker to do, when he doesn't have enough money to hire an investment advisory team? Great news. Free advice will be available. When Social Security is privatized, millions of people will suddenly have free advice cascading down upon them—around dinnertime, of course. *The Wall Street Journal* gave us a glimpse

of what is in store in its article, "'Buffett Is Buying This' And Other Sayings of the Cold-Call Crew":

> When the stockbroker called, Robert Gaddis wasn't interested. He knew all about cold-callers and their high-pressure push to buy speculative stocks. Yet the Illinois insurance man says he eventually ended up sinking $6,000 into a little-known stock through the broker, and losing nearly all of it.... An underground collection of audiotapes circulates among young brokers showing how veterans of the boiler-room business repeatedly woo and win clients against high odds.[3]

Cold-calls from stockbrokers is just one of the downsides that privatization will lead to. For many of those planning for retirement—who don't know the difference between a stock and a convertible bond—the challenges will be overwhelming. Conservative investors will have to select a good mutual fund from among the thousands available, and their luck may largely depend upon which salespersons first contact them. Aggressive investors who decide to try to hit the stock-market jackpot will gamble their futures with brokers who promise them the greatest returns in the shortest time.

The following references to separate articles need no further comment about what conservatives want to exchange our efficient Social Security system for:

"Sleazy Doings on Wall Street ...Why did prestigious Bear, Stearns get cozy with so many discredited bucket shops?... In failing, Baron [bankrupt brokerage company] laid bare a corner of the securities industry that is rarely seen but is hugely profitable: processing trades for other firms.... The whole situation stinks."[4]

"Brokers don't usually push closed-ends, since the commissions are low, and fund companies opt to spend ad budgets on mutual funds which can generate higher fees. Perhaps for this very reason, savvy investors should consider closed-end funds for their portfolios."[5]

"The $700 Million Mystery ...Big brokerages may have propped up David Askin's funds.... Did some of Wall Street's biggest brokerages—notably Kidder, Peabody & Co.—help Askin mislead inves-

tors? Did Kidder and other firms, such as Bear, Stearns & Co. and Donaldson, Lufkin & Jenrette Securities Corp., improperly force his demise? Do they share in the potentially enormous liability—investor losses that exceed $400 million?"[6]

"Retired Americans Should Be on Guard Against Abuse From Financial Advisers …Regulators say the culprits run the gamut from brokers with well-known firms to financial planners who work out of their homes. 'Seniors are being targeted and scammed,' says Michael T. Kogut, Massachusetts assistant attorney general for elder protection."[7]

"Wall Street's biggest ever 'test-taker-for-hire' scam could be more organized than originally believed. As expected, the Manhattan district attorney's office yesterday announced the indictment and arrests of 53 stockbrokers for cheating on broker-licensing examinations."[8]

"Beware the Scalpers …As often as not, funds the independent brokers sell carry famous brand names: Oppenheimer, Putnam, Franklin. Wrapped around these funds, however, is a latticework of extras such as 'timing services' or consultation fees that can easily create a combined expense burden topping 4% of assets annually."[9]

"How One Stockbroker Keeps On Selling, Despite Complaints …[H]e is just one of 112 individuals still active in the securities industry even though they have been on the losing side of two or more customer arbitrations from 1991 to 1995…. This, critics say, is an extraordinary record of survival in an industry that claims its self-policing methods amply protect investors."[10]

"The government's case against Mr. Wolfson, they say, underscores one of the principal perils of today's markets: Promoters are hyping small stocks and unloading them on a new generation of bull-market investors, flouting the civil penalties and other traditional techniques available to regulators."[11]

"Investor beware. A big chunk of the money you sink into small stocks may be lining your broker's pocket. Within the broad community of Nasdaq Stock Market dealers, many brokerage firms that make markets in smaller stocks are in the habit of paying their brokers extra money to sell them, regulators say."[12]

"Unusually heavy trading in Fund American Cos. Stock and options before yesterday's announcement of the sale of its insurance unit to Allianz AG suggests there was trading on inside information

as early as three days before the deal was disclosed.... 'Greed is as American as apple pie,' said Bruce Baird, former chief of the securities and commodities fraud unit in the Manhattan U.S. attorney's office."[13]

"When Michael R. Milken's junk-bond market fell, some of America's flashiest wheeler-dealers went down with it. The collapse also snared Sara Webb. The 73-year-old Tennessee widow lost almost half of her $20,000 investment in Memphis municipal bonds, which turned out to be tied to the sinking fortunes of junk bonds."[14]

"The activities of Prudential Insurance and its brokerage unit present a case study in how a stodgy corporate image can sometimes mask a far more aggressive reality. What irks many investors now is the Prudential Insurance was used as a major marketing tool in promoting the Pru-Bache partnerships."[15]

"A three-month investigation reveals that organized crime has made shocking inroads into the small-cap stock market.... Today, the stock market is confronting a vexing problem that, so far, the industry and regulators have seemed reluctant to face—or even acknowledge. Call it what you will: organized crime, the Mafia, wiseguys."[16]

"'In-House' Trades Can Be Costly for Small Investors ...[T]he Wall Street stock trader sounds a little sheepish. 'It's like taking candy from a baby,' he says of his job, in which he fills small-investor orders at not-always-the-best prices.... It's typically quite legal, though small investors usually aren't aware of it."[17]

"The Rich Have Their Own Means of Staying That Way ...While these small stocks are volatile, wealthy clients have the 'fiscal fortitude' to tough out the ups and downs, says Mr. Elliott. In contrast, he says, the typical small investor usually bails out at the first sign of a downturn."[18]

"Short-Sellers & The Seamy Side of Wall Street ...It's a tale of skullduggery and possible extortion... Add to this pungent recipe greed, fear, and dishonesty, and also cameo appearances by celebrities from Dan Dorfman, whose TV broadcasts helped out the shorts, to baseball tycoon George Steinbrenner III, who was one of 66,000 brokerage customers unhappily caught up in the action."[19]

"Fund-Industry Trade Group Picks a Lemon ...Dean Witter InterCapital decided last month to take the unusual step of liquidating Dean Witter Premium Income Trust because its assets 'have

steadily decreased over the past several years....' Such funds, like Dean Witter Premier Income, are supposed to be havens. They buy government bonds and other securities that are considered low-risk."[20]

"Banks and the investing public gave Dino DeLaurentiis nearly $200 million to build a film company. The money is gone and the company in ruins, but some of Dino's friends and relatives aren't hurting.... Enter Paine Webber. If the industry wouldn't finance him, the public would.... [T]he brokerage house raised $107 million for De Laurentis, selling stock, junk bonds and units of a limited partnership.[21]

"Nearly three dozen Wall Street securities firms have begun preliminary settlement discussions with the Securities and Exchange Commission over alleged trading violations in the past on the Nasdaq Stock Market.... Among the firms that the SEC has held settlement discussions with are Merrill Lynch & Co., the nation's biggest brokerage firm; Morgan Stanley Dean Witter & Co., Paine Webber Group Inc.; Warburg Dillon Read,...and Charles Schwab Corp.'s Mayer & Schweitzer Inc. unit."[22]

"It's one of Wall Street's best-kept secrets: While securities firms allow big institutional investors to dump hot new stocks at their whim, often within hours or minutes of the stock's first trade, they try to persuade individual investors to hold on to IPOs (initial public offerings), for better or worse.... 'While institutions are dumping IPOs, retail [small investors] is stuck holding the bag,' says Lori Dennis, a former Merrill Lynch & Co. broker."[23]

"Although no one knows exactly how many investors aren't getting the money they are due, plaintiffs' attorneys say the number of unpaid arbitration awards has been rising in tandem with the growth of small firms that specialize in highly speculative small-company shares."[24]

"401(k) Do-it-yourselfers Could Use Some Help ...The rise of 401(k)s requires workers to pony up not only the money they'll need for retirement but the time and effort to fathom Wall Street's Mysteries. For vast numbers, that's one burden too many."[25]

"The SEC Should Keep Fund Managers Honest ...Michael L. Schonberg has been put on paid leave while at least three investigations—including the FBI—probe his personal ownership of penny stocks purchased by his two 'aggressive growth' funds. But no

amount of investigating will resolve the thorniest question raised by this mess: Should the Securities and Exchange Commission require that personal trading by fund managers be disclosed, restricted—or banned entirely?"[26]

"Don't Be a Victim ...The bull market in stocks has bred a bull market in fraud.... Because bull markets tend to push all stock prices up, many investment frauds remain hidden. Only when the bull turns tail do these swindles come to light. Bull markets just make people more gullible. They are more likely to believe in miracles."[27]

"Nationsbank Corp. agreed to pay $6,750,000 to settle civil charges that its employees deliberately misled investors—most of them elderly—in selling them two risky bond funds."[28]

"Just how little many investors know about [mutual] fund fees became a hot topic in May, when Securities and Exchange Commission Chairman Arthur Levitt rebuked fund companies for building 'unrealistic expectations through performance hype' and not providing enough information on fees and expenses."[29]

"'Flat Fee' Accounts: Read the Fine Print ...Brokers' no-commission offerings may have hidden charges.... It has been a problem since the dawn of the retail brokerage business: Brokers have a strong incentive to get customers to trade when it might be in clients' interest to do nothing."[30]

"Authorities Probe Growing Wave of Stock-Market Touts ...Here is something else for investors to worry about: tainted financial advice. Stock gurus are sprouting in increasing numbers on radio, TV, the Internet and in newsletters and, according to regulators and law-enforcement officials, more of them are getting paid under the table by executives of the companies they tout."[31]

"CFTC Accuses 2 Firms of Fraud ...ITG customers had losses of $428 million, while ITG made $283 million in commissions between January 1984 and May 1989, according to the suit. During the same period, Siegel made about $40 million in commissions, while its customers lost $33.6 million."[32]

"Charles Steadman is probably the most consistent mutual-fund manager in America. And that's bad news. Three of the four mutual funds in Mr. Steadman's Steadman Group have lost money during the past five years of the bull market."[33]

"For years seniors have been a target not only of scam artists trying to chisel them out of their savings, but also of unscrupulous or not-so-bright brokers urging inappropriate investments."[34]

"You'd think that with inflation in abeyance, high-fee commodity funds would be gone. But there's a sucker born every minute.... What's wrong with these as investments? Three things. They are dragged down by exorbitant fees, they are usually very risky and they do a poor job of diversifying a stock portfolio."[35]

"Don't Panic. Social Security Will Be There For You ...According to government estimates, the Social Security trust fund will be perfectly solvent for the next 32 years.... We'll all hear plenty of scare stories between now and 2029 since fear mongering is a way of life in Washington. But truth be told, there isn't much reason to panic.... Gambling (with the future) may be legalized. Wall Street is salivating at the prospect of investing even a fraction of the half-trillion-dollar Social Security trust fund."[36]

"Wall Street Wants the 'Little Guy,' and It Will Merge to Get Him ...Blue-chip investment bank Morgan Stanley Group Inc. and Dean Witter, Discover & Co., a 'retail' brokerage house catering to individual investors, confirmed that they plan a stock swap to create the nation's largest securities firm.... Driving it was a bid to snare the burgeoning assets of small investors, particularly in mutual funds.... The merger comes as several other Wall Street firms are looking at ways to reach small investors."[37]

The last two excerpts are especially significant. *Fortune* (36) clearly admitted that Social Security isn't broken. The real reason for the Social Security "crisis" is that the securities industry needs a new source of funds to keep the stock market rolling. Washington's new growth industry—privatized Social Security—will be just another means of transferring wealth from workers to sophisticated investors who know how to take advantage of the unsophisticated.

And no wonder "Wall Street is salivating." Privatizing Social Security will allow Wall Street—with its aggressive sales persons, fraud, greed, corruption, incompetence, hidden fees, false advertising, and outright lying—to take a huge cut out of the most efficient governmental program we have.

The *Journal* (37) described Wall Street's new strategy to get control of the assets of small investors, which will dramatically increase if

Social Security is privatized. They not only will have a massive amount of investment funds—in total—they will also be able to manipulate the small investor for their own benefit. Financial institutions and wealthy investors will also be able to transfer many of their risks and expenses to small investors, who have no negotiating power.

Review the previous excerpts from separate articles. Bear in mind that all of them came from America's premier conservative financial publications, and not the "biased liberal news media." Note that in all aspects of investing—fees, IPOs, accurate information, and so on—brokers give significant advantages to institutions and wealthy investors; the little guy is always last in line and, if anyone's account has to be sacrificed for the sake of "the market," it'll be his.

For another perspective about privatizing Social Security, look at the U.K.'s experience during a prosperous economic period. *The Wall Street Journal*'s analysis, "Social Security Switch in U.K. Is Disastrous; A Caution to the U.S.?" suggests that a privatized retirement program for unsophisticated investors could be a serious mistake:

> Britain's pension industry is reeling from the financial fall-out of a decade-old, government-backed program that led millions of Britons to opt out of their public and company-sponsored pension plans and invest the money themselves....
>
> Dubbed the "pension misselling" scandal, it is expected to cost British insurers an estimated $18 billion in compensation payments to nurses, miners, schoolteachers and other workers who were hurt by bad advice.[38]

One has to wonder: Why hasn't the U.K.'s experience been more widely publicized in the U.S.?

- Undoubtedly, some persons in the U.K. invested their pension money wisely and ended up better off. A privatization of such a program gives significant advantages to those who are sophisticated and well-connected. But what happens to those for whom it was a disaster?

- The Social Security system isn't supposed to be a test of one's investment skills. It is supposed to provide a minimum guaranteed

retirement fund for every worker—regardless of his or her personal financial sophistication.

- If Social Security is privatized, what will we do for those people who worked hard all their lives and who are "hurt by bad advice," even advice from reputable investment firms? And that doesn't even take into account the effects of the deplorable moral standards—deception, fraud, etc.—of so many of today's investment professionals.

Those who think that retiring workers need to be responsible for their own investments and for protecting themselves from bad advice miss the whole purpose of the Social Security system. Of course, those who want to privatize Social Security aren't interested in the welfare of workers to begin with.

This whole privatization move is just another way to allow America's most powerful corporations to take control of, and profit from, every aspect of American life.

Aside

America's most prestigious investment firms are represented in the excerpts presented in this chapter, and these excerpts represent a small fraction of what has been reported in recent years. In many cases, the examples of deceit, irresponsibility and fraud are specific to individual firms, but in many others they represent industry-wide practices.

This is the industry that Republicans and conservative Democrats want to control the retirement funds of persons who have little or no sophistication in investments or money markets.

Of course, the control that the investment and securities industries already have over American lives is only a part of the problem. Now it's time to consider the extent to which conservatives have allowed investors and the corporate world to wrest control—from our democratically elected government—over other aspects of our lives.

14.

Corporations Should Run Our Country?

Only Republicans and conservative Democrats can read *The Wall Street Journal*, *Forbes*, *Fortune*, *Barron's*, or *Business Week* and conclude that corporate bureaucrats are better stewards of our country than are government bureaucrats.

Actually, they're probably just pretending that they believe in such an absurd notion. After all, it is only by discrediting government that they can convince voters to turn control of our country over to corporate executives and their supporters.

The reason Republicans and conservative Democrats are comfortable with fraud, greed, and a callous disregard for the public interest—that corporations demonstrate daily—is that they are the primary beneficiaries of these behaviors. They *are* the corporations, and they make sure that they and their CEOs and top executives always make money, even from the disasters that result from their actions.

By destroying the public's confidence in government, they have created a free-for-all, everyone-for-himself economy—an economy in which the rich, powerful and organized can take advantage of the poor, unorganized and uneducated.

Go back to page 115 and read Newt Gingrich's explanation that, to do what he wanted, government first had to be completely discredited—ethically, programmatically, managerially, philosophically. Imagine how incredibly easy that would be to do if the descendants of Newt were able to cite government actions that were as bad or as

numerous as the corporate actions publicized daily in the conservative financial press.

First, consider just a few of some of the more noteworthy ones. Each of the following paragraphs contains excerpts of a separate article from a conservative financial publication:

"The problem is chronic.... [I]t takes more than a year for the full impact of a decline in raw-milk prices to reach consumers. And the dairy industry has become a frequent target for antitrust investigations. Economists and Wall Street analysts say grocers, who generate about 6% of their sales from dairy products, are taking advantage of lower raw-milk costs to sweeten their bottom lines."[1]

"Houston Securities Firms Sold Risky 'Toxic Waste' for Wall Street Giants ...Without the Houston firms' success in dumping toxic derivatives on unwitting investors, Wall Street never would have had other, safer mortgage securities to peddle to sophisticated buyers."[2]

"Investigations of misleading sales tactics rock the insurance industry.... Why the temptation to cloak whole life insurance products as savings plans? Consumers respond better to such offers, but whole-life policies can be far more profitable for agents and companies.... Agents can get a first-year commission of 55%, or $550 on a $1,000 premium, for a whole-life policy. Selling a $1,000 annuity gets them 2%, or $20."[3]

"'Upcoding'—the practice of upgrading the seriousness of a medical malady by filing Medicare bills...that will carry the highest price—appears to be endemic in the industry.... But David Friend, a health-care consultant with Watson Wyatt in Boston, focuses on the abuses: 'Oh, I grant you, there are shades of gray, but when hospitals cross the line, they know it,' he says. That they devote so much energy to beating the system is 'a pathetic commentary on our times,' he says. 'These guys should be figuring out how to better treat patients in their hospitals.'"[4]

"The problem [child labor] was highlighted last week when the government announced civil fines against six Texas farming companies. In a routine sweep, agents found children as young as six years old picking onions in the Rio Grande Valley."[5]

"The Agriculture Department temporarily shut down some or all operations at 34 meat and poultry plants during the first three

months of this year, after inspectors found the food contaminated by feces or the plants operating in dirty or unsafe conditions."[6]

"These people...have never gotten much individual notice for their roles [in the S&L disaster]. They were midlevel figures, some of the thousands of ordinary people—lawyers, consultants, regulators, congressional staffers, state officials, investment bankers—who helped create the crisis, often by calculating their own self-interest first.... Their tales suggest that while some of those caught up in the event were crooked or incompetent, many more were people who simply took a narrow view of their responsibilities in return for hefty fees or powerful jobs."[7]

"More Companies Are Paying Lavishly To Tee Off with Golf Greats ...For one-day outings, prominent players on the PGA Tour, and LPGA Tour commonly command fees of $25,000. Many charge more...Justin Leonard [$50,000]."[8]

"High-Risk Lenders Land with a Thud ...Liberal loans and lax accounting lead to widespread losses.... The financial carnage is piling up.... First, the pack of companies throwing money at high-risk car buyers ran into a wall. Now, home-equity lenders are getting clobbered.... 'I've never seen anything like the collapse of an industry this quickly,' laments George C. Evans, a 40-year finance veteran."[9]

Some corporate CEOs are paid too much because of "interlocking directorates." "It turns out that when an executive of company A serves on the board of company B, and when an executive of company B serves on the board of company A, the CEOs of both reap a special benefit.... With those in charge of fully 123 of the very largest publicly traded companies blessed in this way, the virus of crony capitalism seems to have infected some of those stocks we love to hold."[10]

Mergers of investment companies "should create efficiencies of scale and lower costs for everyone involved. [Some analysts] say just the opposite could be true—at least for the average fund investors. Merger savings rarely get passed along to the small investor. Instead, fund consolidation could ultimately boost fees as a few powerful distributors increasingly control access to investors, and thus charge fund firms more to list their wares with them."[11]

Nationwide, unscrupulous life-insurance agents have persuaded existing policyholders to roll their proceeds into unnecessary new

policies.... "'It's not plausible for the companies to say it's just a bad apple. They create a climate for this sort of thing,' says Joseph Belth, editor of the Insurance Forum newsletter. He contends that 'what goes on in the life-insurance business is a national scandal.'"[12]

Scam artists were able to take "Some big firms for millions by playing on [their] eagerness to do deals.... LBOs were good targets because swindlers didn't have to put up much money of their own but, once having acquired a company, could easily convert corporate assets, such as inventory, accounts receivable and real estate, into cash. And most victims, after being taken, were too embarrassed to admit it."[13]

"A lot of preapproved credit card offers are coming back to haunt the issuers.... A record 1.1 million Americans filed for personal bankruptcy last year, up 29% from 1995.... The credit card industry is reaping the bitter harvest from the easy-credit solicitations it sowed."[14]

"This shadowy retail tactic—called a stocklift or buyback [paying retailers to take competitors' goods off a chain's shelves]—is spreading. Makers of everything from party napkins to bicycle chains are lifting truckloads of competitors' products everywhere from Kmarts to Revco drugstores.... 'Buybacks are a necessary evil in gaining market share,' says Michael Brooks.... Companies are generally reluctant to discuss stocklifting. When pressed, they frequently point fingers at one another."[15]

"Exxon's Restructuring in the Past Is Blamed For Recent Accidents ...'Today the system is overworked and undermanned,' contends William Randol, a former Exxon employee who now is a Wall Street oil analyst.... Then there was the March 24 wreck of the Exxon Valdez, whose captain is accused of drinking on the job. That debacle, dumping some 240,000 barrels of crude into pristine Alaskan waters, has so far cost almost $3 billion to clean up."[16]

"In fact, lending to the little guy—via credit cards, home-equity lines, on-the-spot furniture loans and other installment plans—has become far more profitable than nearly any other banking activity.... Still, it is clear that these lenders' profits depend, at least in part, on the ignorance of their customers, who care more about the size of monthly payments than interest rates."[17]

"Alyeska Record Shows How Big Oil Neglected Alaskan Environment ...Over the years, Alyeska has gradually and quietly scrapped

many safeguards and never even built others that it told Congress it planned.... 'Based on my experience with Alyeska,' says James Woodie, who has been both Coast Guard commander for the port of Valdez and an Alyeska marine superintendent, 'the only surprise is that disaster didn't strike sooner.'"[18]

These brief examples were selected because they represent what has happened, or is happening, within entire industries or segments of our society: savings and loan, dairy and supermarket, life insurance, financial securities, mutual funds, health maintenance, CEO compensation, consumer credit, retail sales, oil production, and the environment. Some were recent and some were classics in our corporate history, but all illustrate the diverse and pervasive nature of corporate-inspired disasters.

An entire book, or encyclopedia, could consist of a listing of individual corporate disasters that resulted from incredible ambition, greed, incompetence, fraud, and outright thievery well beyond anything we find in government. The following is a minuscule sample of what could be presented:

A railroad merger that caused "one of the largest railroad-service breakdowns in history," which "forced hundreds of...customers—from chemical suppliers to grain sellers—to curtail production, lose sales or pay for other means of transportation, with a total cost to the nation's economy of an estimated $1 billion so far."[19]

Four months after the above news report, a pair of University of North Texas economists estimated that this same merger had cost U.S. companies $2 billion.[20]

When an investment bank bought a major corporation, it "drew off millions, loaded [the corporation] with debt, then quietly bowed out." The corporate stock traded as low as 33 cents on the dollar, and a series of layoffs cost thousands of workers their jobs. The investment bank made more than $120 million in fees and another $56 million in a special dividend.[21]

Five companies and "numerous executives" pleaded guilty to roles in a price-fixing cartel.[22]

A major drug chain encouraged its pharmacists "to tack 50 cents or more onto the price of each bottle of pain pills, antibiotics or other treatment purchased with a no-refill prescription."[23]

"Even for Wall Street, the greedy excess was shocking," when a computer company took an aftertax charge of $675 million to pay its CEO and two other executives at the company. Before the charge, the company earned $194.2 million; after the charge, it lost $480.8 million.[24]

"In one of the largest legal settlements involving a Big Five accounting firm, [a major accounting firm] agreed to pay $185 million to settle claims it committed fraud and gave incompetent advice in the bankruptcy-court reorganization of [another corporation]."[25]

A medical equipment manufacturing unit "evidently marked cracked [heart valve] parts as repaired when they hadn't been.... Interviews with former...workers and examination of internal... documents indicate that manufacturing records for many valves were falsified. Critical work on these valves—work recorded as having been done—apparently never was."[26]

"Today, less than three years after the merger was announced, [the company] itself is in need of therapy. Its market value has plunged by more than $1 billion, to less than $750 million...and continues to post big losses.... This is a lesson in shoddy corporate governance and how it can really infect an entire organization."[27]

"In March, [the company] and its top two executives pleaded guilty to defrauding some 10,000 customers by puffing up the value of their homes with misleading appraisals.... 'The fraud permeated the company from top to bottom,' says Ross M. Gaffney, head of the FBI's Miami white-collar crime unit. 'It was not just a few sales guys defrauding people.'"[28]

A mining company's stock surged, split 2-for-1 and hit $18 in 1987. "But then the mine leaked cyanide into Colorado's rivers and streams. [The company] abandoned the mine in 1992, leaving the Environmental Protection Agency to repair the toxic damage. The estimated cleanup bill: $148 million."[29]

"The fall of [company] is a cautionary tale of incompetence and greed. It demonstrates how directors and managers with the best of credentials, and their high-powered advisers, can't always be counted on to guard the interests of shareholders."[30]

"Prompted by a growing number of consumer complaints, the [California Department of Consumer Affairs] conducted a yearlong undercover investigation of billing practices at 33 [auto repair] centers from Los Angeles to Sacramento. It found that its agents

were overcharged nearly 90% of the time, by an average of $223. The department said [the company] pressured repairmen to over-charge by setting punitive sales quotas."[31]

"A state court judge in Boise, Idaho, upheld a $9.5 million punitive-damages award against [automobile insurance company], saying the insurer knew its refusal to pay a woman's medical claim was based at least partly on a 'completely bogus' outside medical review.... 'All of the insurance companies in the country are selling the concept of independent medical reviews, and some may be frauds,' added Eugene Anderson."[32]

Federal prosecutors say companies conspired "to rig prices and squelch competition in the international market for graphite electrodes, an essential component in electric-arc furnaces used to produce steel."[33]

"The State's top insurance official, Neil D. Levin, described a company...out of control: Its financial reports couldn't be trusted, its reserves against future medical claims were inadequate, internal financial controls were seriously deficient and management lacked the mettle needed to turn things around."[34]

The Tip of the Iceberg

Note that these examples represent only a small fraction of similar reports that regularly appear in *The Wall Street Journal, Forbes, Fortune, Barron's*, and *Business Week*. Although they paint a dismal picture of the behaviors of many persons in the business world, their significance probably doesn't come close to the day-to-day incompetence, fraud, and illegal behaviors that remain unreported—hidden from public view.

Many articles in these publications stress the effects of business behaviors on investors; otherwise they probably wouldn't be reported. *Barron's, Forbes*, and *Fortune*, especially, seem to go out of their way not to cover business events that negatively affect workers, consumers, the environment, or the public at large. While *The Wall Street Journal* and *Business Week* are more comprehensive in their coverage of news events, even they don't deal with much of the local business incompetence and dishonesty that are reported in daily newspapers across the country.

Such reports provide only an inkling of the billions upon billions of dollars that the owners and managers of America's businesses are extracting from our economy—with absolutely no regard for their workers, the general public, and often with no regard for their own investors. To put this in perspective, note that the FBI estimates that burglary and robbery cost the United States $3.8 billion a year. Certainly, that's a lot of money, but a relatively small figure compared to the costs of some of the more egregious examples you just read about.

Also note that these corporate misdeeds are not exclusive to little-known or fly-by-night companies. Many are respected blue chip companies that are operating in the relatively unregulated environment that conservatives have created for our country.

In other words, although the documented evidence of general incompetence and malfeasance of corporate executives is enormous, it doesn't come close to describing how massive it really is.

So, when conservatives claim that government is bad and that we should let corporations freely run everything—check out the pages of their own financial publications. As you read, think to yourself: "Would I want these egomaniacs to be in charge of the Post Office, the Internal Revenue Service, or our National Park Service?"

"Would I want to turn over the responsibility for the environment, our health care system, food handling, the testing of drugs, and so on—to these corporate bureaucrats?"

And, while we're on this subject, just what have our newly discovered corporate virtues of greed and materialism already done for worker safety, health care, drug safety, and the costs of auto repair, homes, insurance, medical prescriptions, banking, and on and on?

The excessive enrichment, incompetence and dishonesty of top executives always comes out of the hides of workers and the public in the form of lower moral standards, higher prices, inconvenience, corporate bankruptcy or significant financial loss, loss of jobs, low wages, poorer working conditions—and, above all, loss of what should have been an ethical business competition in the free marketplace.

This is not to say that corporate disasters are always caused by incompetence or dishonesty. Sometimes unpredictable events or simple bad luck play a role. However, the same is true of govern-

ment. Yet, count on it, any time the government makes a mistake, conservative demagogues will rise in mass to politicize the situation.

Unmanaged competition can create conditions in which the lowest moral standards of just one major corporation can become the norm for an entire industry. If a single corporation reduces its costs by using child labor—others can't be competitive unless they also use child labor. If another company's sales persons use deceptive-but-legal sales practices—others will lose market share unless they also use deceptive practices.

From the abuse of workers to the destruction of the environment—what's legal has become the minimum standard for corporate behavior. Even then, some of our most prestigious corporations have proved that they are willing to risk violating the law if it will benefit the bottom line.

Probably the most significant difference between corporate and government bureaucrats is that government bureaucrats have the welfare of the general public as their charter. Although—like their corporate brethren—some are incompetent, dishonest, or unlucky, they have as their organizational goal the betterment of society.

The charter of corporate bureaucrats, on the other hand, is to do anything to maximize profit, even if the net result is harm to workers, their communities, or the society at large.

That's why the federal government *must* set, and enforce, sensible minimum regulations for business practices.

15.

Who Protects the Freedoms that Count?

It's easy to believe and support the politicians who promise a free ride—without taxes and without government getting involved in our lives. It's comforting to assume that time and a magical free market, without controls, will cure all ills. Problem is, reality doesn't work that way and never has.

For example, what do you value: The freedom of moral individuals to compete with each other on the basis of providing the best product or service at the lowest price? Or do you prefer the freedom of the richest, most powerful, and least principled individuals to take over the market and to drive others—who choose to uphold moral principles—out of business?

Do you value the freedom of people to work in a reasonably safe environment? Or do you prefer the freedom of the least principled business owners to risk the lives and health of their employees in order to maximize profits?

Do you value the freedom to breathe fresh air, eat wholesome food, and drink safe water? Or do you prefer the freedom of corporations to destroy the local river, pollute the air you breathe, and sell you tainted food?

Do you value the freedom of the top 20% of our income earners to become merely "rich," by using the labors of working Americans who receive a fair return for their contributions? Or do you prefer the freedom of the top 20% of our income earners in America and their descendants, to, in effect, become a new class of royalty—by taking ruthless advantage of working Americans?

These are all "freedoms," and a society must choose which ones are the true freedoms of a moral society, and which ones are fraudulent shams—acceptable only to a society corrupted by power and greed.

As is becoming increasingly evident, today's corporations have the same moral standards as the American Tobacco Institute. If they *ever* had a sense of moral obligation to their workers, the environment, the consuming public, or the free market itself—they certainly don't today.

The conservative financial press itself demonstrates that predatory corporations and individuals are capable of doing great harm, both to the public and to the free market itself. Without federally enforced national standards, immoral corporations will *always* either:

- Force other corporations who insist on maintaining their moral standards out of business, or,
- Force other companies to lower their own moral standards, if they are to survive in the marketplace.

Therefore, to create a level playing field for businesses, our federal government must require minimum standards for worker income, working conditions, the environment, consumer safety and health, and equal opportunity. This is the only way that the markets can stay free and function as intended in a morally based capitalistic society.

The excerpts in the last chapter demonstrated, among other things, the eagerness of modern corporate executives to take every advantage they can of any weaknesses in the enforcement of existing governmental regulations. If they are willing to violate the law to gain a competitive advantage or to increase profit—just think of how willing they are to behave unethically when the law doesn't specifically prohibit it.

In the excerpts to follow, note how modern corporate executives have sacrificed standards of common human decency in their pursuit of profit. You will read how, without minimum standards, even moral executives, if they are to survive in today's marketplace, must take immoral, although legal, actions.

These actions cover everything from taking cruel advantage of the poor, ignorant, and undisciplined—and creating huge future problems for society to deal with—to callously destroying the environ-

ment. For example, *Fortune* exposed the corporate moral standards of an entire "respectable" industry in its article, "Where Cash Is King":

> Largely unregulated and extremely lucrative, check-cashing companies are booming.... [M]ainstream players are finding this largely unregulated niche hard to resist. Cozying up to the industry are companies such as GE Capital, Chase Manhattan, and Citibank....
>
> This is an industry that promotes spending, not saving; one whose products encourage poor money habits among the fiscally frail.... For these often-desperate ranks, the check-cashing industry prescribes its own sort of subprime remedy: small, short-term loans that carry triple-digit effective interest rates. These "payday loans" are so costly that some states have banned check cashers from making them altogether.[1]

Scrooge lives, and is alive and well in America's premier corporations. Note that GE Capital, Chase Manhattan, and Citibank are not fly-by-night operations. Most of their top executives are undoubtedly from "good" families, and are graduates of prestigious universities. If true to type, they publicly and sanctimoniously claim that the moral standards of *other* Americans are going to hell in a hand basket.

They undoubtedly vote against additional school funding for the public schools that provide them with financially unsophisticated customers, "because you can't improve education by throwing money at it." Of course, they pay three to four times as much—as is spent per student in public schools—to send their own kids to private schools. Naturally, they vote solid Republican.

In the process, they are creating huge future problems that will be extremely costly for our society. What will happen to their naïve victims when the economy crashes? And who will pick up the tab?

Plutocratic vs. *Democratic Capitalism*

It's important to distinguish between two kinds of capitalism: plutocratic and democratic.

Plutocratic capitalism is designed to benefit the educated, wealthy, and powerful, at the expense of the uneducated, poor, and power-

less. It's the product of politicians who believe in "class." Their belief is not simply a recognition of the truth that "the poor will always be with us"—but the belief that their own descendants deserve to inherit the huge advantages that wealth, education and privilege automatically confer. Their attitudes toward those who inherit poverty, illiteracy, and poor health are summed up in the rich man's classic philosophical refuge: "Whoever said that life is fair?"

On the other hand, democratic capitalism, the kind we had between the 1930s and the 1980s, tries to protect the minimal rights of those who are victimized by the predominant economic system. It's designed by politicians who believe that *all* citizens deserve realistic opportunities to live healthy, productive and rewarding lives—regardless of who their parents or guardians were.

In plutocratic capitalism, two qualities always go together: no regulations (no enforced minimum standards of moral behavior) and high profits to the unscrupulous. To illustrate, consider a specific example, and general principle, of plutocratic capitalism. The specific example was provided by Wendy Zeliner in an op-ed piece in *Business Week*, "How Northwest Gives Competition a Bad Name":

> "Its [Northwest Airlines] tactics in Detroit show how dominant players can drive out rivals and keep airfares high.... Northwest's average one-way fare when the tiny Spirit [Airline] entered [the market] was more than $170. Spirit's introductory unrestricted fare: $49 one way.... On June 30, 1996, Northwest slashed its fares to Philadelphia to $49 on virtually all seats at all times.... On Sept. 30 Spirit abandoned the route.... By the first quarter of '97—just a few months after Spirit withdrew—Northwest's average one-way fare on the route had climbed to more than $230.[2]

The general principle was provided by *The Wall Street Journal* in "Air Carriers Face 'Dumping' Enforcement":

> After years of regulatory inaction, the federal government is preparing to clamp down on airlines that use unfair tactics to stifle competition from low-fare start-up carriers.... The guidelines were developed amid mounting concern that major air carriers have been using their market clout

and deep pockets to crush new competitors and maintain their dominance at so-called hub airports....

Transportation Secretary Rodney Slater has found that jawboning major carriers on the issue hasn't worked. Five small carriers have vanished in the past nine months, and only one new carrier has gotten aloft in the past 18 months.[3]

This is the dirty little secret of today's modern financial conservatives: Size and market dominance do *not* mean greater efficiencies, lower prices and better service to the public. It means that mega-corporations are able to drive smaller, weaker competitors out of the market. Result: the public gets screwed and the corporate executives and their investors get seriously rich.

At first, everyone seems to benefit from deregulation and destructive competition. Consumers get access, not only to lower fares, but also to a luxurious array of flight-time choices. Naturally, as soon as the competition is crushed, air fares go up even higher than they were before.

A regulatory vacuum is an open invitation for the least principled corporate executives in an industry to exercise their most unethical options. The largest corporations, with the deepest pockets, are free to compete—not on the basis of providing the best product at the best price—but on the basis of their willingness to abandon all moral standards.

The weak-kneed "jawboning" approach of appealing to corporate executives to behave like decent, moral human beings has about as much impact as trying to get Republican bankers to voluntarily give loans at reasonable rates to poor people.

The results speak for themselves: In an unregulated environment, power, greed, money, and political influence win over honest competition every time. The small air carriers never had a chance.

The Need for "Big Government"

Liberals and Democrats didn't create "big government." Unethical businesspersons created the undeniable need for a government big enough to do its legitimate job of protecting truly free markets from those who would like to subvert them.

Consider the Savings & Loan scandal of the '80s, which cost the American taxpayer about $500 billion. *The Wall Street Journal* pointed out that the "U.S. Finds It Tough To Establish Crimes in Savings & Loan Mess," and noted that it was the result of "complex loan arrangements," and poorly designed or badly monitored regulations:

> Most failed S&Ls didn't collapse directly because of criminal activity; egregious mismanagement and feckless regulation were more often the culprits....
>
> The Bush administration's claim that it has responded sufficiently to the avalanche of S&L cases even has been undercut by the Justice Department's own calculations. In a study of 59 field offices last year, the FBI concluded it needed 425 new agents to begin work on some 2,300 languishing thrift fraud and embezzlement cases. Attorney General Dick Thornburgh has since deployed 202 additional agents—fewer than half of what the FBI requested.[4]

The 1980's S&L fiasco presents us with two major dimensions of the conservative war against sensible regulations: First, they do everything they can to make regulations inadequate in the first place; second, they make sure that funding of the oversight function is inadequate. This article demonstrated several things:

- Complex financial arrangements of corporations are deliberately designed to deceive. They present huge challenges for anyone who tries to investigate the behaviors of unscrupulous executives. That's why financial conservatives always support legislation that makes it harder for regulators to do their jobs. When conservatives say they want to get "big government out of *your* hair," they really mean out of *their* hair. The average worker has no reason to fear governmental intrusions into his uncomplicated financial dealings.
- Think what the FBI could have done if they had had $50 million and four years to do an investigation of almost any failed S&L in the country. Suppose also that they had absolutely no scruples and interviewed the lovers of all the main participants in the failure.

- Of course, "feckless (ineffective) regulation" is exactly what encourages "egregious mismanagement" to thrive in the first place.
- The allocation of inadequate funds to investigate the massive S&L scandals throughout the country was typical: To protect the wealthy and the powerful, the government approved the use of only "half the number of investigators needed."

If the Starr investigation of Clinton proved anything at all, it demonstrated that special investigators with unlimited resources and unlimited time could have thrown one-fifth of the people in the entire Savings and Loan industry into jail (or, for that matter, one-fifth of the current members of your local country club). Naturally, understaffing the FBI in the 1980s fit the conservative mood of the Congress at that time.

There is hope, however, that some financial conservatives are beginning to show faint signs of common sense about the need for regulations. The news division of *The Wall Street Journal* went against its usual anti-environmental editorial policies when it reported that "Fish Stories These Days Are Tales of Depletion and Growing Rivalry":

> Mr. [Walter] Pereyra [chairman of Arctic Storm Co.] says the best hope for big companies such as American Seafoods is more regulation, not less. "The days of being able to go from one resource to the next are gone," he says. "There aren't any uncharted horizons left."
>
> Knut Djuve, operations manager for American Seafoods in Argentina, agrees. He sees a clear message in diminishing catches and increasing conflicts between authorities and pirates. "It is just as important for us to have regulated fisheries as for the countries," he says. "You don't want to invest hundreds of millions of dollars just to fish out the waters in a couple of years."[5]

Business Week also demonstrated common sense when it editorialized about "The Year of the Punctured Myth." It analyzed the economic disaster in Asia and discovered

Myth No. 2. Less regulation is always better than more regulation. Just get the government out of the way and the economy will soar. Right? Well, the Asian mess is due in no small measure to the total lack of bank supervision around the Pacific Rim. Banks made nonsense loans to companies making nonsense investments.... A modicum of government oversight is needed to referee markets and make sure they play by the rules.[6]

Unfortunately, for financial conservatives, impending disaster is the only motivation for action:

- "Depletion and growing rivalry" says it all. As our earth and economy run out of resources, the mad, competitive scramble for a bigger share of what remains can destroy it all for everyone. In the case of natural resources, like fish, the absurdity of unregulated self-interest becomes obvious even to conservatives.
- Often the only answer to destructive competition is "more regulation, not less." Even the top executives of private companies recognize that their own survival depends upon protecting responsible corporations from the "pirates"—the unscrupulous competitors who are willing to destroy the entire fishing industry if it gains them short-term wealth.
- The "Asian mess" adds another dimension to regulation. Interesting, isn't it, that the Asian mess didn't become a mess until it caused the stock market to crash. As long as Asian workers were the only ones suffering, there was no need for governmental oversight. Child labor—no problem. Killing union organizers—no problem. All the wealth being siphoned off by the wealthy and powerful—no problem. The loss of buying power for the region's entire working class—no problem. A declining stock market—humongous problem, and a clarion call for action.

Naturally, the only oversight that conservatives want is the oversight that protects the money machine for the wealthy and powerful: the financial markets. Problem is, when all the wealth is in the hands of the top 20% of the world, and the bottom 80% no longer share sufficient buying power, we're in for a worldwide recession or worse.

Now consider an instructive example of necessary regulation. Think of the air we breathe, the economic benefits of additional gas mileage, and the chronic, paranoid, knee-jerk resistance of Republicans against all attempts to enact anti-pollution regulations. In a *Business Week* op-ed piece, "Don't Thank the Free Market for Eco-Friendly Cars," Robert Kuttner described how government, government regulations, and industry caused Detroit to develop more fuel-efficient engines:

> At last month's auto show, Detroit congratulated itself for finally getting serious about fuel-efficient engines.... Isn't the free market wonderful? Not exactly. This shift in Detroit's thinking can be credited substantially to the U.S. government, both through its anti-pollution regulations and the Administration's Partnership for a New Generation of Vehicles. States such as California have also raised standards....
>
> Why government involvement? Air pollution is what economists call a "negative externality"—something that market forces price too cheaply because they don't directly bear the cost.[7]

More fuel efficient engines. Remarkable! The auto industry was dragged kicking and screaming into the effort to improve gas mileage—with Republicans complaining that environmentalists would destroy the auto industry—and our country not only got better air quality but also incredible improvements in engine design as a result.

Thank heavens for progressive states like California and its stricter air quality standards. Because of its huge market for automobiles, it forced the auto corporations to meet more than just the national standards.

"Negative externality" is the fundamental reason we need regulations for every aspect of corporate activity that impacts the environment. However, the same thing can be said about all other corporate behaviors that transfer what should be their own costs onto workers, the economy, the taxpayers, or the community.

For example, in the past manufacturers didn't worry about carpal tunnel syndrome because the expense of the disability was shifted to

the employees; when the problem made itself known, or they could no longer work, they were "downsized" out of the organization.

If we are to regain control of our own government, we must first discover who sold us out to corporations to begin with. We get a fairly good idea from the following two excerpts. The first is given to us by *The Wall Street Journal,* which concluded that a "Generic-Drug Scandal at the FDA Is Linked to Deregulation Drive":

> The FDA's current problems are a legacy of the Reagan administration's push to deregulate. By scaling back their enforcement actions while publicly embracing the generic-drug industry as a "partner" rather than an adversary, the FDA created "an atmosphere of lawlessness," says Sidney Wolfe, head of the Public Citizen Health Research Group.[8]

The second excerpt comes from *Business Week.* In noting that "The Workplace Cops Could Use Some Backup," it described the conflict between the Clinton Administration and the conservative Congress:

> Buried in the (Clinton) Administration's new spending proposals are hefty hikes for regulatory enforcement espe cially for workplace issues such as civil rights, safety and health, and labor law.
>
> Some Republicans and business groups are gearing up to oppose what U.S. Chamber of Commerce Senior Vice-President Bruce Josten calls "the era of Big Government coming back." But that's a knee-jerk reaction. What's surprising this time is that there are business groups that support the hikes.... Decades of cuts have led to lax oversight, allowing sweatshops to proliferate, for example, and leaving law-abiding companies vulnerable to corner-cutting rivals.[9]

This last pair of articles presents the same cast of knee-jerk conservatives: Republican politicians, fossilized business groups, and the Chamber of Commerce. Except for those few business groups with some semblance of moral standards, conditions for workers and the health and general welfare of the public are irrelevant. Regardless of

how much economic power the richest, most powerful, and least scrupulous members of our society have—it's never enough for them.

Power Abhors a Vacuum

All societies and all markets are always controlled, all the time. Therefore, the only issues in any society, or market, are:

- Who's doing the controlling?
- How did they get their control?
- How are they using it?
- For whose benefit are they controlling?

Ideally, in a democracy, elected officials do the controlling for the purpose of maximizing genuine freedom for its citizens and businesses. The checks and balances of separated powers ensure that all issues and interests are represented fairly. When done ethically, this kind of control benefits society by ensuring that morally based corporations and businesses can dominate the free market by providing the best products and services at the best prices.

To accomplish this, the government must prevent corrupt special interest groups from subverting the system and its markets with their own controls. If government doesn't do its job, with monitoring and sensible regulations, then society—and its markets—become controlled by their most powerful and immoral predators.

And that's exactly what has been happening since Republicans and conservative Democrats began dismantling government.

The great irony is that now—with less "government"—there is more stifling control over the lives of working-class Americans than there was before. Today, in the absence of effective government, wealthy and powerful individuals and their corporations have almost total control of our economy and our markets. It's as simple as that.

- They bought off legislators who favored specific individuals, companies, and industries over the interests of the country.

- They bought unscrupulous lawyers who did whatever it took in court to prevent any lawful attempts to bring about fairness or justice for others.
- They bought control of markets, regardless of the negative effects on their competitors, consumers and workers.
- And, to add insult to injury, they not only bought anti-worker legislation in order to keep wages low—but they also paid conservatives in Congress to shift the tax burdens from themselves onto workers.

By now, it's obvious to almost everyone that wealthy individuals and corporations have purchased the federal government of the United States. They may not own it lock, stock, and barrel yet, but they're close.

The only mystery left about the corruption of the political process is why the public is so passive about it. A major reason has to be that the public knows that incumbent politicians in our two major political parties want to keep the system and they're not about to do anything to change it. It seems futile to work toward improving the system because the people who would do the correcting are themselves corrupt. There appear to be no other choices.

A second reason is that the public doesn't yet realize the magnitude of the damage that these entrenched conservatives have done to our economy and to the long-term welfare of our society—and especially to the long-term welfare of its working-class citizens.

Part 3 should help clarify these issues, as well as present some alternatives that many voters may not have considered.

Part Three

The War Against
Traditional Values

Greed is *always* in the news. The activists and advocates of this world are guaranteed to hit the greed button any time certain subjects come up: chief executive officer compensation, for example. Or threats to the rain forest. Or lowering the tax rate on capital gains....

It is worth recalling that greed (a.k.a. avarice) is at bottom a religious concept. It is one of the seven deadly sins, a package that seems to have originated in Christian monasticism in the Middle East, and was brought to the Western world around A.D. 400, apparently by Roman monks. In the medieval Church all seven sins were deemed especially wicked and all required special penitence. Nobody is demanding penitence today....

Face it: Self-interest is a universal human trait, a near-defining characteristic of Homo sapiens.... But if everybody is greedy (defined as "self-interested") then how can greed be the explanatory variable that accounts for business success? ..."greed." Let's deep-six the damned word.

—Dan Seligman, "Out, out, damned word!"
Forbes, March 9, 1998, 88-92.

16.

How to Destroy Traditional American Values

Conservatives have had a real challenge: How could they convince the public to vote for politicians who favor big corporations and the wealthy—and, no less, at the expense of middle- and working-class Americans? They have met the challenge with amazing ease.

All they had to do was gradually change our traditional American values of fairness and justice for workers to the conservative values of greed and materialism for the established and emerging wealthy. The only way they could succeed at this was to pervert our traditional values by changing their meanings.

It's gotten to the point in the U.S. that wealth is now automatically a sign of virtue and hard work, and—not incidentally—good genes. Poverty, even middle-class affluence, are, in themselves, signs of the indolence and depravity of people with questionable heritage.

By twisting words and concepts around, conservatives have made union members, truck drivers, and secretaries look like greedy, money-driven reprobates who create inflation—and investment bankers, chief executive officers, and professional athletes look like social workers who provide jobs for others.

Where Is the Outrage?

In the final weeks of the 1996 presidential campaign, Robert Dole and the Republicans won the values debate by default. They repeated over and over, "Where is the outrage?" They were referring to Clin-

ton's personal sex life and his private business dealings of 20 years previously.

Their unanswered attacks were so effective that most Americans gave the Republicans credit for maintaining the moral high ground for family values. Congressional Republicans were seen as a political balance to Clinton—not only as guardians of America's sexual standards—but also as defenders of workers against welfare cheats, taxpayers against "big government," small businesses against excessive regulation, and, in general, the moderate citizen against liberals.

If Democrats had understood the importance of the battle of values, they would have stressed the opposite side of the argument: Where was the moral outrage about what the Republican Congress did, tried to do, or proposed to do, to middle- and low-income families?

After all, Dole had to know that his tax proposals would greatly benefit the wealthy, that middle-income families would benefit very little, and that those at the bottom of the wage scale would actually lose benefits. Yet he constantly told the public that the purpose of his tax plan was to benefit typical working-class families. Where was the outrage about that kind of moral bankruptcy?

Republicans used every opportunity to weaken labor unions, explaining that they were defending workers against labor bosses. Yet history tells us, and current conservative financial publications confirm it, unions have always been a major force for increasing wages and improving working conditions for working-class Americans. Where is the outrage, in terms of traditional American moral standards, about deliberately reducing the power of the only organizations whose primary goal is to defend working American families?

On issue after issue, Republicans have become masters of the art of capitalizing on one set of values—power, greed, and materialism—while, at the same time, convincing the public that they hold a quite different set of values: the traditional values of work, compassion, and fair play. Basically, they do this by changing the definitions of what were once solid American values.

The Hard Sell

Some conservative assaults on our traditional values have been blatantly transparent. *The Wall Street Journal,* bless its avaricious

heart, surprisingly and objectively described how conservative "Christians" are trying to convince us, and themselves, that wealth is a virtue and that money isn't about materialism. Under the head "More Spiritual Leaders Preach Virtue of Wealth," the *Journal* observed that "God has a new co-pilot: Midas":

> In a convergence of the conspicuous consumption of the 1980s, and the more spiritual focus of the 1990s, the relationship between wealth and religion is becoming a hot topic in books, church programs, financial seminars and spiritual retreats. Some spiritual leaders even preach that there's a biblical imperative to making money.
>
> At Seattle's Christian Faith Center last month, a lecture by Paul Zane Pilzer, author of "God Wants You to Be Rich," drew 500 people who paid $50 each to attend. The church's pastor, Casey Treat, says his congregation was hungry for the message because of its "positive perspective. If we're all poor, who's going to help the poor?"[1]

It's the old conservative ploy: if you want to be a Christian, but don't want to live the life—then redefine what Christianity is:

- The first step for those who want to feel good about taking ruthless advantage of working Americans is to "pick a new set of spiritual leaders" who can give "the Midas touch" a whole new meaning—spiritual, of course.
- However, "conspicuous consumption" doesn't exactly fit: "If thou wilt be perfect, go and sell that thou hast, and give to the poor, and thou shalt have treasure in heaven: and come and follow me." (Matthew 19:21)
- If you are a rich conservative, $50 is probably well spent if it can convince you that there is a new way to interpret: "And again I say unto you, it is easier for a camel to go through the eye of a needle, than for a rich man to enter into the kingdom of God." (Matthew 19:24)
- Just "help the poor"? Why not use the massive funds of our well-financed conservative think tanks to "Speak up for those who cannot speak for themselves, for the rights of all who are destitute. Speak up and judge fairly; defend the rights of the poor and

needy." (Proverbs 31:8-9) If the rights of working Americans were well protected, they wouldn't be poor in the first place.

Fortunately, as the *Journal* also pointed out, some religious scholars are speaking out against the materialism movement. Unfortunately, only those who still believe that fairness and justice are virtues will listen to them. Conservatives have done a fabulous job of discrediting fairness and justice. For example, one-time Republican presidential candidate Jack Kemp equated fairness with class warfare, of all things, in *The Wall Street Journal* column "Notable & Quotable":

> Today we hear much in our politics about division—of rich against poor, black vs. white—indeed almost of class warfare, disguised as one word—"fairness." In today's political vocabulary, "fairness" seems to have become a euphemism for redistribution of wealth. But any true conception of fairness must recognize the necessity of a link between reward and effort....
>
> At the very moment when liberal democracy, private property and free enterprise are bringing down the Iron Curtain and tearing down the wall between East and West, we in America are being asked to choose between two opposing ideas—the politics of class warfare or Lincoln's all-embracing vision of boundless democratic opportunity.[2]

All through the 1980s, Republicans denied that the income and wealth disparity between rich and poor was growing into a chasm. Now that the income disparity is acknowledged by virtually everyone, Republicans like Kemp say that the income disparity that has been increasing for the past 20 years is as American as apple pie, and anyone who disagrees is waging "class warfare":

- Of course, Kemp ignored the fact that conservatives have been rapidly redistributing the wealth from working Americans to our richest citizens by using the class warfare methods described in the first two sections of this book.
- And does Kemp *seriously* believe that a person working in a chicken processing plant doesn't put as much effort into his work as, say, an investment banker who makes a thousand times as much?

188

Can he really believe that our current links between reward and contribution to society are fair?

• Is it possible that Kemp is unaware that Lincoln had something to do with an *actual, real war* to get fairness for blacks? You might even say he wanted freedom to be "redistributed" to blacks. So who were the class warfarers in the moral sense: Those who made blacks slaves—or those who went to war to free them?

Conservatives go to extraordinary lengths to sanctify their elimination of fairness or justice from their list of virtues. An apparently favorite method is to:

1. Find an obscure speech by a renowned dead white leader, say, Abraham Lincoln.
2. Then lift a quote from it that totally distorts his intent, and
3. Then claim that Lincoln had a peculiar notion of "justice."

For example, consider Gregory Fossedal's op-ed piece in *The Wall Street Journal*, "The American Dream Lives":

> America's dynamism ultimately challenges our notions of justice. Justice can't be "shared" across society; the essence of justice, of course, is its particularity. "Equal pay for equal work" is an accepted maxim, which to have any meaning must imply "unequal pay for unequal work," and even "no pay for no work."
>
> The principles of true justice never change, as Abraham Lincoln insisted in a 1859 speech: "A few men own capital; and that few avoid labor themselves and with their capital, hire, or buy, another few to labor for them.... This, say its advocates is free labor—the just and generous, and prosperous system, which opens the way for all—gives hope to all, and energy, and progress, and improvement of condition to all."[3]

Watch out. Whenever a writer on the *Journal*'s editorial page says he's going to clarify "our notions of justice"—realize that he'll define it in such a way as to make our greediest investors appear "just." The

Journal is always able to find a right-wing crackpot somewhere who is willing to put a conservative spin on almost anything.

Fossedal's quotation is from Lincoln's address to the Wisconsin State Agricultural Society, Milwaukee, Wisconsin, September 30, 1859.[4] He was speaking out against *slavery*, for Pete's sake.

He compared two ways of looking at capital and labor. The "mud-sill" theory assumes that labor is available only through someone having capital, who either hires laborers or *buys* laborers! The mud-sill theory also assumes that workers, hired or bought, are forever locked into their position in life (slavery, or a form of slavery). Admittedly, not a very nice theory.

To describe the alternative theory, our honorable Mr. Fossedal selected an excerpt from Lincoln's description of the "free labor" theory, which states that some people provide capital, some work for others, and some work for themselves and eventually may become rich enough to hire others to work for them. It all seems to fit in perfectly with modern conservative economic thought.

However, earlier in this same speech, Lincoln said that the free labor theory holds that "labor is prior to, and independent of, capital; that, in fact, capital is the fruit of labor, and could never have existed if labor had not *first* existed—that labor can exist without capital, but that capital could never have existed without labor. Hence, ... labor is the superior—greatly the superior—of capital."[5]

Now why do you suppose Fossedal ignored this part of the quotation he chose? To fit the editorial policies of the prestigious *Wall Street Journal*, defender of wealth and greed?

Naturally, the *Journal* doesn't have a monopoly on right-wing zealots. *Newsweek*, supposedly a moderate news magazine, has its own screwball-in-residence. Under the headline "Economic Amnesia," Robert J. Samuelson reported his concern that Alan Blinder, then vice-chairman of the Federal Reserve Board, could succeed Alan Greenspan, and judged that he wasn't qualified:

> Put simply, Blinder is "soft" on inflation. [He has the idea] that the Fed should raise and lower interest rates to keep the economy at, or close to, "full employment" without worsening inflation.

Blinder's views are spelled out in great detail in his 1987 book, "Hard Heads, Soft Hearts: Tough-Minded Economics for a Just Society...."

Blinder and those like him see themselves as economic engineers who can manipulate the whole process. As his book's title implies, the ultimate aims are to promote social justice and help the poor. Blinder is a decent man, and these are worthy goals. But except indirectly, they are not what the Fed is about. Price stability, not social justice, is the Fed's job.[6]

Horrors! Blinder is soft on inflation, and wrote a book about a just society. This one simple word, "just," is enough to terrorize Samuelson and his right-wing friends. Justice for working Americans is plainly un-American—bordering on communism or, at least, socialism—in today's conservative political environment.

Funny, isn't it. According to Samuelson, "price stability"—when the Fed raises the prime to slow the economy and keep wages from going up—is its legitimate job. If it should lower the prime so working Americans can get better jobs and higher incomes—that's "economic engineering" and a "manipulation of the process."

It's remarkable how modern conservatives hate *any* references to the traditional virtue of justice. And, speaking of justice, it's refreshing to read in the following two excerpts about the real motivations of those who are destroying the incomes of working Americans, and the way conservatives view the process. Under the head "Mr. Price is on the Line," *Fortune* explained that

> (Michael) Price's passion is polo, where the primary piece of equipment is a $40,000 pony.... One reason Price gets his way is that many investors simply agree with what he's trying to accomplish. And what exactly is that?
>
> He doesn't bother hiding behind the sanctimonious rhetoric of the 1980s raiders—that they were trying to take over companies and show the world how they should be run. He admits flat out that all he's trying to do is get the stock price up and if his tactics are a little rougher—all right, a *lot* rougher—than those of most other mutual fund managers, well, it works, doesn't it?...

Price saw to it that Al (Chainsaw) Dunlap was brought in to raise the price of Sunbeam's stock, which guaranteed large layoffs, 12,000 employees. The stock went up 50% when Dunlap's hiring was announced.[7]

So what's the big deal? It's all "psychological" anyway. Two weeks previously in another article, "Are Layoffs Rising Again?" *Fortune* had observed that

> Although layoffs are a small part of the overall employment picture, they seem to have an inordinate psychological impact, and they seem to be rising.
>
> Nearly 10,000 more people were laid off in September than in August, and for the first nine months job cuts are up 20% from 1995.[8]

If we're going to create a new class of American royalty—polo players with $40,000 ponies—we'll have to force working Americans to make some sacrifices. A way to do this is to pressure CEOs to fire many of their employees—thus forcing those remaining to work harder and to become more productive.

We can now forget the "sanctimonious rhetoric." The reason for most personnel cutbacks isn't, and never has been, to manage more effectively. It takes brains, talent and experience to manage effectively. However, any idiot can make a corporation more profitable by victimizing American employees, or by shipping their jobs overseas where other workers are openly brutalized.

Congratulations to Mr. Price, however. Finally, an investment manipulator tells the truth: All that counts is raising the price of a stock and increasing his own personal wealth.

Not to worry about workers, though. Layoffs merely create an *"inordinate* psychological impact." Of course, the numbers actually fired are not what is important: What *is* important is that modern barbarians like Dunlap are able to terrorize working Americans— nationwide—with the constant threat of downsizing. What a great set of corporate values we've created.

The Subtle Sell

Probably the most successful recent effort to pervert our moral values was William Bennett's *Book of Virtues*. It has been widely acclaimed in the news media and it's probably the slickest, most devious philosophical attack on working Americans yet published.

Take a look at the list of virtues that Bennett chose to head each chapter in his book:

The Book of Virtues[9]
by William J. Bennett

1. Self-Discipline
2. Compassion
3. Responsibility
4. Friendship
5. Work
6. Courage
7. Perseverance
8. Honesty
9. Loyalty
10. Faith

This is a powerful book because it does two things. First, it omits from any substantive discussion the virtues most important to the treatment of workers—fairness and justice.

Second, it allows wealthy conservatives who caused the income disparity between rich and poor to feel virtuous about themselves and to publicly claim the moral high ground. Note that, with the absence of fairness or justice, any greedy and materialistic chief executive officer today could meet the criteria for virtue on the basis of this list.

They're disciplined, give money to charity, are responsible to their shareholders, have friends at the county club, "work" hard, have the courage to fire thousands of employees, persevere in their efforts to make a profit, are honest (follow the laws that are biased in their favor), are loyal to the politicians who do them favors, and pretend religious fervor occasionally.

In other words, with a few rationalizations, the qualities of greed and materialism can easily be embraced by Bennett's list. His strategy: If you can't make greed a virtue, by blatantly calling it so, you at least can make the *pursuit* of greed a virtue by calling it work, perseverance, discipline, and so on. Of course, leave fairness and justice—in the ways work is rewarded—out of the picture entirely.

Admittedly, it's still a good list of virtues. Who can argue with loyalty, compassion, responsibility and so on. Still, how could anyone—that is, anyone who gives the subject more than five minutes of thought—leave out fairness or justice from a list of virtues?

It's not likely that Bennett simply didn't think of them, because he included "Plato on Justice" as a minor essay in his Chapter 8, which dealt with "Honesty." Look at Bennett's introduction to Plato's essay, and Plato's definitive statement about justice. Bennett:

> The ancient Greek word for "just" is a slippery one for modern translators. Depending on the context, it can mean honest, pious, fair, legally correct, lawful or obligated, to name a few possibilities. In the end, it may be that the meaning of Plato's "justice" comes closer to our modern notion of "integrity."[10]

Plato on Justice, from *The Republic*:

> But in reality justice was such as we were describing, being concerned however, not with the outward man, but with the inward, which is the true self and concernment of man: for the just man does not permit the several elements within him to interfere with one another, or any of them to the work of others—he sets in order his own inner life, and is his own master and his own law, and at peace with himself; and when he has bound together the three principles within him, which may be compared to the higher, lower, and middle notes of the scale, and the intermediate intervals—when he has bound all these together, and is no longer many, but has become one entirely temperate and perfectly adjusted nature, then he proceeds to act, if he has to act, whether in a matter of property, or in the treatment of the body, or in some affair of politics or private

business; always thinking and calling that which preserves and cooperates with this harmonious condition, just and good action, and the knowledge which presides over it, wisdom, and that which at any time impairs this condition, he will call unjust action, and the opinion which presides over it ignorance.[11]

Bennett's confused introduction is revealing. To include justice in his book, he must have searched for days to find an obtuse essay by Plato that has justice in the title, but has nothing to do with our modern concept of fairness.

In fact, when you read Plato's definitive statement about justice, you have to wonder: Does Bennett himself have the foggiest notion of what the hell Plato is saying here? (Your eyes aren't deceiving you. Plato did say all that in one sentence.)

So why did Bennett omit fairness and justice from his list of virtues? Easy: These virtues are not consistent with the political strategies of Wall Street and its supporters.

That's why the only references to these virtues in *The Wall Street Journal, Forbes, Fortune, Barron's* and *Business Week* are those that, in one way or another, justify greed and materialism. They *have* to say these absurd things in their publications. Their ability to maintain any semblance of a clear conscience and a pretense of virtue is to deceive each other and the public about their pretended moral superiority.

"Work"

Look at some other curious things in the "Book of Virtues," especially Bennett's definition of "work":

WORK

"What are you going to be when you grow up?" is a question about work. What is your work in the world going to be? What will be your works? These are not fundamentally questions about jobs and pay, but questions about life. Work is applied effort; it is whatever we put ourselves into, whatever we expend our energy on for the sake of accomplishing or achieving something.

Work in this fundamental sense is not what we do *for* a living but what we do *with* our living.[12]

This perversion of the definition of "work" has become an important part of the defense of greed. Financial conservatives align themselves with one of the most potent symbols of American values by expanding the definition of work to include just about anything. To give their own activities moral respectability, they make them equivalent to the work done by real workers.

Attila the Hun, Money-Changers-In-The-Temple, stock brokers, investment bankers, professional athletes, Hollywood actors, chief executive officers, real estate agents, politicians, and some of the greediest members of society fit Bennett's definition of "work" better than do truck drivers, assembly line workers, secretaries, farm laborers, janitors—and so on.

Most manual laborers work *for* the money. They have to to survive—not because, in some inspirational moment, that's what they choose to do *with* their lives (which, apparently, Bennett feels is a more virtuous motivation to work).

The Selective Scrooge

Bennett's selections of materials to put in his book are instructive. Of all the passages he could have taken from *A Christmas Carol,* Bennett picked:

Marley's Ghost
from *A Christmas Carol*
by Charles Dickens
(After Marley's Ghost complained of his "chain I forged in life," he described how his lack of compassion had led to his plight.)
"Business!" cried the Ghost, wringing its hands again. "Mankind was my business. The common welfare was my business; charity, mercy, forbearance, and benevolence were, all, my business. The dealings of my trade were but a drop of water in the comprehensive ocean of my business!"
It held up its chain at arm's length, as if that were the cause of all its unavailing grief, and flung it heavily upon the ground again.
"At this time of the rolling year," the specter said, "I suffer most. Why did I walk through crowds of fellow beings

with my eyes turned down, and never raise them to that blessed Star which led the Wise Men to a poor abode? Were there no poor homes to which its light would have conducted *me?*"[13]

Bennett chose a passage in which Marley's Ghost doesn't discuss his deplorable treatment of employees. Instead, he describes his failure to go outside his business to seek out the poor and give them charity.

So, what is the lesson we get from Bennett? After you become wealthy by screwing your employees—and making them poor—go to their homes and give them charity. How redeeming. How inspirational. How perfectly Republican!

Instead of this excerpt, what could Bennett have selected from Marley's *Ghost?* Why not use Dickens' description of the deplorable way Scrooge treated his clerk? His clerk worked "in a dismal little cell," and warmed himself with a comforter because Scrooge threatened to fire him if he used too much coal. No, that wouldn't serve Bennett's purposes—Scrooge's behaviors sound too much like the behaviors that modern conservatives endorse.

Or, from "The First of the Three Spirits," why not pick Dickens' description of Old Fezziwig? Fezziwig was Scrooge's former boss and he treated his employees decently. Scrooge observed that "He has the power to render us happy or unhappy; to make our service light or burdensome, a pleasure or a toil."

No, that wouldn't do either—it sounds too much like a virtue that today's corporate bosses should have, but obviously don't. And, of course, these are the same guys who finance the campaigns of Republican and conservative Democrat politicians.

Or, he could have quoted the passage from "The End of It," where Scrooge said to Cratchit, "I'll raise your salary, and endeavour to assist your struggling family, and we will discuss your affairs this very afternoon." Obviously, an undesirable concept in a book intended to make today's financial barbarians appear virtuous.

The Real Conservative Virtues

When conservatives extol the virtues of "hard work," they're saying:

- If your parents didn't send you to college, you are virtuous if you work two jobs in manufacturing plants or fast-food restaurants, develop carpal tunnel syndrome in both wrists, have no medical coverage in the process, and end up at the age of 65 with no retirement funds. Oh, by the way. Be a disciplined worker, be loyal to your employer, don't cheat your employer, get your satisfactions from your friendships, and be courageous. You must not be envious of the rich, or complain about how little you make compared to your bosses, or complain about your terrible work conditions. On the other hand,

- If your parents send you to college, or you inherit huge sums of money from them, you are virtuous if you have the discipline to go to France to study art, become an expert in French impressionist painting—and spend your life "working hard" by traveling all over the globe giving lectures. Oh, by the way. You have a moral obligation to complain about how much money uneducated or poorly born waiters and assembly-line workers make for doing such uninspired and uninteresting work.

Greedy and materialistic people never change their behaviors to meet moral or religious standards—they redefine their moral or religious standards to justify their egocentric behaviors. And when enough of them gain control of government, their concepts of morality become the new national standards for behavior.

The New Conservative Journalistic Virtues
These new national standards have enabled conservatives to develop—with clear consciences—weapons of economic warfare that are both subtle and incredibly effective. One of the most disturbing developments is their deliberate corruption of the journalism profession. Traditionally, journalism students have been educated to be as objective and fair as possible in informing the public about what is actually happening in the world.

Traditionally trained journalists have stringent professional ethical standards by which their communication performance is judged. Their news stories must be complete enough to be properly understood, important qualifications must be included, and facts must be verifiable. If a journalist should violate any of these standards, his

boss, his peers, and his professional associations would judge him harshly.

The right-wing Intercollegiate Studies Institute is changing all that. In its "America's student newspaper," *Campus*, it described how conservatives are "Advancing Student Journalism."[14] It bragged that "Key Conservative Leadership Organizations Unite to Provide Training and Tradition" to journalism students on college campuses. Although they claim that "We're not here to politicize anything," they state that

> The IPJ's (Institute on Political Journalism) mission is to expose underclassmen to the free-enterprise system and encourage them to support it through sound journalism....
>
> "We hope students come away with a real understanding of the free-market and sound principles and values," said IPJ Director Bill Keyes.[15]

It's downright scary. Right-wing conservatives are systematically "educating" underclass journalists about how to more effectively spread their "sound" economic values throughout modern America. That might help explain why, after the riots in Seattle over the World Trade Organization meeting, even supposedly "moderate" newspapers rushed to publish the standard conservative defense of our policies that destroy workers' incomes.

Under the head, "World Trade Helps the Poor," the *Charlotte Observer* chose to quote Bernard Wasow of the conservative Century Foundation:

> There is an irony in the choice of world trade as scapegoat. The United States would still do very well if it drastically cut down its trade with poor countries. The reverse is not true: The woman sewing a shirt in Bangladesh needs that income more than I need another shirt....
>
> If we shut down the opportunity to trade, in the name of justice and rights, we will create a world in which there is greater poverty, slower decline in population growth, greater pressure on natural resources and more misery than otherwise.[16]

Conservative "journalists" have learned to effectively incorporate into a brief quotable statement their two-step justification for waging class warfare on workers. First, claim that liberals' attempts to create a just society for workers actually create a more unjust world. If we would let free market greed rule business decisions, everyone would be better off.

Then, provide the totally distorted heart-rending example, the "woman" (or child) that liberals want to prevent from having a job, even though it is at starvation wages.

What's missing from this pathological misrepresentation of reality is the rest of the story. First, the woman in Bangladesh took the job from the woman in Korea, who took the job from the woman in Taiwan, who took the job from the woman in South Carolina, who took the job from the woman in America's Northeast.

That's the way the textile industry moved—always seeking women desperate enough to work for less money and under more brutal working conditions—and thus driving down the wages for all women at every previous stage of the process.

Of course, conservatives don't limit their hypocrisy to women. They also claim that their compassionate conservatism benefits Third-World children as well—when they give them the jobs formerly held by much higher-paid American men and women.

It's Not Fair and It Isn't Just

Who profits most from the movement of investment funds from country to country, based solely on which country has the lowest wages and the worst working conditions? Global investors, corporate executives and all those associated with the money and investment markets.

Who benefits from the cost savings of this kind of world trade? Everyone who buys the inexpensive products made by brutalized workers, including workers themselves—at least for the short term.

But who makes *all* the sacrifices, which are substantial and often permanent for vast numbers of people? Workers everywhere. Those who make up the majority of the world's citizens.

As a result of this disgusting process—with the total elimination of fairness and justice from our moral standards—modern conservatives have created a whole new class of American royalty.

17.

The New American Royalty

Most commentators missed the significance of *Forbes'* 1999 issue reverently devoted to the 400 richest persons in the United States. Sure, many marveled that more than half (268) of the members were billionaires. And in 1999 it required at least $625 million to be admitted to the group—a $125 million jump over the previous year.

What most people didn't stop to think about, however, were the other articles in the same *Forbes* issue. The "Families" article described all the families and heirs of millionaires who didn't qualify as the richest 400 because their fortunes were distributed to more than one person. These family fortunes were worth from $1.3 to $13 billion each.

The "Near Misses" article poignantly described all those who came close to being on the richest 400 list, but not quite. They only had a piddling $580 to $620 million each.

The "Drop Outs" consisted of those who used to be on the 400 list but who died recently or suffered stock losses, or whose wealth didn't increase fast enough for them to stay qualified.

Nowhere listed in this issue of *Forbes* were the thousands of persons in the lesser multimillionaire class who had achieved a somewhat less ostentatious, but still royal, life-style for generations of their descendants to come.

With monotonous repetition, *The Wall Street Journal* describes in its headlines the outlandish enrichment of corporate America's lesser multimillionaires: "Chairman Receives Jump of 35% in Compensation" (to $2.1 million); "Paine Webber's CEO Got Compensation

Totaling About $11 Million Last Year"; "Cendant's Silverman Got $27 Million in '97 In Exercising Options"; "Paxson CEO Awards Himself $1,875,000 Cash Bonus"; "Ex-Bank of New York Chief Received $31.5 Million in Compensation"; "Allied Signal's CEO Saw $23.1 Million Gain Due to Stock Options"—and on and on, day after day.

The real story of the 1999 *Forbes'* richest-400-issue—and the *Journal's* daily listing of world-class greed—is: While the real wages for most working-class Americans are just beginning to go up relative to inflation, after more than 20 years of stagnation or decline, our country is creating a large number of royal dynasties of people who will never have to work, except for therapeutic reasons, in their entire lives.

The dark side of this uplifting scenario is that all these people will expect working-class Americans to support them—and to provide them with their continued wealth—for as long as they can keep their well-paid conservative politicians in power.

Look at *Forbes'* description of the "Richest People in America," the "Forbes 400":

> Our billionaire ranks swelled by 79 names, to 268, making this the first year that billionaires make up more than half the list. Together, the 400 have a net worth of $1 trillion— greater than the gross domestic product of China. The minimum needed to get on: $625 million, up from $500 million last year.
>
> Clearly, there's no better time to be in the three-comma club.[1]

In its previous annual 400 issue, *Forbes* included an article that contended that "anyone with talent and energy" can get the necessary backing to take a shot at making a fortune. Under the head "Land of Opportunity," it claimed that

> America has created a system in which anyone with talent and energy has access to the financial resources needed for success. That alone won't lead to fortune, but it pretty much guarantees that talented people don't fail for lack of capital.

Today banks, venture capitalists, underwriters and stock brokers here don't much care who your grandfather was or whether you went to prep school or dropped out of college. All they care about is: Can we make some bucks by backing this guy (or gal)?[2]

A billion dollars is *one thousand* million dollars. So how does one go about getting capital to become worth that much, or even half that much? No doubt "talent and energy" help a lot. But inheritance counts for a lot more.

To see the extent to which these kinds of people brought themselves up by their own bootstraps, researchers Paul Elwood, S.M. Miller, Marc Bayard, Tara Watson, Charles Collins and Chris Hartman analyzed the *Forbes* richest 400 members for 1996 and 1997.[3]

In "Born on Third Base," they reported the results in baseball terms. They found that 43.35% of the richest 400 were actually born on home plate. They simply inherited their way onto the list.

Inheritances also appeared to help many people "work" their way onto the list: 6.85% were born on third base. In other words, they inherited over $50 million to begin their journey to wealth.

Five and three-quarter percent were born on second base, inheriting $1-50 million; 13.9% were born on first base, being merely upper class; and the remaining 30.1% started in the batter's box, having parents who did not have "great wealth or business with more than a few employees."

Uneducated, disadvantaged kids from the ghetto were mysteriously missing from the lineup of America's richest. And is it really true that people in the banking industry really "don't much care" who your relatives are?

To get an idea of who gets financial and business backing, and how the rich keep getting richer, read how *Business Week* answered the question "Can Sam Walton's Daughter Make It Big On Her Own?":

Rivals claim her new investment firm, Llama, has an advantage.... Some of Alice Walton's rivals charge that Llama is heavy-handed in using the family's political and economic clout, especially to win public finance contracts. One competitor says the company implies to potential clients

that the family or WalMart will reward them for hiring Llama. "It makes it a little tough to compete," says an-other....

Llama was recently selected to be the sole senior manager of a $33 million bond issue for Fayetteville. Rivals grumble that Llama sold fewer than a third of the bonds and paid other firms less than the usual concession for their help.[4]

Evidently, being a billionaire gives you the right—and power—to do less work and still make better deals with your business associates than can less well-connected people. A cynic might also point out that, if you have six individual family members, including yourself, listed among America's richest 400 persons to begin with, it's dif-ficult to fail. This is the same Alice Walton who, while intoxicated, careened her Toyota 4-Runner off a road and destroyed a gas meter and telephone box. She told a Springdale, Arkansas officer: "You know who I am, don't you? You know my last name?"

In its annual celebration of greed, *Forbes* often tries to demon-strate that inheritors of millions deserve to remain members of the world's aristocracy—because they sweat a lot. Under the head "Young, moneyed and driven," we learn how commendable, though demanding, it can be to inherit billions:

> So Dad's worth a billion—or more. What's that like? Some kids surely lead the jet-set rich-kid life, a la Mohamed Khashoggi, but many billionaire kids appear to have busi-ness in the genes, sweating to persuade Dad and Mom that they are fit to fill their shoes.
>
> The working rich kids share some common traits. Many have been educated in the U.S. They're comfortable with new technology and new management styles.[5]

Surely, working rich kids "share some common traits," commend-able ones at that. They get first rate educations at prestigious schools; they inherit a set of influential personal contacts (country clubs, alumni, industry associations, political acquaintances, family friends, parents' business associates, and so on); they get personal role mod-eling in the areas of management, finance, investment, tax avoidance and, in general, in the whole area of wealth accumulation.

Add a few million bucks, and you get the best financing rates from banks, access to expert advice in technology, marketing, and finance and—even better—if you fail at your fling in business, you just rely on the rest of your investments to continue to live like royalty for the rest of your life.

And there's the rub. America's ridiculously wealthy, whether they work or not, are successful or not, are a new class of royalty, with the traditional benefits of royalty, and there is almost no way they can lose. For America's new aristocracy, maintaining a royal status for their descendants—no matter what their talents, discipline, or effort—has become a science. In "Achieving Immortality via the Family Office," *Forbes* warned its readers that "You made your money the hard way, but will your grandkids know how to hang on to it?":

> By establishing a family office, you hope to protect heirs yet unborn against economic misfortune long after you are dead....
>
> Six generations after Commodore Cornelius Vanderbilt made his fortune, it [half-billion dollars] continues to grow. By pooling their money and following an aggressive investment strategy, 43 of the descendants of the Commodore's great-great-grandson William A.M. Burden...remain individully and collectively wealthy....
>
> Though all the Burden heirs are wealthy, few are by themselves wealthy enough to hire the specialized talent that the Burden office provides. "The beauty of it is, I can cherry-pick products and hire world-class money managers unavailable to ordinary investors," says Jeffrey A. Weber, the 33-year-old chief executive.[6]

Prior to ClintoReaganomics, workers made decent incomes, our country had a progressive tax system, unions had power, and everyone shared in the benefits of technology. It wasn't quite so automatic that descendants without any special talents would hang on to their inherited wealth, or even increase it.

But that was before Republicans and conservative Democrats got control of Congress and the presidency. Now—as long as our new American royalty can take ruthless advantage of workers all across

the globe—it has become an automatic right of birth to remain in the aristocracy.

With sophisticated investment management, generations of descendants will live like royalty long after today's patriarch leaves his legacy. These are the same sanctimonious hypocrites who say that requiring a decent minimum wage for beginning workers, or giving reasonable unemployment compensation to people who have lost their jobs, will destroy the incentive to work hard among the common folk. Evidently, it's a different story when conservatives give free, unearned millions—or billions—of dollars to their own descendants.

Two more observations: First, the *Forbes* article is another admission by the same people who want to privatize Social Security that good investment advice ("specialized talent") is hard to come by, even for relatively wealthy persons.

Second, working-class Americans should be aware that an "aggressive investment strategy" means that investments will be made in those countries that take the most ruthless advantage of workers. *The Wall Street Journal*'s following description of "aggressive" investing leaves no doubt about the moral standards of today's wealthy American investors. Under its appropriate headline, "The Haves," the *Journal* gave its vision of the future for American workers:

> If there's one thing you can count on in the 21st century, it's that the rich aren't going to just sit back and watch those fortunes dwindle away.... For a start, they're going to get a lot more aggressive about the way they manage their money....
>
> That means the rich will be shifting more of their funds to investments in rapidly developing nations where returns are likely to be highest, says Richard Marin, managing director at Bankers Trust Co.'s Private Bank in New York....
>
> Over the coming decades, this new group of rich people will be part of the greatest transfer of inherited wealth in American history as the parents of baby boomers—those born from 1946 to 1964—leave trillions of dollars to their children.[7]

Mere wealth preservation is no longer the goal of America's wealthiest. Neither is loyalty to this country, to its workers, to its communities, or to its environment. It's all about maximizing the personal wealth of oneself and one's descendants—no matter what injustices are perpetrated against others in the process.

When people invest in Third World countries with deplorable moral standards, they know full well that they are getting richer by betraying American workers and communities, and the environment. It's reported daily in our conservative financial publications.

The transfer of wealth from one wealthy generation to another, although massive and significant, isn't the most important transfer of wealth. Far more important is the preceding transfer of wealth from workers to investors. Investors have cashed in the value that workers built into this country prior to 1980 by selling out our industries, and using the funds to invest overseas where workers have no protections or bargaining power.

The full effects of this transfer of wealth are still to come, and the American public has yet to appreciate a simple fact: All these people are getting locked into life-styles that will require huge amounts of money in the future, and that will be the subject of the next chapter.

Aside: Virtue and "Family Values"

To make themselves appear more virtuous, modern conservatives have attributed "sound family values" to themselves, and they cite divorce and the lack of marital fidelity as major causes of poverty. They've even made the single-mother-with-children the poster mom for the link between poverty and irresponsibility.

Note that of 1999's richest 400 people, 72 were divorced once, 19 were divorced twice, 5 were divorced 3 times, one was divorced four times, and one was divorced 5 times. So much for the claim that wealth is the natural result of solid family values, and that poverty is the result of poor family values.

Of course, most of the 400 are married or remarried. Being filthy rich certainly makes one more desirable in the marriage market— even if divorced, ugly as sin, and with ten kids. On the other hand, even an attractive welfare mother, with just one kid, doesn't exactly have people standing in line to get married.

No doubt solid family values contribute to financial well being, but they are not the most important consideration. Political power,

inherited wealth, economic policy, education, opportunity, connections, and role models—not a responsible sex life—are the primary determinants of who gets rich.

As with all large-scale social injustices, when the economic system becomes too biased in favor of small groups of privileged people, bad things are going to happen.

The longer we continue to create large numbers of America's new royal class, the more painful any corrections will be for everyone, predators and victims alike, when the economic system reaches its limit. And time is getting short.

18.

Time Is Getting Short

In a front page article, "Wealth Gap Grows; Why Does It Matter?" *The Wall Street Journal* reported that

> For all the talk of mutual funds and 401(k)s for the masses...the stock market has remained the privilege of a relatively elite group. Only 43.3% of all households owned any stock in 1997.... Nearly 90% of all shares were held by the wealthiest 10% of households. The bottom line: That top 10% held 73.2% of the country's net worth in 1997, up from 68.2% in 1983....
>
> Stock options have pushed the ratio of executive pay to factory worker pay to 419 to 1 in 1998, up from 42 to 1 in 1980.[1]

If you are a middle- or low-income worker, this should worry you. Sure, the more money the rich make, the more they spend, and the more they spend, the more money lower-income workers can make. But that doesn't mean that everyone benefits in the long term, because money isn't wealth; it's just green paper or an entry on a ledger.

Real wealth—the kind that counts—is the kind of home you live in, the car you drive, the quality of food you eat, the effectiveness of the health care you receive, the kind of education your kids get, and so on. In other words, real wealth consists of things—products and services—that you can actually buy with the money *you* have.

209

Wealth Is a Zero-Sum Game

As all conservative economists know, and deny to the public that they know, wealth is a zero-sum game. That is true at both the front end—when income is divided up, and the back end—when it is spent.

The Front End of Zero-Sum: Dividing the Loot

There is only so much corporate income in a given year. The more of that income that is used to pay workers, the less profit the corporation makes. The less profit, the less the stock goes up. The less the stock goes up, the less the CEO and the investors make. It's as simple as that. Profit equals income minus expenses. No more, no less. Subtract the right side of the equation from the left side and the answer is always zero. Hence the term, "zero-sum."

So, to the extent a corporation can keep from sharing the wealth with workers—the ones who created the wealth to begin with—investors and executives get a bigger slice of the income pie and become richer.

To understand this aspect of the zero-sum nature of wealth, and the way many people get rich—that is, besides selling-out our workers to Third World countries—consider how Gates, Eisner, and Welch Jr. did it. It's no mystery, and it isn't all that hard to do.

Although the following specific details are fictional, the scenario is accurate. Through their emissaries, Mr. Bill Gates (CEO of Microsoft), met with Michael Eisner (CEO of Walt Disney Corp.), and John Welch Jr. (CEO of General Electric). Their discussion went like this:

Gates: "Gentlemen, you astute, wise, talented, outstanding, and morally principled managers of today—I can sell you something that cost me $10 per unit to produce for $400 each. It's a little disk with a bunch of zeros and ones on it."

Eisner and Welch Jr., in unison: "Why in the hell would we be stupid enough to do something like that?"

Gates: "Simple. It will enable your secretaries to produce twice as much work in half the time. In other words, you can fire half your secretaries—those who helped make your organizations successful in the first place. And the secretaries who remain will still work the

same hours for the same pay. You will cut your labor costs in half, the stock of your companies will skyrocket and your grateful shareholders will reward your managerial brilliance by making you incredibly, fabulously rich. Not like me, of course, but pretty damn rich.

"Here's another wrinkle you'll love. When your companies start growing again, Disney will hire the experienced secretaries that GE fired, and GE will hire the secretaries that Disney fired. Since they are new employees, they'll start out at base pay, which has hardly budged for the past 20 years—and with no benefits. Times are tough for secretaries these days, you know, with the corporate downsizing and all.

"Oh yes, with Republicans in control of Congress and Clinton appointing conservative judges to the courts, you can work your secretaries' asses off, and you don't have to worry about them getting carpal tunnel syndrome and suing you."

If you think that this scenario is far-fetched, read what *Barron's* had to say about "What's Behind America's Trend Towards Widened Income Inequality?":

> The revolution in office technology has broken the back of the market for secretaries and clerks. Robotics has destroyed whole categories of factory work. These seismic shifts have meant that millions of people who might otherwise have gotten the blue- and pink-collar positions in these sectors must now chase what jobs remain. And an increased labor supply generally brings a lower wage.[2]

Two simple questions: Who got most of the benefits of all this new technology? Who made *all* the sacrifices? It was no accident. It was a matter of naked greed combined with raw political and economic power. When those with the power divide up the income that workers generate, it's a totally zero-sum situation.

The same kinds of discussions occur daily in our major corporations, dealing with issues from outsourcing work to temp organizations, to closing down U.S. operations and moving overseas. When Michael Eisner insists that his suppliers use sweatshop labor in Third World countries like Haiti, Burma, China, and Indonesia, he's not "creating jobs for women and children." He's forcing American

211

manufacturers to abandon their communities and workers so that labor costs will go down and he will get a bigger share of Disney's income when it is divided up at the end of the year.

In exactly the same way, when John Welch Jr. forces his suppliers to abandon their communities and unionized American workers to go to nonunion Mexico—just like he has done with his own GE workers—he's not "creating jobs"; he is reducing labor costs so that he will get a bigger share of General Electric's income when it is divided up.

The people who divide up the spoils in this class war are the CEOs, investors, investment bankers, accountants, lawyers and general hangers-on who are associated with the power centers. They negotiate among themselves over who gets how much of the available money—a finite amount. When the feeding frenzy is over, the workers get what's left. If they're in a Third World country, and if they're lucky, they *may* get subsistence wages. If they are Americans, and if they are lucky, they get an opportunity to find another job, usually at lower pay.

The barbarians of antiquity at least had to work to earn their living. They rode horses in the snow, rain and mud, and used swords, spears, and arrows to destroy families and communities. Today's barbarians have it much better. They destroy families and communities by pitting workers against each other, and they can do it by using their telephones—and they don't even have to leave their comfortable air-conditioned offices.

The Back End of Zero-Sum: Spending Income

Since we live in a society of auction markets, the more money other people have, in effect, the less you have. Even *The Wall Street Journal* recognized this patently obvious fact in the previously referenced article, "Wealth Gap Grows...":

> A growing disparity in affluence *can* hurt the less well off, even if their incomes are also on the rise. In the San Francisco Bay area, where stock-driven wealth exploded in the 1990s, a middle-class family earns about 33% more than the national average—but has to pay up to four times the national average to buy a home because of intensely competitive bidding from freshly minted millionaires....

Cornell University economist Robert Frank argues that Silicon Valley could, as it has in so many other ways, be foreshadowing a national trend. From bigger cars to higher tuition for the best schools, the richer rich will ratchet up prices for everyone else. "Extra spending at the top," he says, "raises the price of admission."[3]

It's gotten to the point that even professionals like doctors and lawyers are sometimes being priced out of the kind of life-style they've grown accustomed to expect. *Fortune* reported that real estate prices in the San Francisco area have escalated to the point that "it has gotten so bad that well-salaried professionals without big options packages—even doctors and lawyers—simply can't compete."[4] They're being out-bid for traditional doctor/lawyer-type homes by the newly created multi-millionaires of the computer industry, who don't even have to bother applying for a mortgage. They pay cash.

The land-grab that the *Journal* and *Fortune* were referring to here is actually old hat. Back in 1993, *Newsweek* called the zero-sum nature of land and housing "Aspenization":

> A town [Crested Butte, Colorado] with such attractions is a natural target for what people in Colorado call Aspenization: the upscale living death that fossilizes trendy communities from Long Island's Hamptons to California's Lake Tahoe. Aspen was a splendid place, too, before it was discovered by the rich and famous—and the greedy and entrepreneurial. Now it's a case study in over-development. Its lavish second homes sit empty for most of the year while three-quarters of the work force, who can't afford to live there, commute from forty miles down-valley—a two-hour trek at rush hour.[5]

Similar situations are occurring all over the United States. People who do the service jobs along the North and South Carolina coast have to commute by bus 2½ hours each way to work. They can't afford the rents that have risen because the wealthy bought up available land and cheap homes, and replaced them with expensive homes, if not mansions. Even the city of Branson, in the formerly remote hills of Missouri, had to build dorms for workers, because

they could no longer afford the rents in the area after it was discovered by America's high-income earners.

It's not just in resort areas that low- and middle-income persons are feeling the pinch. From the mountains of Arkansas to the deserts of New Mexico, people are finding that a massive land and property grab has accompanied the huge increase in wealth of America's royalty. Even *The Wall Street Journal* expressed surprise at the rise in housing costs across the country in its article, "3BRs, 3 Baths, No Vu. Price: $500,000":

> What Can Half-Million Buy? Not Much, Even in Fargo
> …Weekend Journal recently went on a cross-country house-hunting tour, and we were amazed to discover how extensive and widespread the price increases have been. It wasn't just the usual real-estate nightmares such as Manhattan and Silicon Valley. In states from Oklahoma to Minnesota, we found half-million-dollar listings that upscale buyers only recently would have viewed as "starter homes."[6]

This kind of problem is going to spread in ways most people have not foreseen. In its article, "No Inflation? Look Again; It's confined to stocks today, but it will spread," *Barron's* warned its readers that

> Rising stock prices will inevitably lead to rising prices in the rest of the economy….
> Since much of the newly created money has gone into the stock market, stock prices have been bid up to astronomical levels relative to prices of other goods in the economy. Consequently, by selling some shares, stockholders have a great and growing ability to buy consumer goods, such as homes and automobiles.[7]

This warning is not often heard by those who have been conned into believing that everyone, even those who don't own securities, will benefit from a soaring stock market. And those who feel good about their $2,000, which grew to $4,000 in the stock market, had better get a grip on reality. By today's standards their $2,000 gain is a minuscule amount, and they're eventually going to lose most of it to

those who *really* made money in the stock market—or to those who are going to inherit massive amounts of profits from the stock market. When the wealthy start seriously buying up everything in sight, especially land and homes, low- and middle-income Americans will suddenly discover what the skyrocketing stock market was really all about.

This kind of economic reality doesn't hurt just poor people. *The Wall Street Journal* reported that even some "rich" people are being priced out of the market for the summer vacation rentals they've been getting in the past.[8] For the summer of 2000, it will cost $20,000 for two weeks in a cottage in Nantucket, a 25% increase over the previous year. In Martha's Vineyard, it's $3,000-5,000 a week for standard cottages. It's been estimated that the price for vacation rentals nationwide rose 18% in 1999, after rising 11% in 1998.

So, as the rich get a lot richer—and your increasing income doesn't keep up—*poverty* trickles down to you. You get priced out of the markets you have been able to enjoy in the past.

Similar observations could be made about college tuition, quality health care, meals at restaurants, automobiles, entertainment (from movies, plays, and concerts to professional sports events), and on and on. The same problem exists for virtually every aspect of life in which people must work in order to participate in auction markets. It even carries over into recreational opportunities and discretionary time with one's family, since people are forced to work more hours to keep abreast of rising prices.

Naturally, members of our new American royalty fully expect themselves and their descendants to stay ahead of the game and to continue to afford all the luxuries of modern life, and in unlimited quantity. Their supply of money will require high profits for corporations, investors and businesses—and low wages for workers—for as far into the future as we can see.

If you now live in a $200,000 home, drive a modest car, eat at home, never take vacations and plan to send your kids to a state university—and are satisfied with your life and don't desire any more— you may think that the inflation described above won't affect you.

Wrong. Remember: the writer of this book, the doctor you go to, the professor at your local college, your lawyer, the local pharmacist, your state senator, the managers and owners of your insurance com-

pany, grocery store, theater, hardware store—ad infinitum—they *have* been infected by the greed and materialism virus. In its article, "Amid Economic Boom, Many of the 'Haves' Envy the 'Have-Mores,'" *The Wall Street Journal* described how our greediest Americans are driven to become even richer:

> As the job market surges and the stock market has boom-ed, a wave of envy is gnawing at those near the top of the economic pyramid as they see others making even more....
> Even some of the newly envious feel vaguely guilty about it. But they are rankled nonetheless, especially when they compare themselves to neighbors, college classmates and former co-workers making far more in high tech, Wall Street, or as entrepreneurs.[9]

The only way these envious people are going to realize their dreams of a royal life-style is by charging you more for the products and services you must have. And if they have the power to pull it off, and you are powerless to stop them—count on it—they will. And the additional income you work for in the future will buy less than your present income buys today.

2000 Plus: 1929 and Déjà Vu All Over Again?

The fact that workers' wages started to go up in 1999 is small comfort. If increases in workers' wages don't keep pace with income increases for other categories of people, their net wealth—in terms of what their money can buy—goes down.

The problems that have plagued societies since the beginning of time are the same that today's conservative financial press describe in their news stories. Wealthy conservatives never seem to recognize when their accumulation of power and money becomes excessive to the point where it is self-destructive.

As today's conservative financial press clearly recognizes, the wealth and income disparity is continuing to get worse. It isn't debatable any more. Conservative pundits have had to change their position from the 1980s—that the income disparity didn't exist—to today's position: it exists, but it's fair because the rich work harder and are more successful than anyone else.

They continue to deny that income disparity is the result of their power and their control of politicians, and they've been able to convince the majority of voters that their political policies will eventually benefit everyone.

It's only when the economy comes crashing down that those same voters will discover the long-term disaster that they have brought upon themselves. Just what will happen when:

- The bottom half of the world's consumers no longer have enough money to purchase the products they need, as happened in the late 1920s, and more recently in Asia, South America, Russia, and most of the Third World?
- Wealthy investors, to preserve their assets, withdraw their funds from the stock market, as they did in 1929-32?
- Recently affluent executives and investors suddenly find their income streams cut off and can no longer make payments on $500,000 ranchettes and $1,000,000 homes?
- Social conditions for the poor become intolerably worse, with the corresponding increase in crime, drugs, divorce, child and spouse abuse, violent revolutionary groups, etc.?

If you think that wealthy conservatives will invest their money in order to provide jobs and to help our country solve its problems, forget it. That isn't *ever* why they invest.

They also don't invest to get tax breaks, or to stimulate the economy, or to help out their community. They invest only to get rich off the labor of others. And if they are already rich—and see that the stock market is crashing—they simply withdraw their funds and use them to buy up severely depreciated homes, farms, raw land, and whatever else desperate people are dumping onto the market.

But, that's all somewhere in the distant future, right? The constant drumbeat we hear today is that this is the best economy we ever had, and we'll never again be as bad off as we were in the depression. There is simply too much wealth and prosperity to spread around for us to worry about who is getting how much, to what effect, and for what effort.

Sounds good, but if you read between the lines, you find that even conservatives are beginning to worry. A schizophrenic optimism/ pessimism duality is beginning to surface in the financial press. Sure,

conservatives tell us that times have never been so good. But, almost as an afterthought, they admit their nagging suspicion that all is not well in this economy that shamelessly favors the rich—at the direct expense of the poor and middle class.

For a classic example of this kind of duality, look at *Fortune*'s description of this best of all economic worlds in its article, "These Are the Good Old Days." After repeating the usual mantra of low inflation, booming business, and low unemployment—better even than the "swinging sixties," "earnest fifties," or "roaring twenties"—it acknowledged:

> Not that it's a perfect economy. Eleven percent of America's families live in poverty. Many others have suffered a decline in real income since 1989....
>
> Wages have stagnated—the often-quoted Department of Labor figures show that the average hourly wage today is worth only $7.50 in 1982 dollars, down from a peak of $8.63 in 1973.... Average family income has grown robustly, due in part to millions of wives who've taken jobs....
>
> But perhaps the single biggest long-term danger for the U.S. economy isn't one that will much affect the normal economic measures or pose any immediate threat to the current expansion: the growing gap between rich and poor, and between those who have the education and skills to benefit from the emerging high-tech economy, and those who don't. While millions of Americans have marched into comfortable prosperity, at least as many—perhaps even more—have fallen back.[10]

So, this is how conservatives describe an economy that "is stronger than it's ever been before":

- Jobs are plentiful (enough for workers to work two jobs),
- Business sales and profits are growing,
- Inflation (increase in wages) has almost disappeared,
- The financial markets are booming, and
- We're leading the technological revolutions of our age (so the wealthy and educated will continue to benefit).

That's right, the best economy so far. After all, conservatives never evaluate an economy on the basis of:

- The number of American families who live in poverty,
- The number of persons who suffered a decline in real income,
- Stagnating wages, or the fact that now,
- Wives have to work so a family can have a decent income.
- The income gap between rich and poor is exploding, or the fact that
- At least as many (as got rich)—perhaps even more—"have fallen back" in terms of their inflation-adjusted income.

This is a better economy than the one we had in the "swinging sixties" or "earnest fifties," when the income gap was narrowing? When wives didn't have to work, and husbands had time to spend with their families? When working Americans had reasonable levels of income and job security? When those who benefited most from our nation's economic policies paid far more taxes (70-90% of income between 1942 and 1982) than did those who were making all the sacrifices?

So, after the wealthy, educated, and powerful benefit from the sacrifices that they forced on workers, what will they do when the economy tanks? Bet the farm on it: When the going gets tough, the wealthy and powerful will get going—as in "gone." In a *Forbes* op-ed piece, "Time to Switch," Steve Hanke described the standard time-honored strategy for sophisticated investors when it looks like workers are about to make more money, thus cutting into corporate profits:

> All seems right with the world. The Dow is up 85% over its reading of a little more than two years ago....
>
> [But] How will higher wage costs play out? With little pricing power in the markets for goods, business will just have to eat the higher wage costs. As wage pressures slowly build, sky-high profits won't be sustained. A prop gets knocked out from under the stock market....
>
> Given this state of affairs, what should investors looking for value do? As he was rushing to catch a flight to London

from his home in Nassau, Bahamas, the ever-wise Sir John Templeton remarked to me last month that it is now time to switch from stocks to bonds. I agree.[11]

Although this investment advice was at least three years premature, it shows that wealthy conservatives always remain alert to danger signs that indicate when it is time to withdraw from the American economy: Low unemployment rates, average hourly earnings begin to creep up, and sky-high profits aren't as easy to come by.

So what are investors to do when it looks like the economy is going to tank? Switch from stocks to bonds, of course. That is, quit investing in the kinds of securities that produce products and services, or create jobs. After all, when the majority of the public has no money to buy products and services, why invest in a business to produce them? In other words, if times get tough—because of what wealthy conservatives have done to the purchasing power of workers—bail out of the economy. The party is over! Take the money and run! Switch from stocks to bonds. Make sure you and your descendants stay rich.

Signs are proliferating that time is getting short for the burst of our economic boom. Almost daily throughout 1998 and 1999, there were reports about the danger that workers may begin to share the prosperity of the previous two-and-a-half decades. In one of its periodic "The Snake in Wall Street's Eden" articles, *Business Week* noted that "1998 is looking more and more like the year reality creeps into paradise":

> 1998 looks more and more like the year when economic reality overtakes nirvana. That is, exceptionally strong economic growth and red-hot labor markets will eventually have unfavorable consequences for profits and Fed policy....
>
> Aside from some weakness in exports and manufacturing, there is nothing in the latest data to show that Asia by itself is slowing the economy sufficiently to blunt rising labor costs or ease the Fed's growing concern that overly rapid growth in 1998 could fuel inflation in 1999.[12]

An entire book could be filled with articles just like this that were published by the conservative financial press throughout 1998 and 1999. Conservatives prove beyond doubt that when they brag about this economy being the best ever, they don't include working-class Americans in their rosy scenario.

They openly admit the zero-sum nature of corporate profits—the more money workers get, the less the investors and executives will get. If the economy ever gets to the point where workers' wages start to go up, it's time to pull the plug on economic growth and raise interest rates.

But that could cause the economy to come crashing down. Increased profits would be harder to come by. Not only that, the bottom half of consumers all across the globe are running out of money. Even *The Wall Street Journal*, in its more honest moments, saw the problem and described it like it was. Under the head "U.S Firms May Lose Labor-Cost Advantage," the *Journal* publicly acknowledged that "During most of the 1990s, U.S. manufacturers have cashed in on a great bargain: the American worker":

> U.S. factory wages and benefits have remained low, compared with those in many other industrialized countries. And companies have turned that edge into growing global market share and solid profits. Recently, however, several factors have combined to reduce that labor-cost advantage....
>
> Foreign companies are starting to adopt some of the cost-cutting tactics that U.S. companies introduced earlier in the decade.... Many of America's competitors, however, are just starting to downsize, outsource or otherwise trim labor costs....
>
> "I think we've reached the limit to squeezing labor," Mr. Roach [chief economist for Morgan Stanley Dean Witter] says. "I think that process is just beginning in Europe, Japan and probably developing Asia."[13]

Incredible. As if workers in the U.S. haven't already been squeezed enough by having to compete with victimized workers in other countries—now their competitor-workers are themselves going to be squeezed even more.

A trio of articles from the same issue of *Business Week* gives a hint of where our country is in its economic cycle. The first, "Up in Arms But Down in Clout," describes how even the most profitable corporations are cutting union jobs:

> Companies in industries from apparel to electronics have shifted production to nonunion shops and to Mexico....
>
> Even the most profitable companies are still cutting union jobs. In June, General Electric Co. announced that it would lay off 1,500 members of the International Union of Electric Workers...where pay averages $17.50 an hour. Some jobs will go to nonunion workers earning $9 an hour at a plant GE bought in LaFayette, Ga. Others will be moved to a joint venture GE has in Mexico with a Mexican company called Mabe.[14]

These are not just American low-tech jobs, and it's not just American union members who are hurting in the exodus of industry from our country. In the second article, "Why Mexico Scares the UAW," *Business Week* revealed that

> No longer do Mexican workers merely produce low-tech parts such as wire harnesses and seat covers. Now, dozens of new plants churn out higher-tech components such as airbags, brake systems, and instrument panels for automakers in the U.S., Europe, and Japan. And Mexican engineers, skilled but paid a fraction of what U.S. counterparts earn, design and test transmissions, brakes, and engines at state-of-the-art facilities, such as GM's Delphi Division technical center in Juarez.[15]

No doubt die-hard conservatives will see no relationship between the previous two articles and the following article from the same issue of *Business Week*. For those with some sense of history, however, the third article, "The Summer of Wretched Excess," is prophetic:

> Religion in the Hamptons means repeating "thank you God for Alan Greenspan" at every party, every polo game,

and every benefit. It's the mantra of money in this summer of glut....

Yet, all is not perfect in this monied paradise. Beneath the gloss there is an edginess. "When will it all end?" is heard as much as "Is that Martha Stewart?"... No one actually says it out loud, but the question is always there: If the market goes, how in the world will I pay for that enormous house? The cars? The lessons? The clubs?" How will I remain a dues-paying member of the leisure class?...

So, people bravely party on. The extravagant benefits with chandeliers adorning giant tents, the networking, the dancing, the celebrity shoulder-rubbing. It's splendid. It's exciting. It's like that other Long Island party that Gatsby threw in the '20s, waiting to end badly.[16]

Conservatives have done such a thorough and complete job of destroying the incomes of working-class Americans that it's impossible to tell how long the party for our new aristocracy will last. Another year? Two years? Five years? Who knows?

But what we know for sure is: the longer the party lasts, the more disastrous it will be when it ends. Of course, for those who have built up substantial financial resources—those who are already paying cash for their homes and businesses—it will be an economic boon. They will be able to increase their ownership of our country even more, as real wealth—land, buildings, businesses, etc.—go on the auction block at fire-sale prices.

Those who can least afford the end of the party—those who have no financial resources to fall back on—will present our society with problems that have no acceptable solutions. Certainly, the conservatives of our society, and especially our politicians, will not want to address them, or to admit their own roles in creating them.

So. What do we do about all this?

19.

Workers of America, Unite!

Because Conservatives Already Have, and They Own Congress and the Presidency

In his classic book, *Whatever Became of Sin?*, Karl Menninger equated mental health with moral health. After referring to Arnold Toynbee's observation that "all the great historic philosophies and religions have been concerned, first and foremost, with the overcoming of egocentricity," he went on to conclude:

> Egocentricity is one name for it. Selfishness, narcissism, pride, and other terms have been used. But neither the clergy nor the behavioral scientists, including psychiatrists, have made it an issue. The popular leaning is away from notions of guilt and morality.... Disease and treatment have been the watchwords of the day and little is said about selfishness or guilt or the "morality gap." And certainly no one talks about sin![1]

If the clergy and behavioral scientists are leaning away from notions of morality, what can one expect of those whose professions are primarily concerned with personal power and wealth? Consider Dan Seligman's previous rationale for "deep-sixing" the word "greed" (see page 183). Similar justifications for greed and materialism are spoken or published almost daily in the mass media.

The rationale seems to be that "greed is what made our country successful," "greed is responsible for the greatest economy mankind has ever developed," and "greed is the essence of capitalism."

None of which is true. As Toynbee and the world's mainstream religions have concluded, in one form or another, greed is one of the seven deadly sins—and for good reason. It eventually destroys human organizations and societies. If unchecked, it will destroy our capitalistic system.

Apologists for America's wealthy and powerful deliberately confuse greed with a normal, healthy, self-interest. Self-interest is the necessary motivation that enables a person to provide for the welfare of himself and his family—adequate housing, food, education, health care, a good sense of values, and so on.

But self-interest becomes greed, as any dictionary defines the term, when it becomes *excessive*: when it leads to behaviors that are dishonest, fraudulent, devious, deceptive, or manipulative. The people who made the United States the greatest and strongest country in the world were *not* greedy. They were dedicated to the ethical and moral standards of their professions or work. They succeeded *in spite of*, not because of, the greed of others. They overcame the negative and costly effects of greed on society:

- They went into the medical profession because healing the sick was their calling, and patients' care and welfare was their primary consideration.
- They became journalists because they wanted to report the truth as objectively as possible, and—in the process of reporting what was actually happening in the world—most became liberals.
- They went into business in order to provide a quality product or service for the public at the lowest possible price and with a decent return to themselves.
- They went into politics in order to make our society a better place for everyone—which meant that they had to protect the free market from unscrupulous predators, and to uphold the rights of investors, workers, and the general public.
- They worked as laborers in order to provide a decent living for themselves, and to do a responsible job of raising their families.

Since the mid-1970s, wealthy conservatives have pursued policies that have changed all that—at least for our most basic industries and businesses, for some of our most important professions, and, especially, for our political·environment. Now, greed and materialism have replaced the virtues of fairness and justice. Profit, the bottom line, and personal wealth, in themselves, justify *any* kind of behavior as being morally acceptable:

- Most of our basic manufacturing industries have either left the country or they have adopted employment and pay practices that place our country back in the pre-1930 era.
- Big business has taken over the medical profession. They promote and give bonuses to the doctors and nurses who will give the stingiest care possible at the highest price. Naturally, they ignore patients who can't pay. Medical professionals who uphold their traditional values may be fired or blackballed.
- More people become journalists because they want to advance the interests of their conservative sponsors—the ones who financed their education, and can give them promotions, salary increases, power and prestige.
- More people go into business only to make incredible amounts of money in the shortest possible time, and nothing is unethical if it improves the bottom line—or if a person can't be convicted in a court of law.
- More people go into politics in order to advance the interests of those who give them the most money, which automatically means that wealthy investors gain control of the markets, keep workers' incomes as low as possible, and remove protections of the environment—and to hell with the rights of consumers, communities and the general public.
- As a result of the above, laborers have to work in two or more jobs in order to provide a marginal living for their families. Too many of them have precious little time to do a responsible job of raising families.

The transfer of wealth and power from those who work to those who manage money, information, ideas, and people is just about complete. Investors, corporate executives, accountants, consultants,

investment bankers, and related professionals now have the power to command almost unlimited incomes for themselves.

They do it by inserting themselves between those who produce products and services—workers, engineers, scientists, doctors, true "family farmers," nurses, truck drivers, and so on—and the consumers of those products and services. At every step, from financing a new business venture to advising corporations about how to prevent unions, they take huge amounts of money for themselves and leave relatively little for those who are the true producers of wealth in our country.

It took conservatives at least 20 years to create this kind of political and economic system, although they've been working at it and making slow progress for the entire century. It also will take at least 20 years to reverse. It will be a long and difficult task, but it can be done.

First, a Non-Option

Those who value the kind of democratic capitalism that America had from the mid-1930s to the mid-'70s might be tempted to misplace their anger about what Republicans and conservative Democrats have done to this country.

Joining the right- or left-wing crazies who store weapons and plan to destroy the U.S. government, any of its buildings or any of its officials just shifts the problems from one bad form of government to an even worse form of government. At least the bad government we now have is democratically and peacefully elected.

There isn't an identifiable militant fringe group in the country whose leaders have benevolent intent. Even if one of the more popular fringe groups ended up in power, most people wouldn't want to live under its idea of government.

Instead, those who don't like what is happening in this country must work for peaceful, *political* change. With all its faults, democratic capitalism is the best system mankind has come up with. Our country just has to regain the values and policies that made it great.

The #1 Priority

There are all kinds of valid ways to improve a society. Some emphasize personal action: organizing workers, teaching values to children, volunteer work, conserving energy, donating to charity, writing

letters to the editor and so on. These are important, but they pale in comparison to getting the right persons into political office, especially at the federal level—because the federal level affects what happens at the state and local levels.

If national labor laws are biased against unions, it's almost impossible to organize workers, as the "right-to-work" states have amply demonstrated. When an individual buys and drives a compact car, he pollutes the air less, but his impact is overwhelmed by the fleets of SUVs that our national and state laws allow and even encourage. Private donations to charity certainly help the poor and are necessary, but as the great depression proved, in a real economic crunch private charity will last for a few months at best.

The basis for meaningful change—the change that allows further positive changes to occur—is an informed, politically active public that votes the right people into office in the first place. So,

1. As a general rule, and barring unusual circumstances, never, *ever*, vote for a Republican, anywhere, for anything—even for the proverbial dog catcher. *All* the Republicans voted against the 1993 Deficit Reduction legislation. Misguided voters who thought they were voting for moderate Republicans in 1994 and '96 actually, in effect, gave more power to their anti-worker right-wing Congressional leaders.

 Qualification: I know an exceptional Republican—who once was an Illinois politician—who I would vote for every time. But, again, barring similar unusual considerations, the general rule applies.

2. Vote for a conservative Democrat *only* if there are no other realistic choices, and if a non-vote would result in a win for a Republican.

3. In the primaries, pick a traditional, liberal Roosevelt/Truman-style Democrat who has a realistic chance of winning over a conservative Democrat.

4. *Always* vote for a progressive populist if one is available. A few Democrats fit the bill, but not many. Maybe the next economic downturn and its accompanying problems will encourage more Democrats to remember what their party used to stand for, and why.

228

Progressive Populists

It's easy to identify the progressive populists who believe in the kind of liberal Roosevelt/Truman-style democratic capitalism that we had from the 1930s to the '80s. Progressive populists:

- Support a progressive income tax (higher taxes for those who have benefited most from the sacrifices forced upon working Americans)—*versus* those who want to reduce inheritance, capital gains, and real estate taxes for the wealthy.
- Support a reduction in regressive taxes, such as sales and social security taxes—*versus* those who support flat taxes and increases in sales taxes, which hit low- and middle-income citizens the hardest.
- Support laws that protect the rights of workers to collectively negotiate for wages and humane working conditions through their organized unions—*versus* those who use their power to destroy unions and decent working conditions.
- Believe that world trade can be truly free *only* when it is managed. That is, businesses with high moral standards—those who respect workers, the environment and the public—must be protected from unprincipled competitors, and be able to compete on a level playing field.
- Work to improve relations between cultural subgroups—*versus* those who use code words and divisive rhetoric to drive wedges between them. Progressive populists are interested in justice and in improving conditions for all Americans. This is what separates them from some of the so-called populists who want to demagogue their way into political power.
- Work to improve the environment—rather than corporate bottom-lines—so our descendants will be able to survive beyond the next 20 years.
- Recognize that it is always cheaper and more efficient to prevent our nation's problems from growing than to ignore them until it is too late to take effective action. Progressive populists believe that proactive problem solving is preferable, and ultimately more cost effective for the taxpayer, than cutting taxes for the wealthy.

In other words, progressive populists actually believe in government. They recognize that no private organization has as its charter

the obligation to solve social problems—only our democratically elected government does.

Now Is the Time

The revered guru of modern corporate philosophy, Milton Friedman, posed and answered his famous question: "So the question is, do corporate executives, provided they stay within the law, have responsibilities in their business activities other than to make as much money for their stockholders as possible? And my answer is, no they do not." This is one of the most frequently quoted justifications for greed that today's corporate executives cite.

Face it. Unless there is a profit in it, corporate executives not only feel no responsibility for how their actions and decisions affect average Americans or their local communities—they sanctimoniously claim a moral superiority for holding such selfish values.

An effective government—with honest, not-paid-for politicians—is our only defense against corporate executives who have no moral standards for the treatment of workers or the general public.

So, prepare to participate in political discussions and to influence the ways other people vote by reading the news pages of *The Wall Street Journal, Forbes, Fortune, Barron's* and *Business Week*. Their news reports are fairly accurate and can't help revealing what corporate America and our right-wing politicians are doing to workers at all levels. Read their editorial pages and opinion pieces for entertainment only; they are so violently anti-worker, anti-government, anti-tax-on-the-rich, and pro-corporation, it's hard to see how anyone can take them seriously. (Don't support these conservative publications by actually buying them; they're in most libraries and the *Journal* can be found lying around almost anywhere.)

The recommendations about voting may seem a bit dogmatic and extreme. Not at all. Conservative politicians have made such inroads into the American psyche that they've become outrageously overconfident. They don't even try to disguise their pro-business, anti-worker biases anymore.

As the materials throughout this book demonstrate, their behaviors have become blatant to the point of recklessness, and they've done almost irreparable harm, not only to working-class Americans, but also to one of the greatest economies ever developed in history.

The voting public needs to send a message. Now.

Notes

Preface
1. "The Prosperity Gap," *Business Week*, September 27, 1999, 92.

Introduction
1. *Wall Street Journal*, May 11, 1998, A2.
2. "The Fed's Rivlin to Bond Market: Calm Down, It Really Is Different This Time," *Barron's*, May 31, 1999, MW16.

Chapter 1
1. *Forbes*, January 30, 1995, 39.
2. Ibid., 39.
3. *Forbes*, May 20, 1996, 184.
4. *Barron's*, December 5, 1994, 49.
5. *Business Week*, November 11, 1996, 31.
6. *Fortune*, August 19, 1996, 36.
7. Ibid., 36.
8. *Business Week*, May 9, 1994, 23.
9. *Barron's*, October 14, 1996, 52.
10. *Wall Street Journal*, January 2, 1997, R1.
11. *Wall Street Journal*, February 27, 1997, A2.
12. *Business Week*, March 22, 1999, 31.
13. *Wall Street Journal*, August 12, 1999, A2.
14. *Business Week*, May 3, 1999, 188.
15. *Business Week*, May 3, 1999, 194.

Chapter 2
1. *Wall Street Journal*, September 8, 1994, A10.
2. *Forbes*, February 10, 1997, 40.
3. *Fortune*, June 10, 1996, 22.
4. *Business Week*, January 27, 1997, 21.
5. *Business Week*, February 10, 1997, 29.
6. *Business Week*, February 10, 1997, 42.
7. *Wall Street Journal*, May 5, 1997, A2.
8. *Wall Street Journal*, May 5, 1997, C13.
9. *Wall Street Journal*, April 30, 1999, A2.
10. *Business Week*, July 19, 1999, 37.

Chapter 3
1. *Wall Street Journal*, January 24, 1995, A1.
2. *Business Week*, November 27, 1995, 38.
3. *Wall Street Journal*, January 27, 1997, A1.
4. *Barron's*, November 11, 1996, 60.
5. *Barron's*, July 8, 1996, 27.

6. *Business Week*, May 24, 1999, 23.
7. *Wall Street Journal*, December 14, 1999, A6.

Chapter 4
1. *Barron's*, September 9, 1996, MW10.
2. *Business Week*, October 21, 1996, 29.
3. *Wall Street Journal*, March 10, 1997, A2.
4. *Wall Street Journal*, April 11, 1996, R1.
5. *Business Week*, April 21, 1997, 59.
6. *Wall Street Journal*, November 1,1999, A1.
7. Ibid., C1.

Chapter 5
1. *Business Week*, January 27, 1997, 4.
2. *Barron's*, May 30, 1994, 29.
3. *Wall Street Journal*, October 11, 1994, A1.
4. *Wall Street Journal*, February 27, 1997, B10.
5. *Wall Street Journal*, February 23, 1999, A1.
6. *Wall Street Journal*, March 8, 1999, A1.
7. *Wall Street Journal*, May 6, 1999, A2.

Chapter 6
1. *Business Week*, November 6, 1995, 161.
2. Ibid., 161.
3. Ibid., 161.
4. *Wall Street Journal*, September 30, 1994, A1
5. *Business Week*, Special issue, "21st Century Capitalism," 112.
6. *Wall Street Journal*, March 17, 1993, A1.
7. *Wall Street Journal*, June 15, 1999, A1.
8. *Wall Street Journal*, July 29, 1999, A2.

Chapter 7
1. Bureau of Labor Statistics, "Employer Costs for Employee Compensation, 1986-98," Bulletin 2508, December, 1998, 21.
2. *Wall Street Journal*, February 26, 1997, A16.
3. *Business Week*, May 8, 1995, 30.
4. *Fortune*, April 22, 1991, 214.
5. *Wall Street Journal*, December 28, 1993, A1.

6. *Business Week,* February 17, 1997, 56.
7. *Wall Street Journal,* July 28, 1992, A1.
8. *Wall Street Journal,* January 27, 1994, A1.
9. *The Economist,* November 5, 1994, 19.
10. *Business Week,* December 23, 1996, 60.
11. *Wall Street Journal,* February 25, 1997, 1A.
12. *Wall Street Journal,* March 14, 1994, A1.
13. *Wall Street Journal,* February 19, 1997, A18."All's Not Fair in Labor Wars,"
14. "All's Not Fair in Labor Wars," *Business Week,* July 19, 1999, 43.
15. "Maybe the Fed Isn't Finished After All," *Barron's,* September 6, 1999, MW13.

Chapter 8

1. *Wall Street Journal,* December 16, 1996, A1.
2. *Business Week,* January 15, 1996, 56.
3. "True, the Jobs Report Buoyed Bonds, But Don't Overlook Those Seasonal Adjustments," *Barron's,* October 7, 1996, MW12.
4. *Wall Street Journal,* December 1, 1994, A1.
5. Ibid., A1.
6. *Wall Street Journal,* February 20, 1990, A1.
7. *Wall Street Journal,* April 3, 1990, A1.
8. *Wall Street Journal,* January 3, 1993, A1.

Chapter 9

1. For a detailed discussion of this issue, see Michael Lind, "The Southern Coup: the South, the GOP and America," *The New Republic,* June 19, 1995, 20.
2. "Issues Beyond Impeachment Vex GOP About Clinton," *Wall Street Journal,* January 22, 1999, A12.
3. *Wall Street Journal,* February 22, 1999, B18.

Part 2

1. Richard Darman, *Who's In Control,* New York: Simon & Schuster, 1966, 283.

Chapter 10

1. *Newsweek,* January 30, 1995, 42.
2. *Wall Street Journal,* June 14, 1995, A18.
3. *Forbes,* January 20, 1992, 94.

4. Ibid., 94.
5. *Business Week,* August 15, 1994, 78.
6. *Wall Street Journal,* September 30, 1997, A2.
7. *Business Week,* September 27, 1999, 90.
8. *Forbes,* November 1, 1999, 158.
9. *Scientific American,* January 1996, 32.

Chapter 11

1. *Wall Street Journal,* October 26, 1994, A22.
2. *Wall Street Journal,* August 1, 1996, A1.
3. *Wall Street Journal,* May 22, 1997, A2.
4. *Wall Street Journal,* April 2, 1998, A10.
5. *Forbes,* December 30, 1996, 47.
6. *Charlotte Observer,* August 22, 1996, 13A.

Chapter 12

1. *Wall Street Journal,* October 10, 1997, A1.
2. *Wall Street Journal,* November 22, 1995, A12.
3. Ibid., A12.
4. *Wall Street Journal,* April 28, 1997, A1.
5. *Wall Street Journal,* August 25, 1997, A2.
6. *Wall Street Journal,* April 7, 1997, C1.
7. "GOP Targets Estate Taxes, Capital Gains," *Wall Street Journal,* June 10, 1997, A3.
8. *Business Week,* June 30, 1997, 43.
9. *Wall Street Journal,* July 11, 1997, C1.
10. "Capital-Gains Cuts Are a Boon to Workers with Stock Options," *Wall Street Journal,* August 6, 1997, C1.
11. *Wall Street Journal,* August 21, 1997, C1.
12. *Wall Street Journal,* October 21, 1997, C1.
13. "The GOP's Worst Enemy," *Business Week,* June 30, 1997, 102.
14. *Wall Street Journal,* July 18, 1997, C1.
15. *Wall Street Journal,* January 7, 1998, C1.
16. "More Tax Breaks," *Wall Street Journal,* August 13, 1999, A1.
17. *Wall Street Journal,* September 30, 1999, A2.
18. "As Congress Ponders New Tax Breaks, Firms Already Find Plenty," *Wall Street Journal,* August 4, 1999, A1.
19. *Wall Street Journal,* August 9, 1999, A3.
20. *Business Week,* July 26, 1999, 43.
21. *Wall Street Journal,* July 16, 1999, A16.
22. *Wall Street Journal,* August 5, 1999, A19.

23. "This Is a Tax Cut Whose Time Hasn't Come," *Business Week*, March 8, 1999, 24.

24. *Wall Street Journal*, September 14, 1999, A24.

25. *Business Week*, December 12, 1994, 30.

Chapter 13

1. *Fortune*, July 22, 1996, 141.

2. *Fortune*, August 19, 1996, 171.

3. *Wall Street Journal*, June 1, 1998, A1

4. *Forbes*, February 24, 1997, 114.

5. "Your Guide to Closed-End Funds," *Business Week*, February 17, 1997, 86.

6. *Business Week*, December 18, 1995, 76.

7. *Wall Street Journal*, March 26, 1997, C1.

8. "Prosecutors Look at Ties in Test Scam," *Wall Street Journal*, January 9, 1997, C1.

9. *Forbes*, February 24, 1997, 172.

10. *Wall Street Journal*, March 14, 1996, A1.

11. "Stock-Rigging Sting Has a Familiar Face: Allen Wolfson, Felon, *Wall Street Journal*, December 2, 1996, A1.

12. "Big Profits Can Lie Under Nasdaq Spreads," *Wall Street Journal*, August 26, 1996, C1.

13. "Trading in Fund American Prior to News of Deal Raises Suspicion of Insider Trades," *Wall Street Journal*, August 3, 1990, A3.

14. "'I'm One of the Suckers'," *Business Week*, September 24, 1990, 118.

15. "Partnership Problems at Prudential Embroil Insurance Business, Too," *Wall Street Journal*, February 1, 1993, A1.

16. "The Mob on Wall Street," *Business Week*, December 16, 1996, 92.

17. *Wall Street Journal*, December 20, 1994, C1.

18. *Wall Street Journal*, April 7, 1989, C1.

19. *Fortune*, July 22, 1996, 66.

20. *Wall Street Journal*, February 27, 1997, C1.

21. "No, thank you, Paine Webber," *Forbes*, March 7, 1988, 52.

22. "Nasdaq Dealers and 100 Traders Face SEC Case," *Wall Street Journal*, July 9, 1998, C1.

23. "Wall Street Brokers Press Small Investors To Hold IPO Shares," *Wall Street Journal*, June 26, 1998, A1.

24. "Investors Find That Arbitration Claims Against Their Brokers Don't Always Pay," *Wall Street Journal*, July 29, 1998, C1.

25. *Business Week*, August 3, 1998, 94.

26. *Business Week*, August 3, 1998, 74.

27. *Forbes*, June 2, 1997, 42.

28. "NationsBank to Settle Securities Charges," *Wall Street Journal*, May 5, 1998, B15.

29. "Pain of Mutual-Fund Fees Is More Acute When the Market Is Going Down Than Up," *Wall Street Journal*, August 25, 1998, C1.

30. *Business Week*, July 14, 1997, 56.

31. *Wall Street Journal*, April 23, 1998, C1.

32. *Wall Street Journal*, September 12, 1989, C1.

33. "At Dead-Last Steadman, Past is Prologue," *Wall Street Journal*, April 15, 1997, C1.

34. "Seniors, Prey of Con Artists and Brokers, Are Mad as Heck, Won't Take It Anymore," *Wall Street Journal*, February 20, 1997, C1.

35. "Back to the Futures," *Forbes*, May 3, 1999, 224.

36. *Fortune*, August 18, 1997, 109.

37. *Wall Street Journal*, February 6, 1997, A1.

38. *Wall Street Journal*, August 10, 1998, A1.

Chapter 14

1. "Are Grocers Getting Fat by Overcharging for Milk?" *Wall Street Journal*, February 18, 1997, B1.

2. *Wall Street Journal*, December 20, 1994, A1.

3. "Policies of Deception?" *Business Week*, January 17, 1994, 24.

4. "Hospitals Profit by 'Upcoding' Illnesses." *Wall Street Journal*, April 17, 1997, B1.

5. "Child Labor Continues to Flourish, Even in the U.S." *Wall Street Journal*, April 21, 1998, A1.

6. "U.S. Shut 34 Meat and Poultry Plants in Quarter Due to Sanitation or Safety." *Wall Street Journal*, 5/8/98, A6.

7. "Besides S&L Owners, Host of Professionals Paved Way for Crisis." *Wall Street Journal*, 11/2/90, A1.
8. *Business Week*, August 10, 1998, 85.
9. *Business Week*, February 16, 1998, 100.
10. "Ties Among Corporate Directors: The Missing Link to CEOs' Fatter Pay," *Barron's*, April 13, 1998, 30.
11. "Takeover Moves Could Jolt the Mutual-Fund Industry," *Wall Street Journal*, April 8, 1998, C1.
12. "Life Insurers Now Find They Are Held Liable For Abuses by Agents," *Wall Street Journal*, January 21, 1994, A1.
13. "How LBOs Provided Major Opportunities for Two Scam Artists," *Wall Street Journal*, March 15, 1990, A1.
14. "Debtors' Vision," *Forbes*, June 2, 1997, 45.
15. "Where Are the Gloves? They Were Stocklifted by a Rival Producer," *Wall Street Journal*, May 15, 1998, A1.
16. *Wall Street Journal*, March 16, 1990, A1.
17. "HFC Profits Nicely by Charging Top Rates on Some Risky Loans," *Wall Street Journal*, December 11, 1996, A1.
18. *Wall Street Journal*, July 6, 1989, A1.
19. "Union Pacific Earnings Outlook Worsens," *Wall Street Journal*, November 18, 1997, A3.
20. "The Wreck of the Union Pacific," *Fortune*, March 30, 1998, 94.
21. "Morgan Stanley Found a Gold Mine of Fees by Buying Burlington," *Wall Street Journal*, December 14, 1990, A1.
22. "Trial Details Workings of ADM Cartel," *Wall Street Journal*, July 16, 1998, B7.
23. "Lawsuit Reveals a Pricing Secret at Drug Chain," *Wall Street Journal*, February 26, 1998, B1.
24. *Business Week*, August 10, 1998, 29.
25. "Ernst & Young Will Pay $185 Million To Settle Claims of Merry-Go-Round," *Wall Street Journal*, April 27, 1999, A2.
26. "Artificial Heart Valves That Fail Are Linked to Falsified Records," *Wall Street Journal*, November 7, 1991, A1.
27. "Home-Health Rivals Try Merger of Equals, Get Merger From Hell," *Wall Street Journal*, February 26, 1998, A2.
28. "'I Thought Florida Land Scams Were Over'," *Business Week*, April 23, 1990, 107.
29. "Mining the Suckers," *Forbes*, February 10, 1997, 50.
30. "Trouble!" *Business Week*, April 28, 1997, 68.
31. "Sears Is Accused Of Billing Fraud At Auto Centers," *Wall Street Journal*, June 12, 1992, B1.
32. "Award Against State Farm Mutual In Policyholder's Suit Is Upheld," *Wall Street Journal*, September 4, 1998, B8.
33. "Ucar to Pay Record $100 Million in Federal Probe of Price Fixing," *Wall Street Journal*, April 8, 1998, B2.
34. "At Oxford Health, Financial 'Controls' Were Out of Control," *Wall Street Journal*, April 29, 1998, A1.

Chapter 15

1. *Fortune*, June 8, 1998, 201.
2. *Business Week*, March 16, 1998, 34.
3. *Wall Street Journal*, March 13, 1998, A3.
4. *Wall Street Journal*, June 26, 1990, A1.
5. *Wall Street Journal*, November 25, 1997, A1.
6. *Business Week*, December 22, 1977, 110.
7. *Business Week*, February 16, 1998, 24.
8. *Wall Street Journal*, September 13, 1989, A1.
9. *Business Week*, February 23, 1998, 42.

Chapter 16

1. *Wall Street Journal*, April 5, 1996, B1.
2. *Wall Street Journal*, November 23, 1990, A8.
3. *Wall Street Journal*, February 14, 1997, A14.
4. *The Collected Works of Abraham Lincoln*, (New Brunswick, N.J., Rutgers University Press, 1953), 471-482.
5. Ibid., 478.
6. *Newsweek*, September 12, 1994, 52.
7. *Fortune*, December 9, 1996, 72.
8. *Fortune*, November 25, 1996, 38.
9. William J. Bennett, *The Book of Virtues*, New York: Simon & Schuster, 1993.
10. Ibid., 657.
11. Ibid., 657-660.
12. Ibid., 347.

13. Ibid., 156.
14. Brent Tantillo, "Advancing Student Journalism," Intercollegiate Studies Institute, *Campus*, Fall, 1999, 14.
15. Ibid., 15.
16. *Charlotte Observer*, December 5, 1999, 1C.

Chapter 17
1. *Forbes*, October 11, 1999, 169.
2. *Forbes*, October 12, 1998, 66.
3. Reported at United for a Fair Economy's website, http://www.ufenet.org.
4. *Business Week*, November 19, 1990, 124.
5. *Forbes*, July 6, 1998, 242.
6. *Forbes*, October 12, 1998, 47.
7. *Wall Street Journal*, December 9, 1994, R24.

Chapter 18
1. *Wall Street Journal*, September 13, 1999, A1.
2. *Barron's*, October 26, 1998, 55.
3. *Wall Street Journal*, September 13, 1999, A1.
4. "Mortgage Shmortgage; I'll Pay Cash," *Fortune*, July 19, 1999, 27.
5. "Chic Comes to Crested Butte," *Newsweek*, December 27, 1993, 45.
6. *Wall Street Journal*, September 10, 1999, W1.
7. *Barron's*, November 15, 1999, 58.
8. "Summer Rentals: The Heat Is On," *Wall Street Journal*, January 28, 2000, W1.
9. *Wall Street Journal*, August 3, 1998, A1.
10. *Fortune*, June 9, 1997, 74.
11. *Forbes*, June 2, 1997, 136.
12. *Business Week*, May 11, 1998, 25.
13. *Wall Street Journal*, January 26, 1998, A1.
14. *Business Week*, August 3, 1998, 36.
15. *Business Week*, August 3, 1998, 38.
16. *Business Week*, August 3, 1998, 35.

Chapter 19
1. Karl Menninger, *Whatever Became of Sin?* New York: Hawthorne Books, 1973, 227-228.